THE ART OF
ADVENTURE

OUTDOOR SPORTS FROM SEA TO SUMMIT

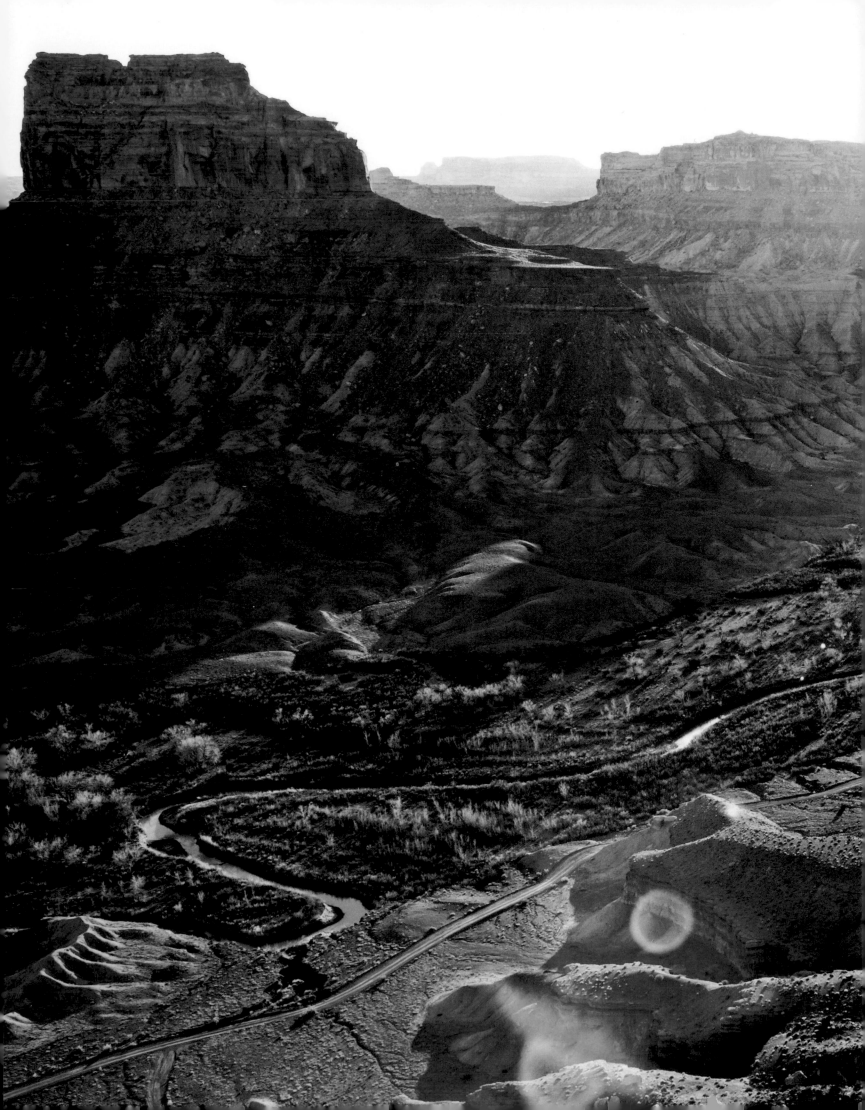

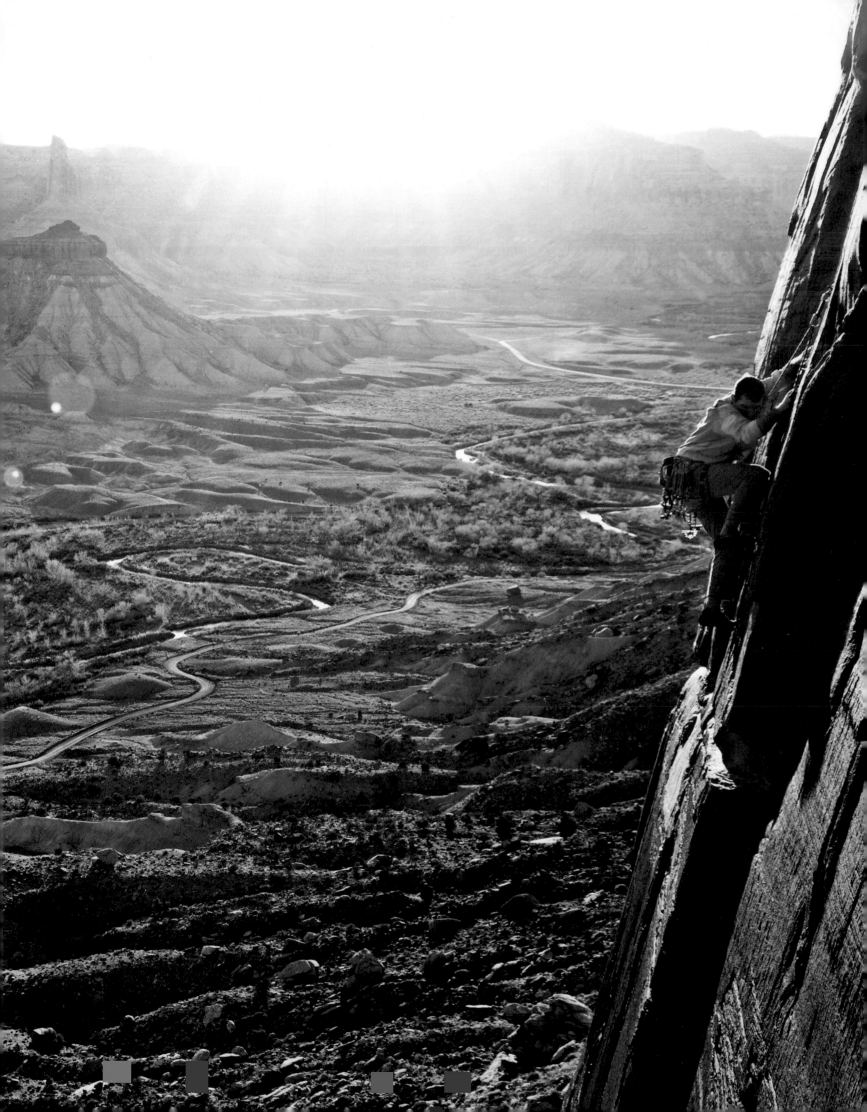

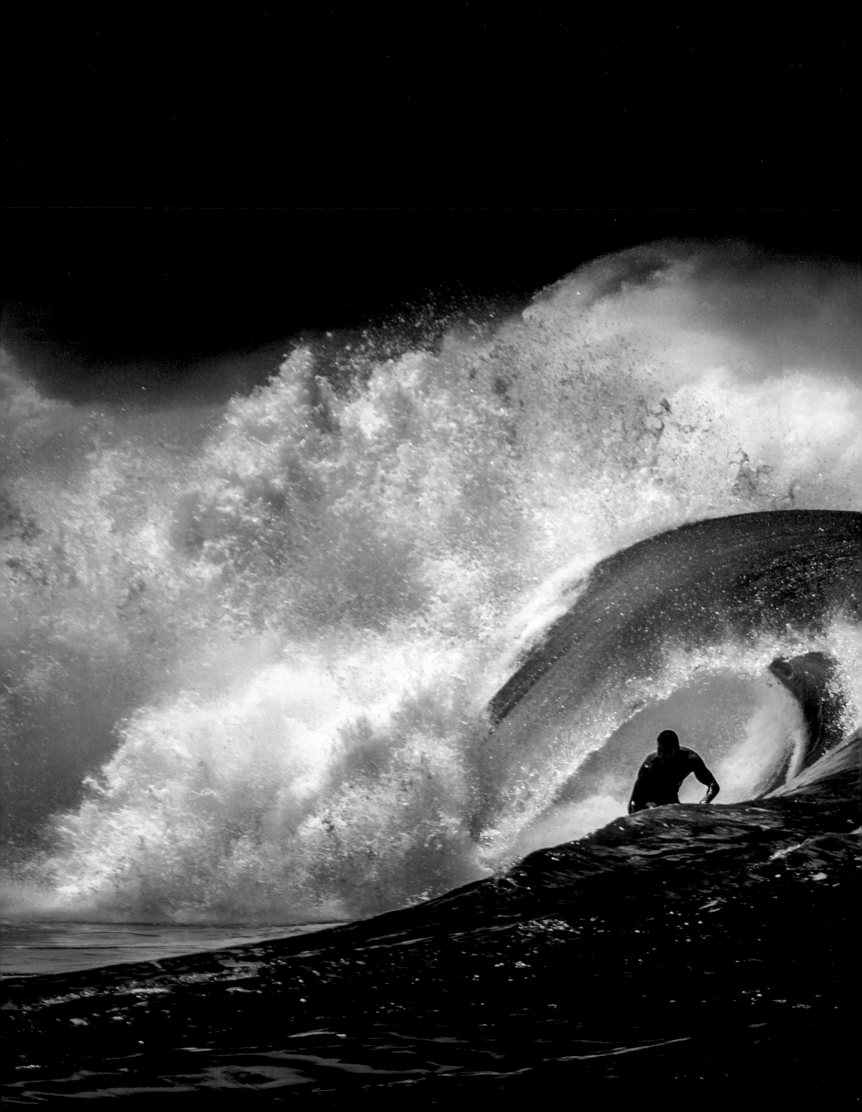

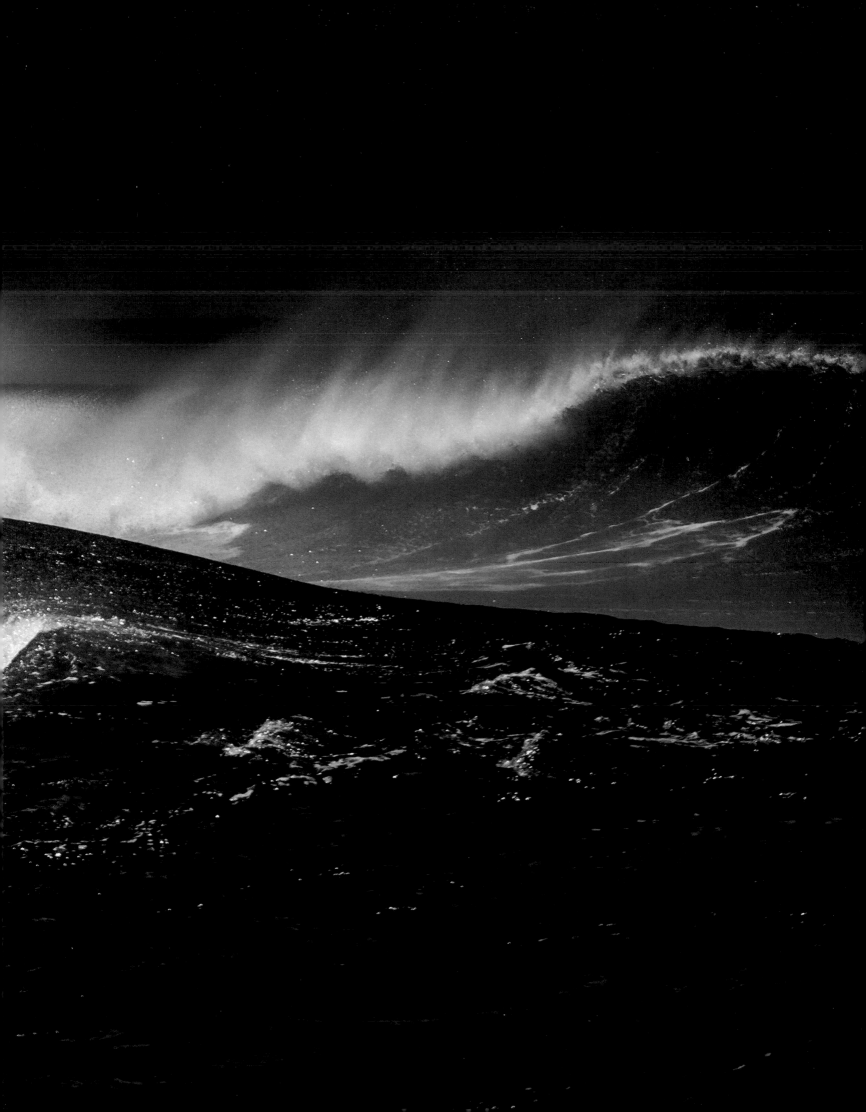

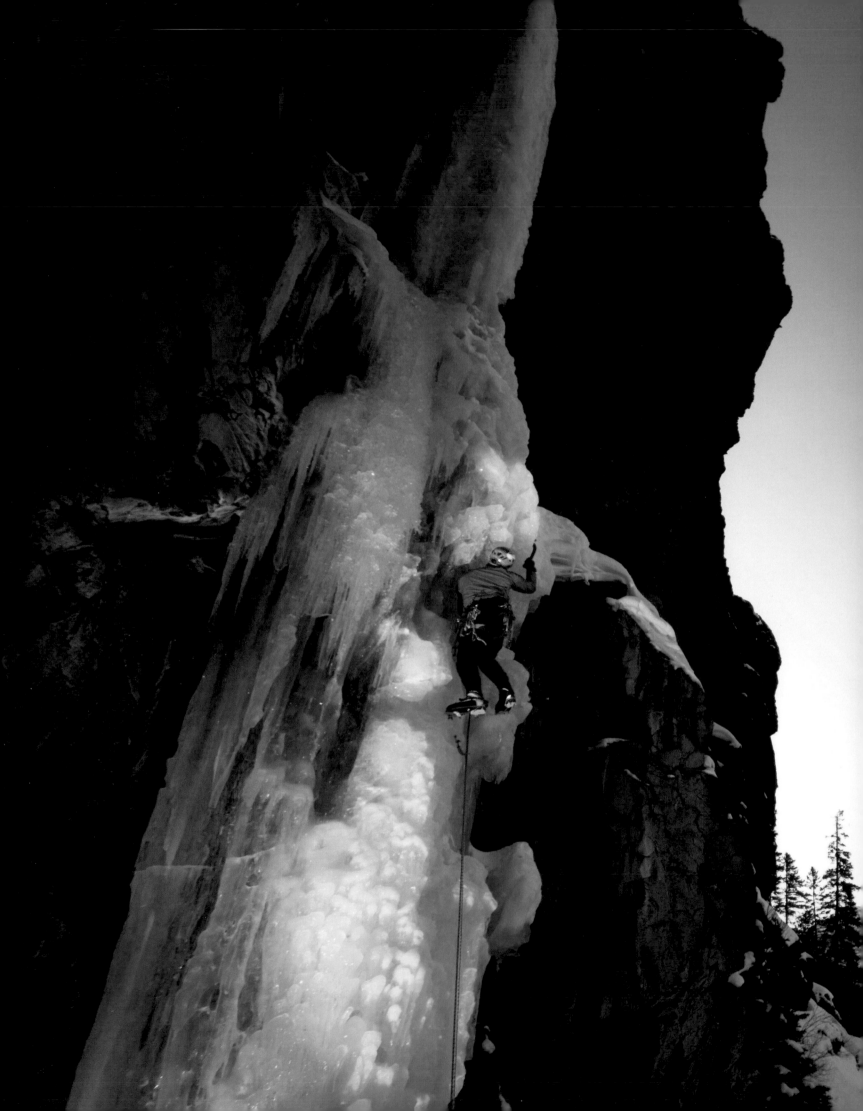

THE ART OF
ADVENTURE

OUTDOOR SPORTS FROM SEA TO SUMMIT

FOREWORD BY
SUSAN ALKAITIS

INTRODUCTION BY
IAN SHIVE

AFTERWORD BY
JON-PAUL HARRISON

PHOTOGRAPHS BY

INSIGHT 👁 EDITIONS

San Rafael, California

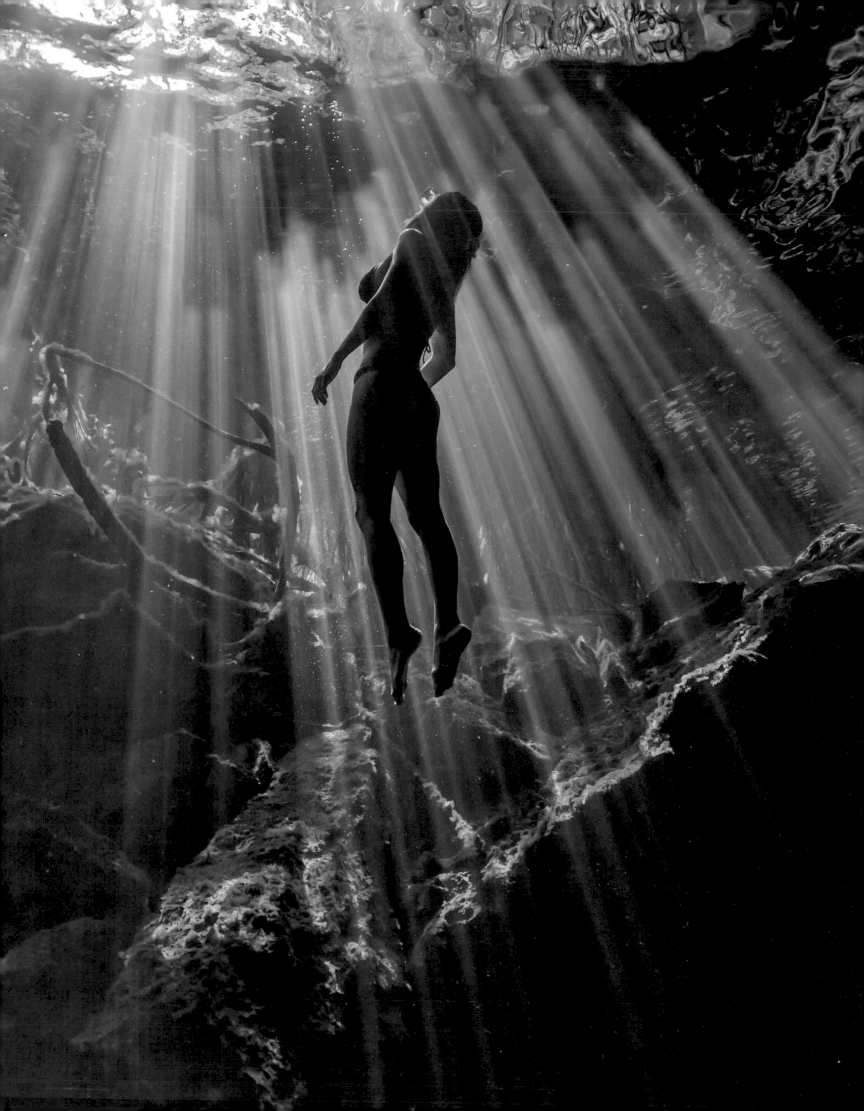

CONTENTS

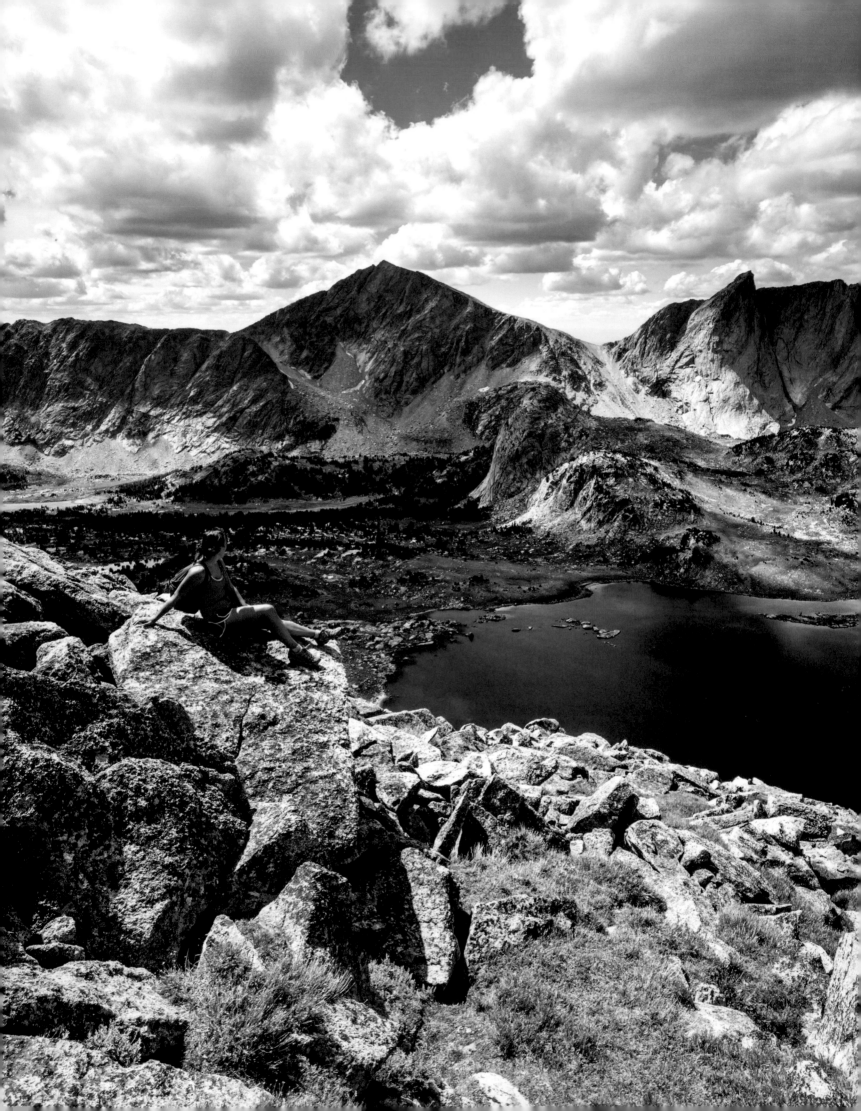

FOREWORD

BY SUSAN ALKAITIS

Deputy Director for the Leave No Trace Center for Outdoor Ethics

We have been entrusted with both great joys and great responsibilities. This is the underlying message of *The Art of Adventure*, as well as that of the Leave No Trace Center for Outdoor Ethics, an organization dedicated to responsible stewardship of the earth and partaking in its many pleasures in a way that celebrates rather than destroys its grandeur. We accept a simple doctrine that mandates we embrace the earth's beauty with a fierce dedication to doing it no harm, pursuing the physical challenges of adventure in full awareness of our ethical commitment to the natural world that buoys the human spirit.

The images of athletes and landscapes captured in *The Art of Adventure* are overwhelming. The intensity of human interaction with such sweeping, wild places has a stunning visual impact. Through these photographs, you will fall viscerally into deep recollection of your own adventures. They will induce the palm-sweating, mythic spirit of your own endeavors in the wilderness. If you are lucky, you may have even experienced some of the very places that are found in these pages, shot through isolated canyons in a kayak, surfed secret reef breaks, or skied powder untouched by another soul.

As you enjoy this breathtaking volume of photographs and essays, you may also be struck by the breadth and scope represented—from tales detailing the excitement and potential peril of venturing into remote corners of the world, to images evoking the euphoria found on the banks of hometown creeks and rivers. Adventure can be defined in as many ways as there are individuals journeying into the outdoors—a fact profoundly rendered by the diverse contributions that make up this volume.

These stunning photographs also remind us that the world's rugged and seemingly endless expanses of wilderness are in fact fragile and ever-shrinking assets. Entire species of plants and animals are lost by the thousands every year. A mere sliver of the United States is protected as wilderness. People are engaged in struggles all over the world to preserve the places they love. As civilization thrives—as we seek to go deeper for energy and reach wider for resources—our wild world can be compromised. The prevailing certainty is that the state and future of these unique places are lodged firmly in our hands. This is why the Leave No Trace Center for Outdoor Ethics was asked to partner with this publication.

Leave No Trace started as a wilderness concept more than a half-century ago. The organization has grown into an international movement with research, education, and outreach programs to support it. Leave No Trace offers a framework to support people

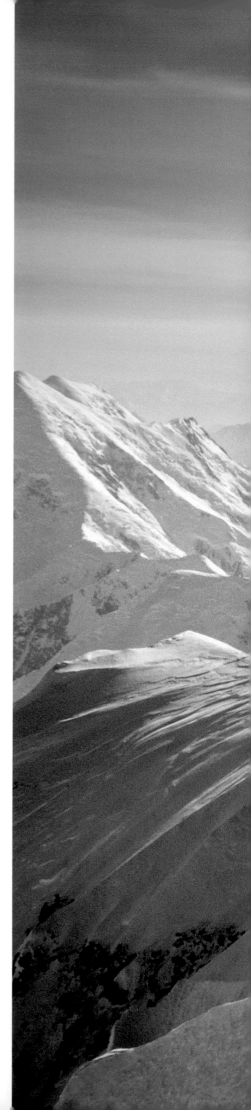

with practical, scientifically derived skills. These skills help people protect all facets of the outdoors, from the far reaches of wilderness to city parks. The Leave No Trace Center for Outdoor Ethics works with partners around the world—land managers, school systems, and like-minded outdoor and environmental organizations— connecting people to the outdoors in an environmentally sustainable way. While many conservation organizations work to repair environmental impacts or protect lands by limiting people's access to them, Leave No Trace's key to land protection is education and mobilization. By focusing on people and the choices they make when they are in the outdoors, Leave No Trace provides education about outdoor sustainability, skills, and ethics that can last a lifetime instead of merely patching up the impacts that people have ultimately created.

Leave No Trace programs exist because every time you step into the outdoors, you are confronted with a series of decisions. Those decisions are integral to the foundation of your outdoor ethic. And many of our collective actions have been studied with the overwhelming conclusion that people can make significant, lasting impacts to the nature they care so deeply about. To address these impacts to wild lands and wildlife, Leave No Trace has developed a set of outdoor skills, principles, and recommendations that are shared around the world. They appear at trailheads and are being taught to schoolchildren as well as some of the greatest outdoor athletes and adventurers of our day.

Your Leave No Trace ethic is not only engaged when you are climbing mountains; it begins when you step into your backyard and can be absorbed into the way you live you life. Your relationship to your natural world—every choice you make when you are outside—creates the framework for your personal outdoor ethic. This ethic is formed from the fundamental set of values and principles that govern your interaction with nature. Each one of your choices has an impact, and all these impacts add up over time.

The Art of Adventure brings you into untamed landscapes, with all of their formidable energy and profound solitude, and not only serves to sow seeds of inspiration but reminds us all of the vast remoteness our world still possesses. These uncharted experiences are still possible, but the wilderness that hosts them is entrusted to all of us to protect. So know your outdoor ethic. Then ensure that you have the best information to protect the outdoor places that you hold so dear. It has monumental significance, especially when weighed against the cumulative impacts affecting our communities and our planet. Here, we are reminded of why our natural world is the greatest of gifts.

OPPOSITE: Mt. McKinley, Alaska Range, AK, USA

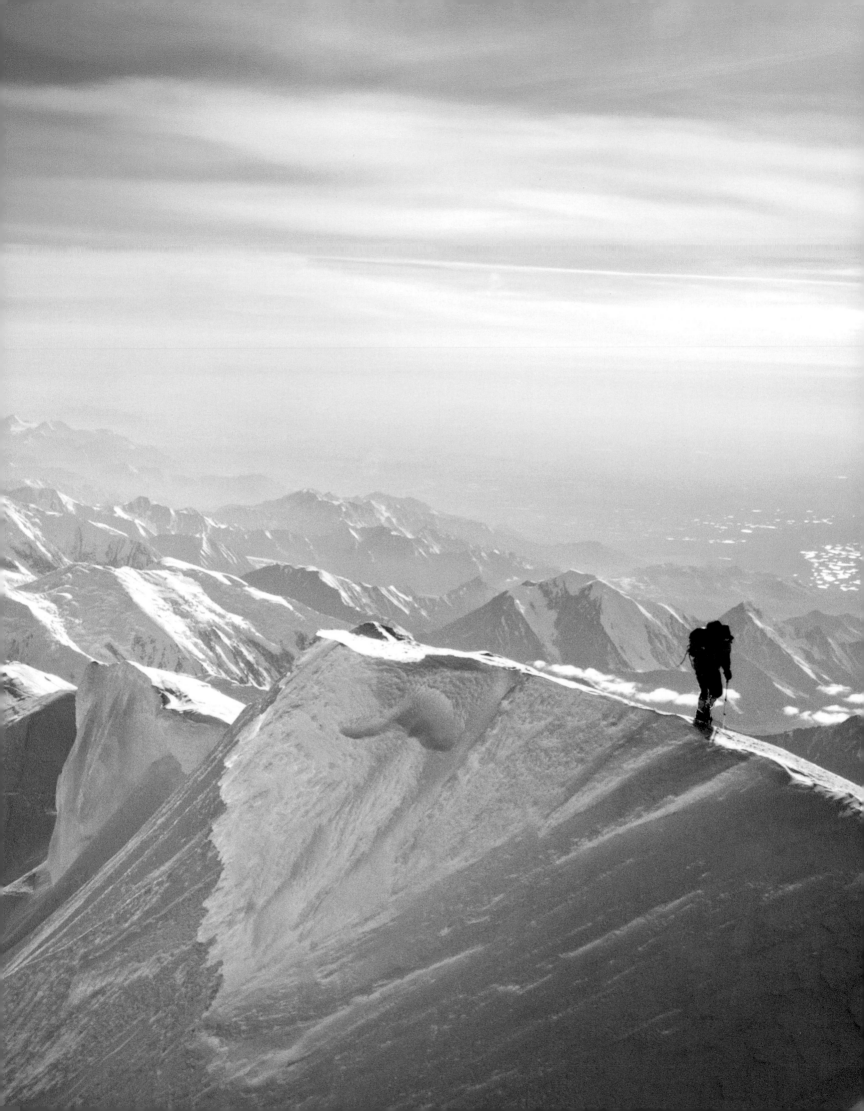

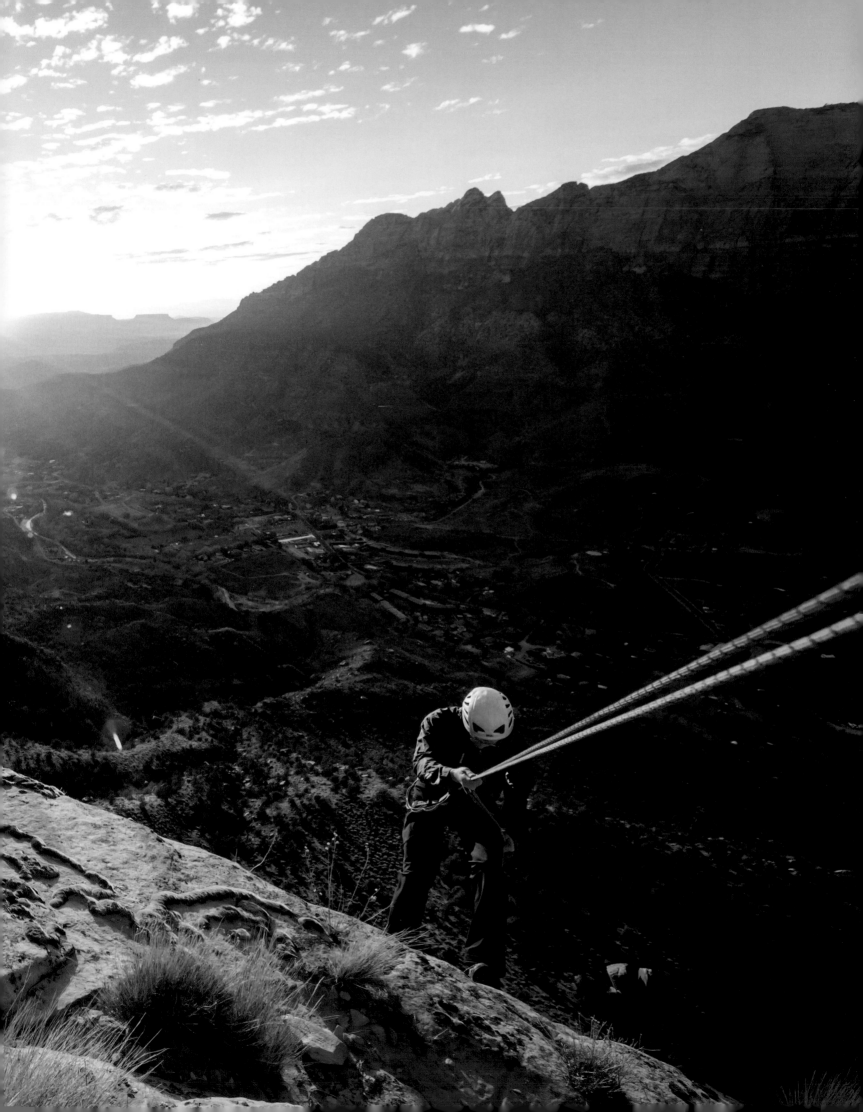

INTRODUCTION

BY IAN SHIVE

Founder of Tandem Stills + Motion

Physicians, lawyers, corporate executives, administrative assistants, service technicians, and the guy and gal who stock groceries on the shelves of your local supermarket—these are the true faces of the most dazzling and inspiring adventurers of our modern society. They are the base jumpers, ice climbers, and roaring river riders who raise the bar on our most daring of collective dreams. Behind the suits and the ties, the chef's aprons or high heels, are the physically conditioned bodies of athletes with hair-trigger reflexes and the bold audacity to push the furthest limits of the human experience. In the digital age, where information is delivered faster than a jolt of caffeine to the senses, the definition of *adventure* has been completely reinvented. In this landscape, Friday night conference calls are about early Saturday morning drives to boulder fields where climbing routes are born.

For every adventurer ascending a personal summit, there is an equally daring soul willing to attempt to capture it in photographs. With cameras strapped around their shoulders, these image-makers must not only reach for the next handhold, but also stay several steps ahead. Like the agile, quick-witted fox, their finely tuned senses are acute, crafty, and always anticipating their subject's next move, the next belay, the next turn of a skier as he or she smashes through two feet of fresh powder . . . even the next laugh shared around the last quiet embers of a campfire, where tales of the day's excursions are recounted far from one's living room, but close to those cared for most.

As the founder and chief executive of Tandem Stills + Motion, Inc., I have a unique job. Every day, my team and I bear witness to a steady, live stream of images pouring in from around the globe in real time, each one a defining moment of the adventurous life captured by the many hundreds of photographers we represent. It is a mind-blowing experience to be staring at a large computer screen in the relative safety of an office as equally mind-boggling images enter the queue—clear blue cenotes from Mexico, the bow of a sailboat tossed by fierce gray New England winds, a slender kayak tipping over the edge of a hundred-foot waterfall, a lone individual suspended in a climbing harness hundreds of feet above the earth. The photo desk at Tandem is like looking through a window onto the world of adventure, and this book is our opportunity to share that experience with you. It is our chance to share a bit about the many different and dynamic people with whom we are lucky enough to work.

The Art of Adventure is the ultimate culmination of Tandem's homage to the adventurers, photographers, and magazine staff who deliver these triumphant moments to mailboxes everywhere. It is a photography-rich compendium of the exhilarating

world of adventure that happens beneath sky, across land, and upon the sea—intended to thrust you into the realms of backpacking, rock and ice climbing, camping, mountaineering, skiing, trail running, surfing, and free diving—accompanied by insights and commentary from leading photo editors of the most revered outdoor magazines, including *Outside*, *SKI*, *Climbing*, *Backpacker*, and *Canoe & Kayak*.

This riveting collection captures the free spirit of outdoor pursuits and passions like never before. Filled with wisdom and colored by both epic and quiet moments alike, *The Art of Adventure* is a gripping reminder of the vast recreational potential that awaits anyone willing to experience life as few ever will.

As you turn these pages and find inspiration, or maybe even recognize places from your own excursions, I hope that you feel the power and beauty of our incredible planet. I hope that you will see not only the spirit of the individuals who dare to test themselves, but also the talent and craft of the photographers who so passionately create these images and reignite wonder for the natural sanctuaries that host them. By the time you turn the last page of this book, I believe you will be left awestruck and with a new appreciation for the art of adventure.

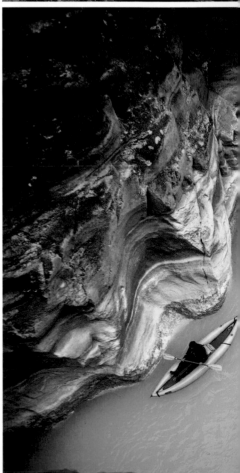

OPPOSITE, LEFT TO RIGHT, TOP TO BOTTOM: Supertubes, Ventura, CA, USA; Cave Route 5.10d, Indian Creek, UT, USA; Craig Pope climbing Come and Get It, Hyalite Canyon, MT, USA; Skolai Pass area, Wrangell-St. Elias National Park, AK, USA; Sven Brunso skiing remote backcountry in Iceland; Cyclocross bike racer at Wheeler Farm, Salt Lake City, UT, USA; Kayaker exploring Havasu Creek, AZ, USA; Snowboarder in Mt. Baker backcountry, WA, USA
FOLLOWING PAGES: Chad Peele and Althea Rogers prepare to rappel into Box Canyon, Ouray Ice Park, CO, USA
PAGES 20-21: Spirit Falls, Little White Salmon River, WA, USA

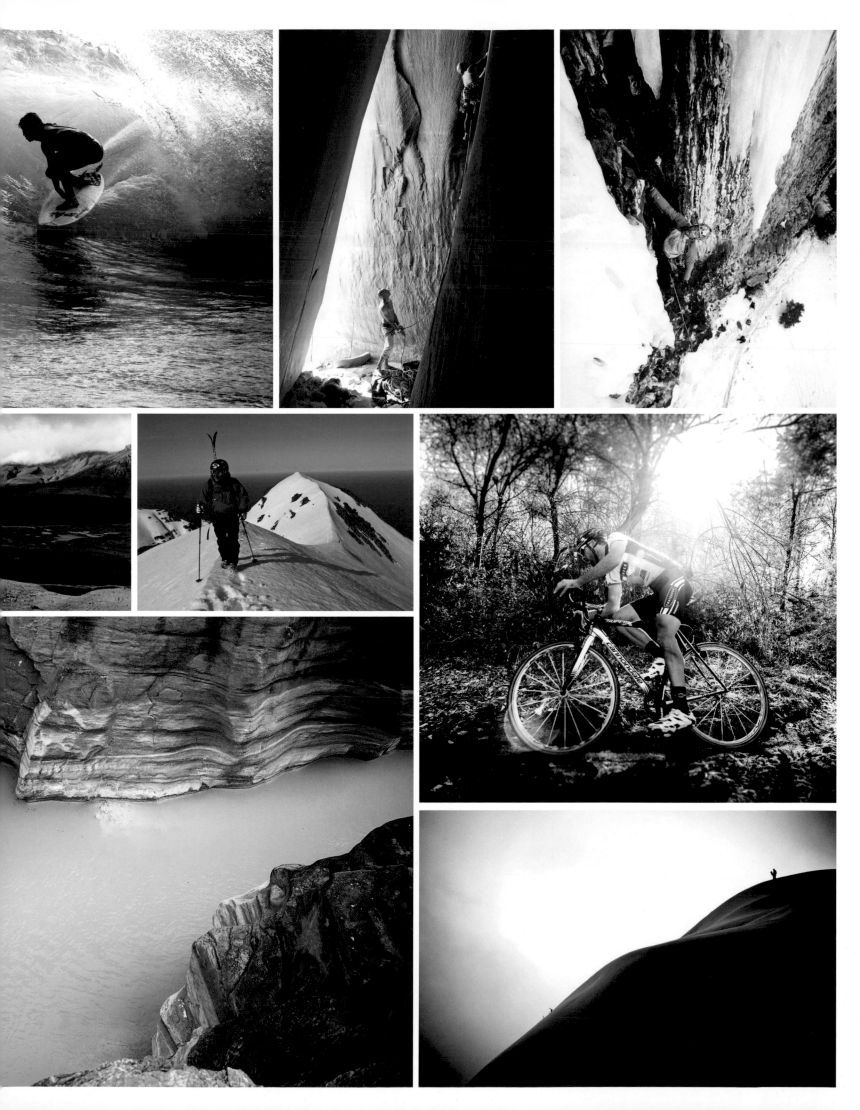

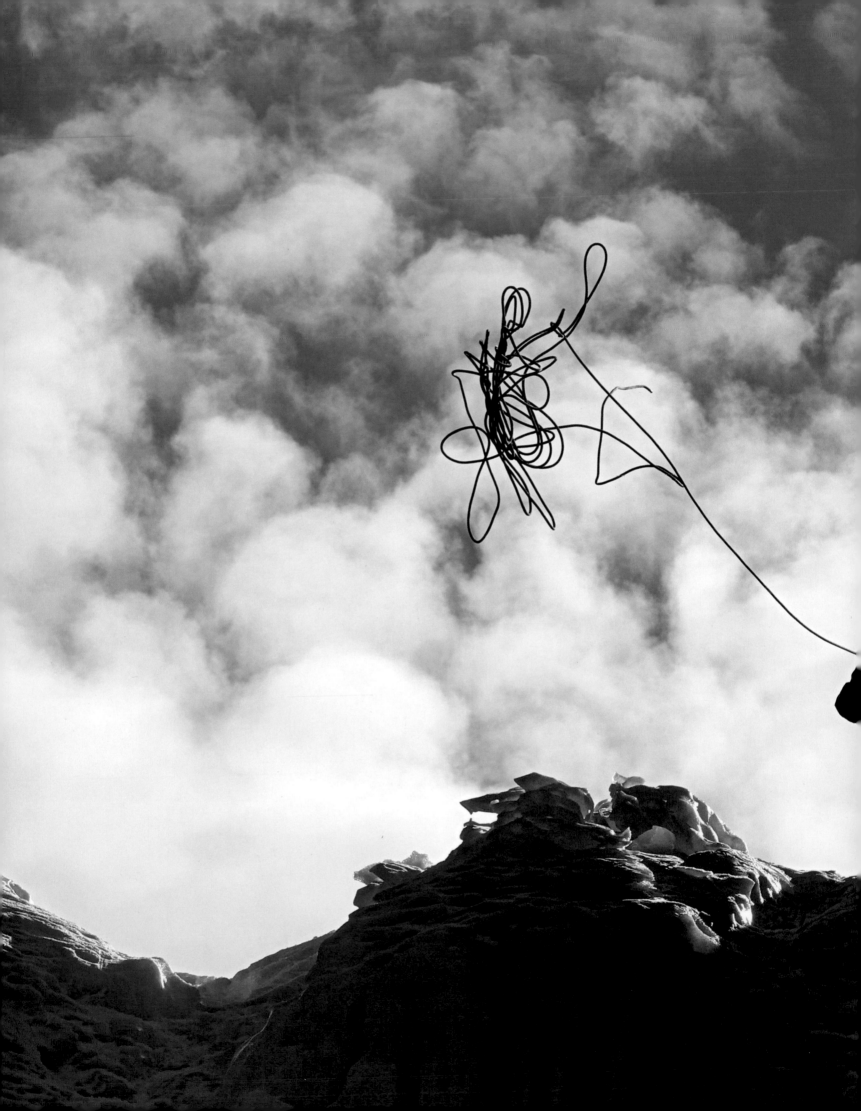

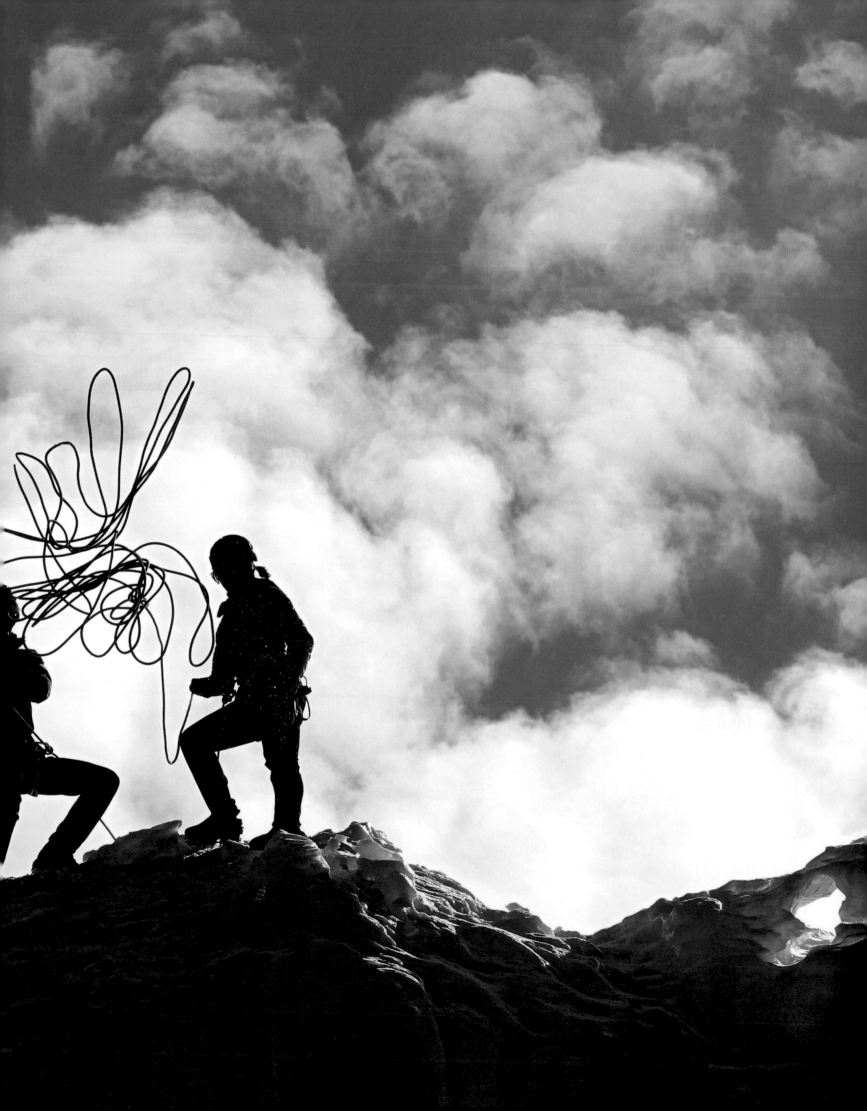

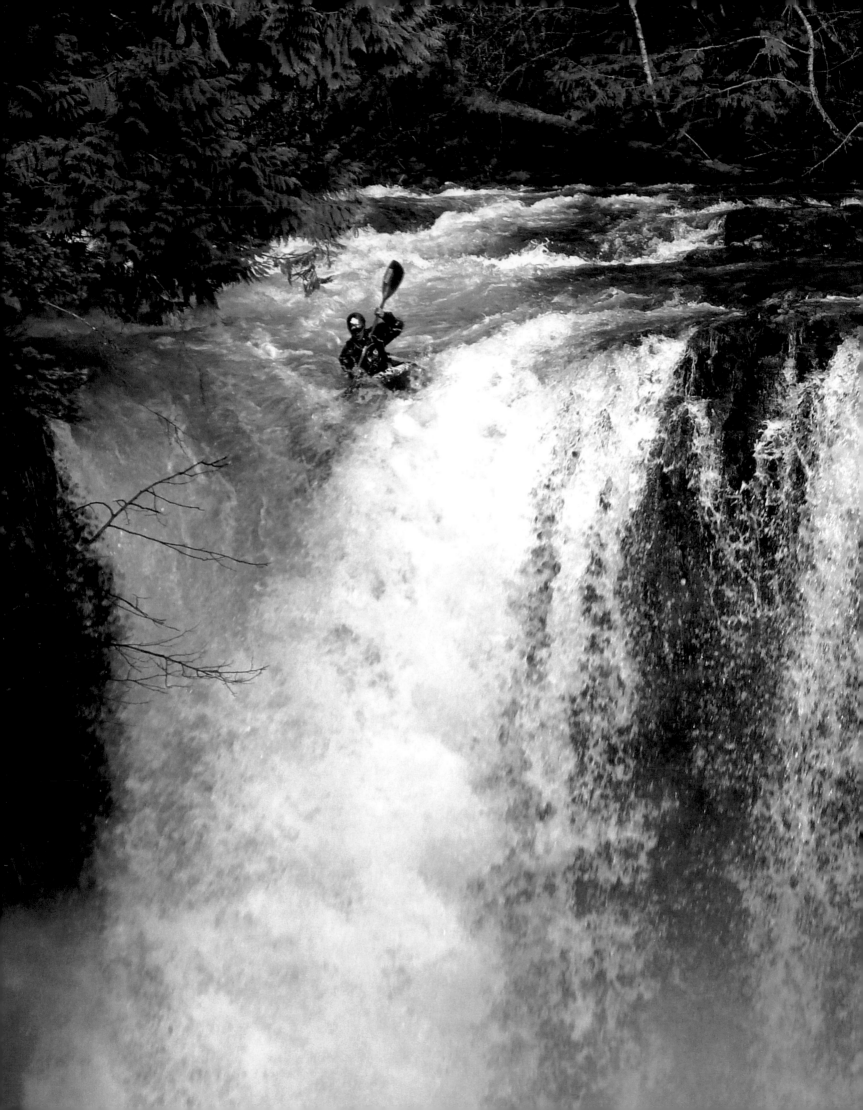

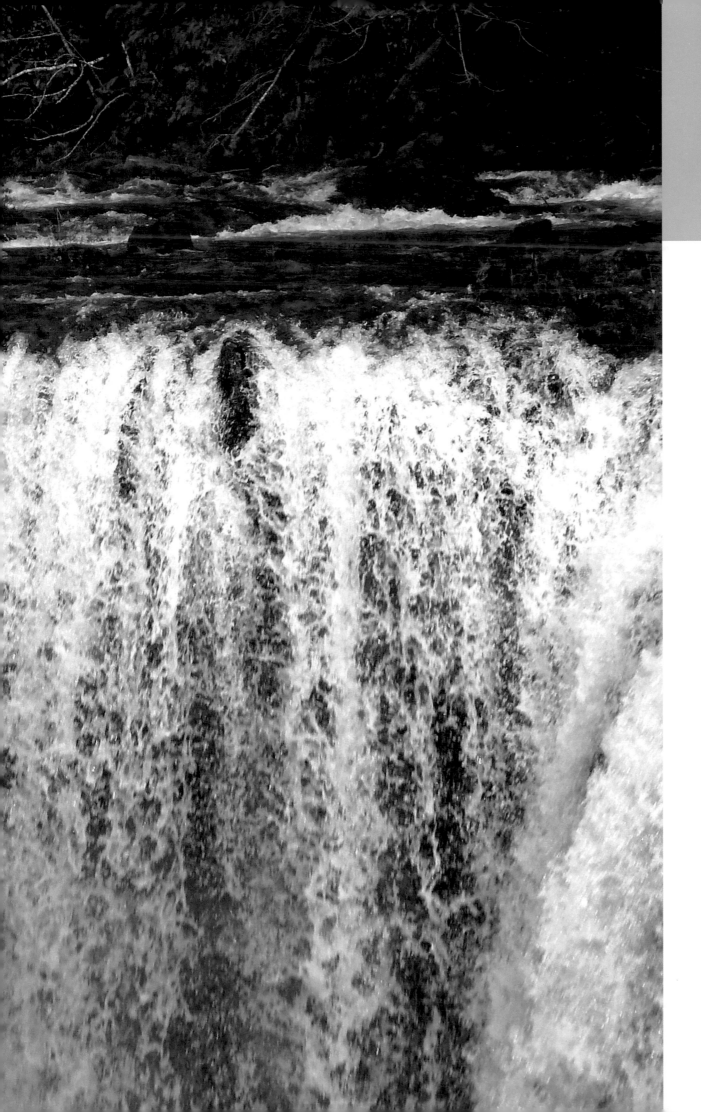

WATER

KAYAKING

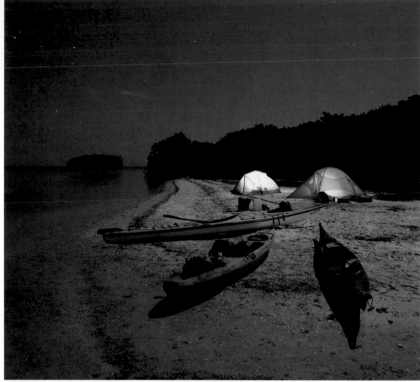

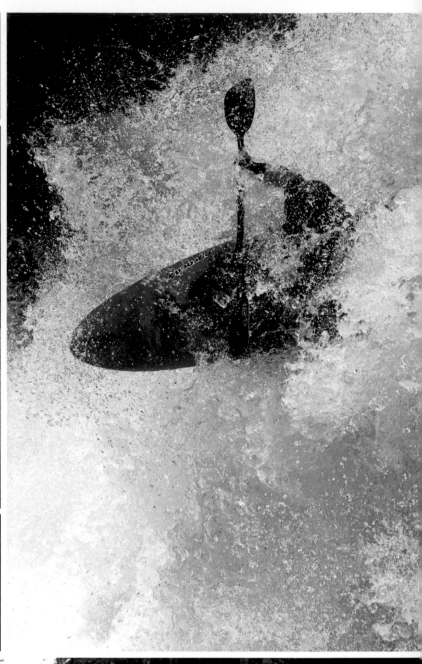

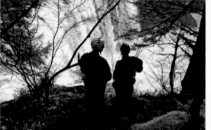

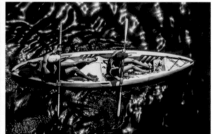

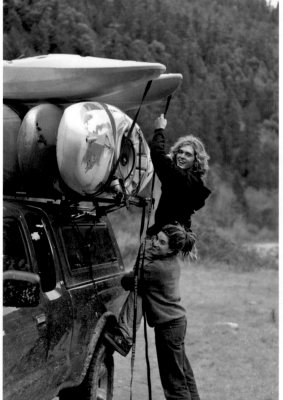

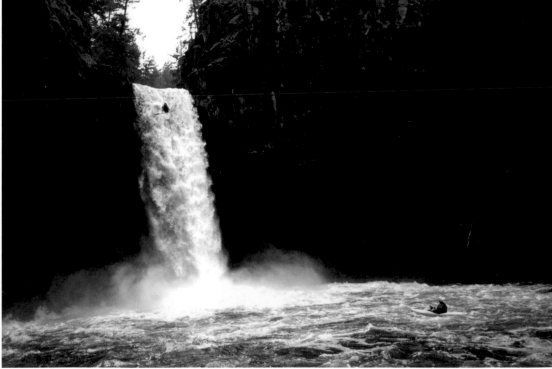

ABOVE, LEFT TO RIGHT, TOP TO BOTTOM: Rabbit Key, Everglades National Park, FL, USA; Whitewater kayaker on Oh Be Joyful Creek near Crested Butte, CO, USA; Todd and Brendan Wells discuss their line for dropping Spirit Falls, Little White Salmon River, WA, USA; Russian River, CA, USA; Loading kayaks near New River Gorge, CA, USA; Erik Johnson descends Outlet Falls, WA, USA, while Todd Wells sits in his kayak below as safety for the descent · OPPOSITE: Drangme Chhu River, Bhutan

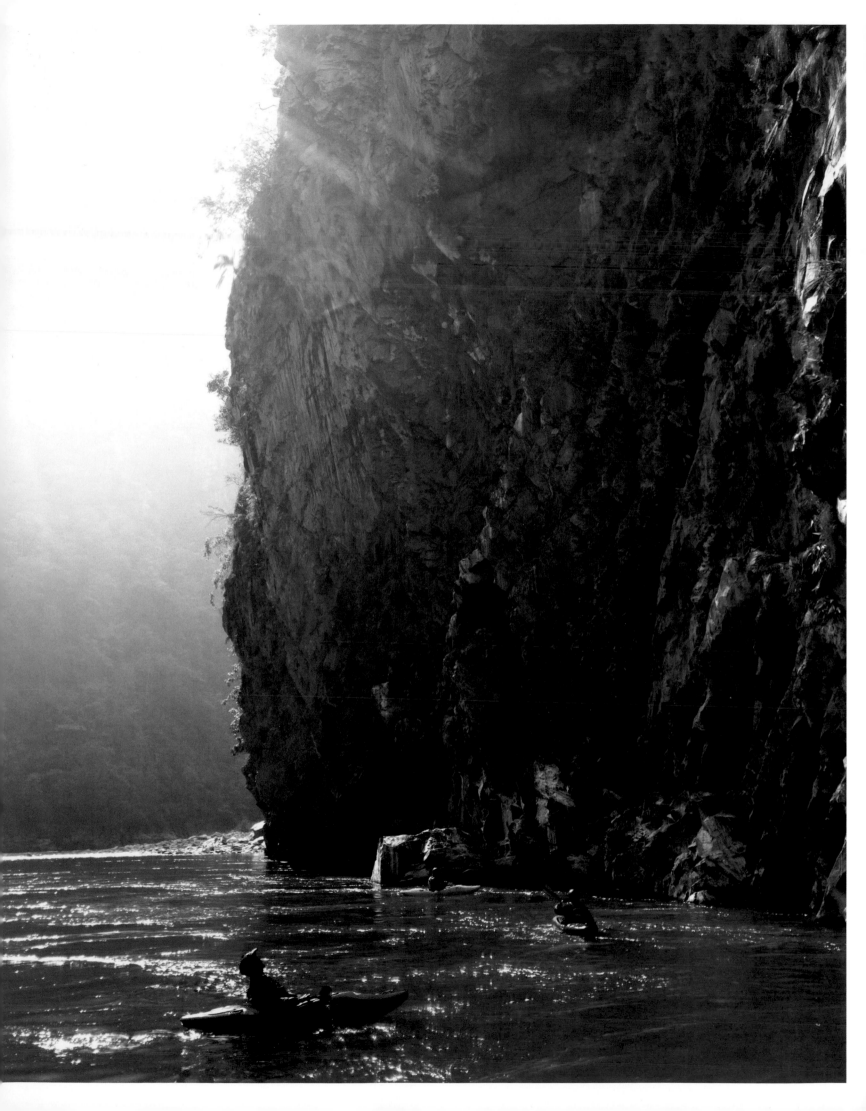

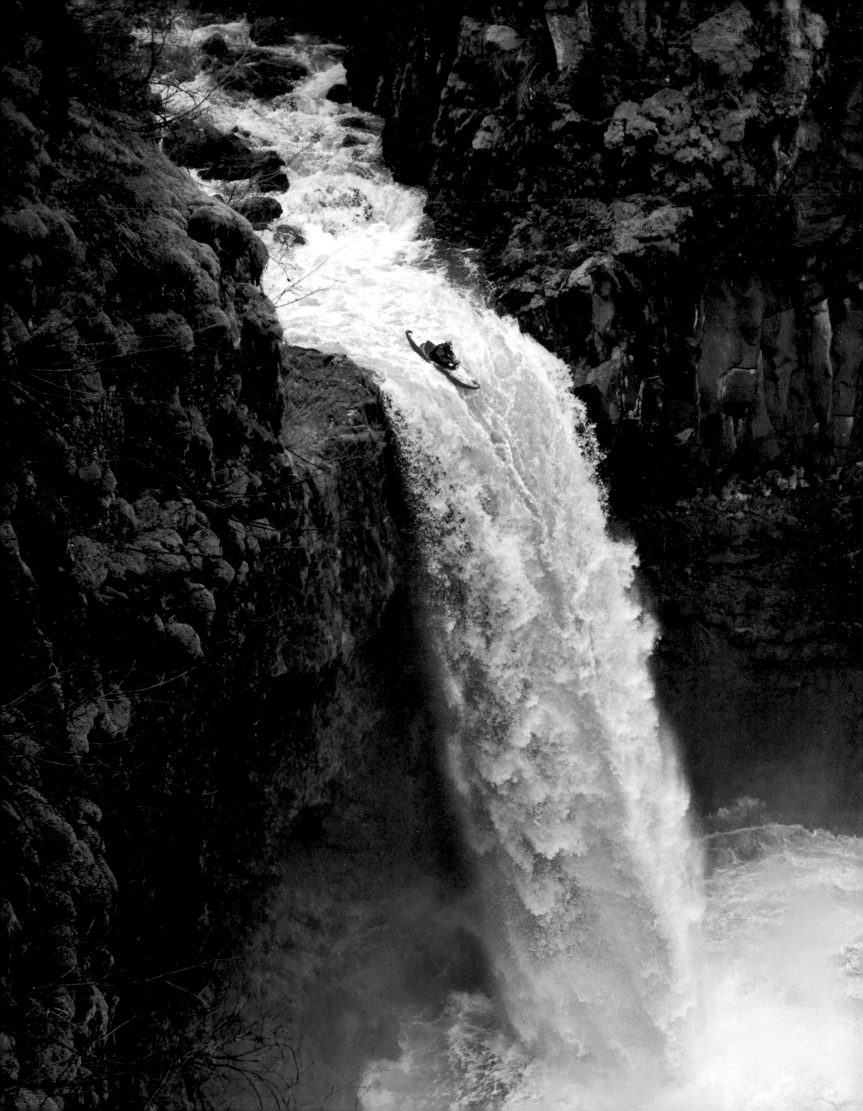

WE CALL IT "RIVER TIME"

Aaron Schmidt, *Canoe & Kayak*

WE CALL IT "RIVER TIME"—the feeling you get when purposefully abandoning civilization, at least temporarily, and you find that all of its stresses are blissfully forgotten. Here, the imposed notion of time fades, replaced by the diurnal cycles of sunrise and sunset, and constraints exist only in the form of weather and changing terrain. Your cell phone doesn't work, and you might begin to understand what it means to "food-ration." But without the distractions of home you can become totally in tune with the environment; you read the light and learn to anticipate the mist as it rises off the water in the early hours of the morning. Perhaps rapids you would have considered portaging yesterday are easily charged today.

But as photographers we need to push it, to get ahead and get in place for the shot. When you swim you fear more about the seal on your camera's dry bag than the class IV hole downstream. You hope that you brought enough batteries because in the back of your mind you know that river time is fleeting and how important it is to capture as many images as possible.

But that's why we shoot in the first place; to hold on to those moments when we were beholden to nature and shared in the camaraderie that boating creates.

Boaters are a special breed; they know the importance of teamwork. I remember one of my first whitewater swims and how stoked I was to see a guy I had only just met at the put-in paddle his ass off to make it over and tow me to an eddy. There is a certain kind of friendship that is born out of these harrowing situations. One of my photojournalism teachers always told us not to make photographs but to make relationships. And he's so right—the "fly on the wall" approach doesn't really work on the river.

So go for it, commit yourself to the people on your trip. Ask questions, take candid portraits, and learn who the real people are beneath the drysuits, PFDs, and other paddling gear. Your images will be the better for it, and as photographers we need to capture every angle—from the hucksters testing their skills as they launch over the maw of a waterfall to the smile on the face of a friend as he passes the peanut butter jar.

Even with the all-in approach, creating epic photographs on these trips is both extremely challenging and frustrating. Let's face it, no one wants to sit in an eddy and wait for the photographer to paddle ahead, get out of the boat, and climb up some slippery rock just to get a shot. It can ruin the natural flow of a trip. Photographers need to know that it's sometimes better to abandon good photo locations and wait for the right moments. The best photographers I work with are often very talented boaters—they need to be. Guys like Mike Leeds, Erik Boomer, and Darin McQuoid were exceptional boaters first before they ever even picked up a camera . . . and it shows in their work.

But as with most things in life, it pays to start small. Kayaking can be dangerous business, but that's probably why we go—to push ourselves to that edge and see what we're made of. Keep it simple to begin with, go with safety conscious boaters, and remember it's OK to portage the bigger drops. And if you are walking around that big class V hole, definitely take the time to pull out the camera. You better believe your bros will be glad you did, because they are going to want that visual reminder of their time on the river just as much as you.

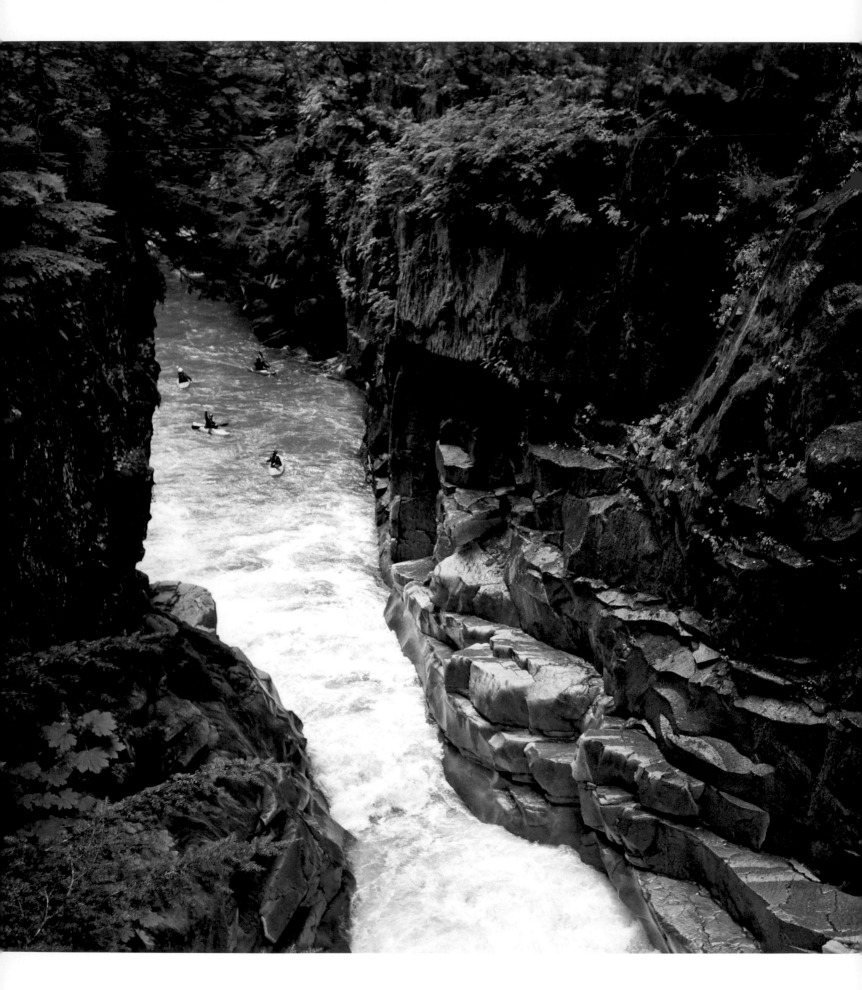

Humanity has been paddling boats since Moby Dick was a goldfish. From Native Americans developing seal-skin kayaks in the Arctic to Polynesians sailing their canoes across the Pacific, humans can trace the history of paddling back a long way. Recreational paddling started to take hold around the turn of the nineteenth century as canoeing skills were passed down from fur trappers and explorers to those that found that paddling was a great way to escape into the wilderness. Not to mention that fun segment of history that saw young couples in the early 1900s taking to canoes to escape the view of chaperones, spawning a whole litany of "sex in a canoe" jokes . . . What do American beer and making love in a canoe have in common? They're both fucking close to water!

Paddling experts like Bill Mason helped pass on detailed canoeing skills to a whole generation of paddlers who were looking to take their endeavors to the next level, opening up the possibilities of tackling more serious whitewater. And the late '60s saw the emergence of kayaking as the de facto method for charging even heavier rivers. In the '70s, wild men like Walt Blackadar and Rob Lesser, who charged previously unthinkable waters, paved the way for what was possible in a kayak. Things have only gotten crazier since then as younger generations found out it was feasible to tackle huge waterfalls and survive.

The current status of paddle sports can be defined only by the variety in which we see it. The whitewater heyday of the late '90s might not have the stardom that it used to, but there are still elite crews exploring the globe, doing crazy missions like tackling first descents of jungle waterfalls in areas of drug-cartel controlled Mexico or paddling foldable kayaks on unknown rivers through Siberia. Even the true source of the Amazon River was only recently found to be a different river than originally thought, and so far only a small handful have paddled the complete source to the sea.

So where is the future of paddling going? We are going to see people paddling for all sorts of reasons, on many different crafts. The recent explosion of stand-up paddleboarding and kayak fishing are indicative of this. But whatever the means, people are going to want to be out on the water—it's our nature.

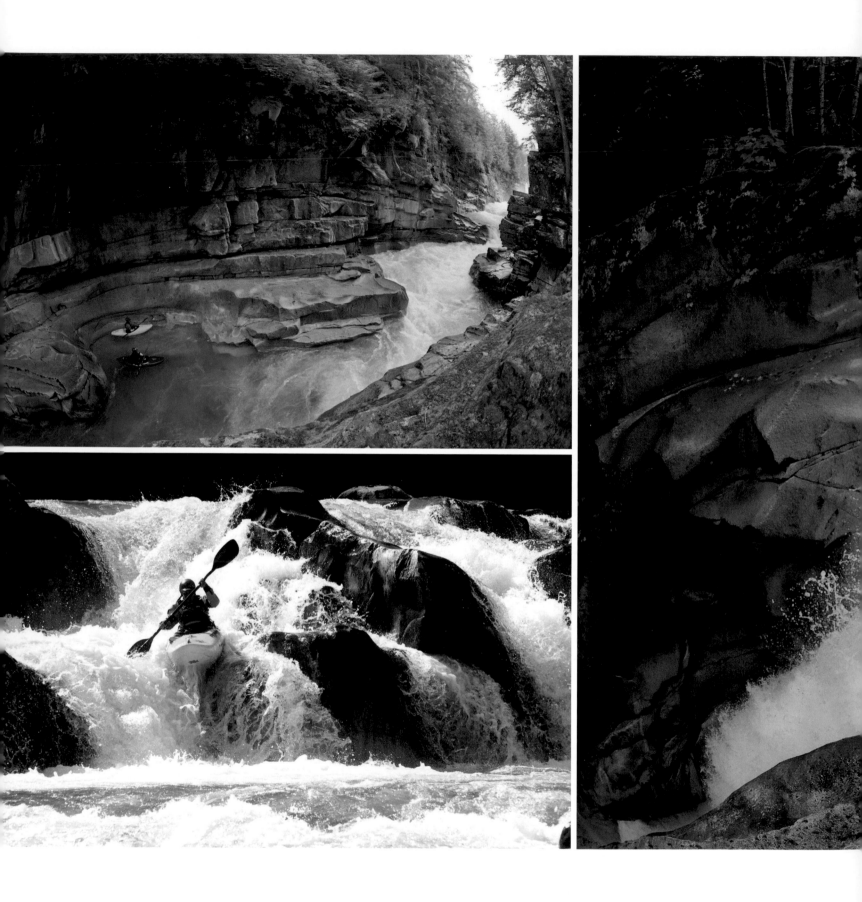

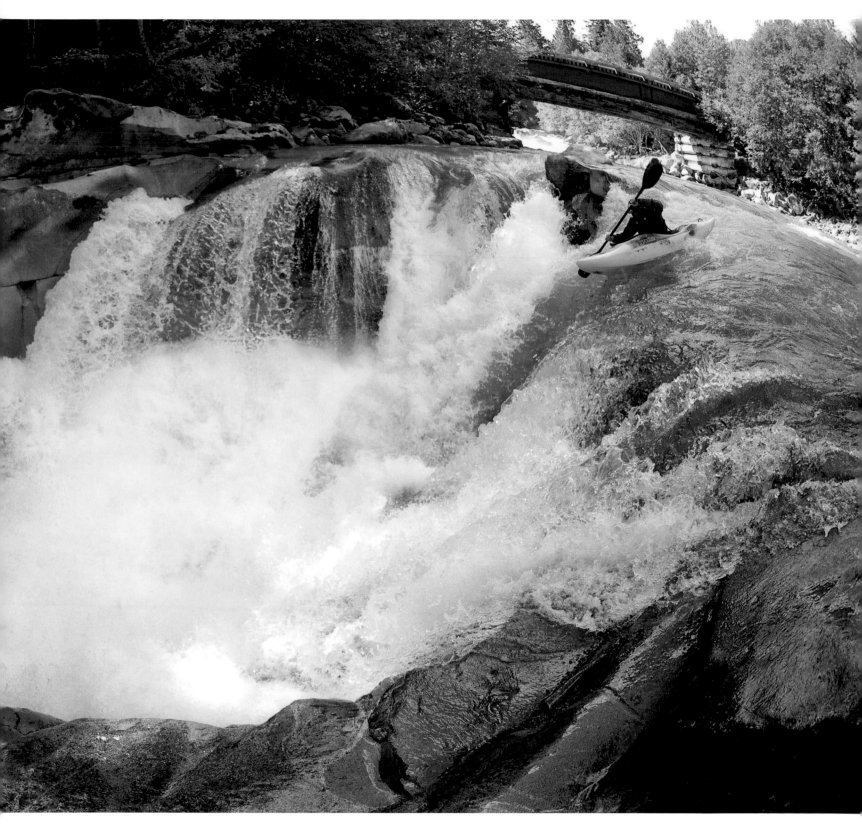

THESE PAGES: Box Canyon Creek, Squamish, BC, Canada

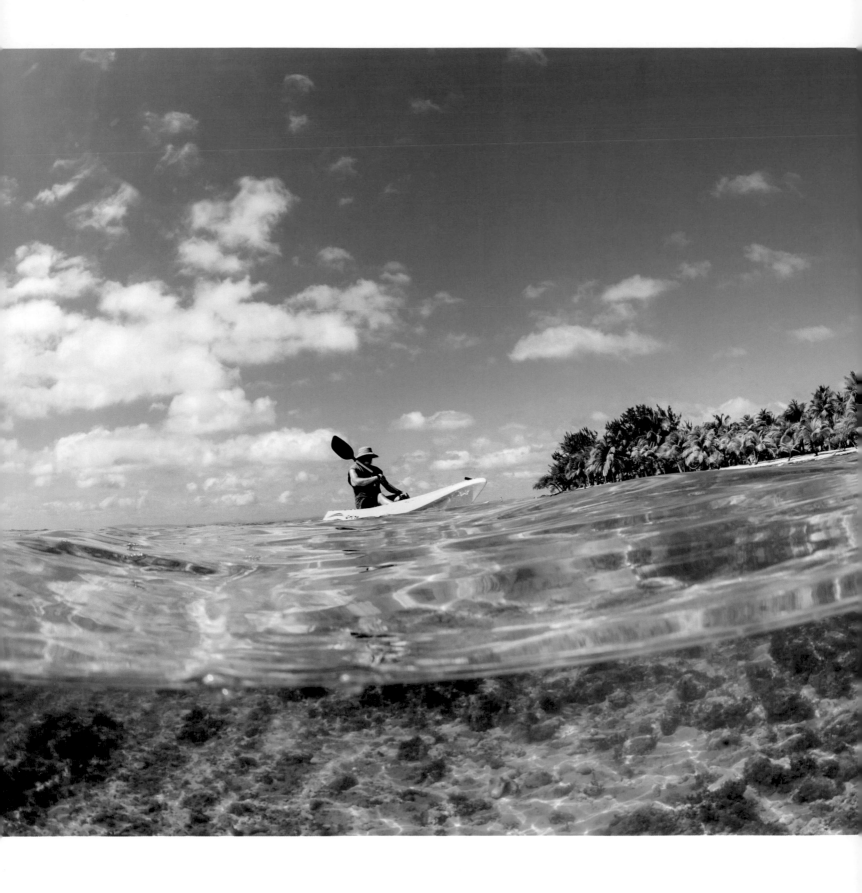

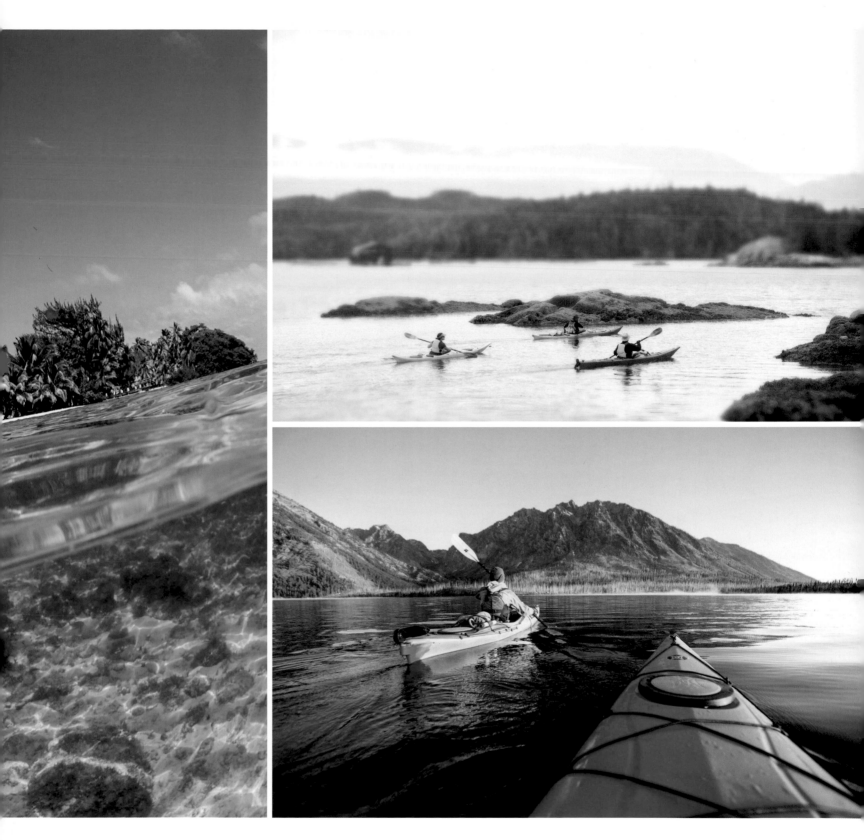

OPPOSITE: Sea kayaker in the waters off Blue Marlin Beach Resort, Belize
TOP: Sea kayaking out of Farewell Harbour, Johnstone Strait, BC, Canada
ABOVE: Jackson Lake, Grand Teton National Park, WY, USA

RAFTING

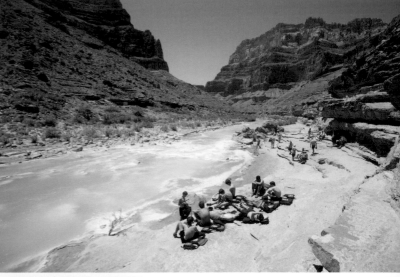

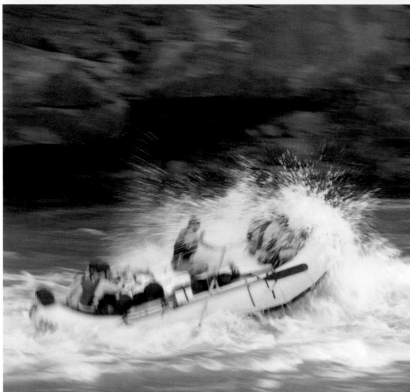

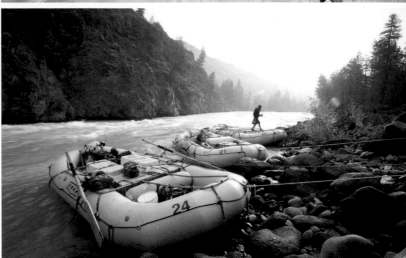

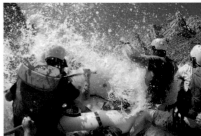

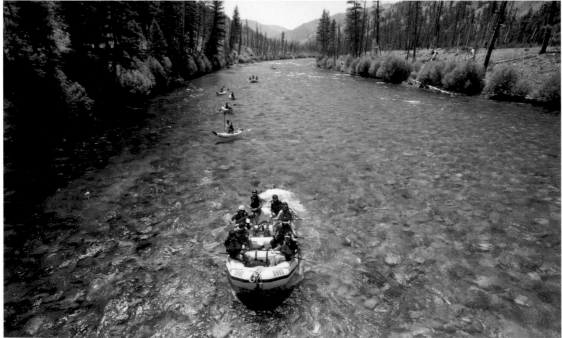

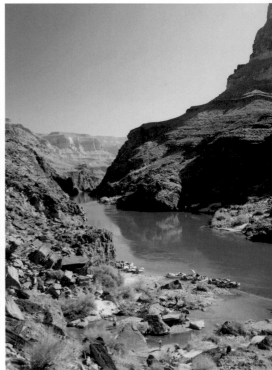

ABOVE, LEFT TO RIGHT, TOP TO BOTTOM: Colorado River, Grand Canyon National Park, AZ, USA (top left, middle left, and bottom right); Little Colorado River, Grand Canyon National Park, AZ, USA; Chilko River, BC, Canada; Raft guide pulling hard, Tatshenshini River, AK, USA; Onboard shot taken during Yampa River trip, CO, USA; Salmon River, ID, USA · OPPOSITE: Stanislaus River, CA, USA

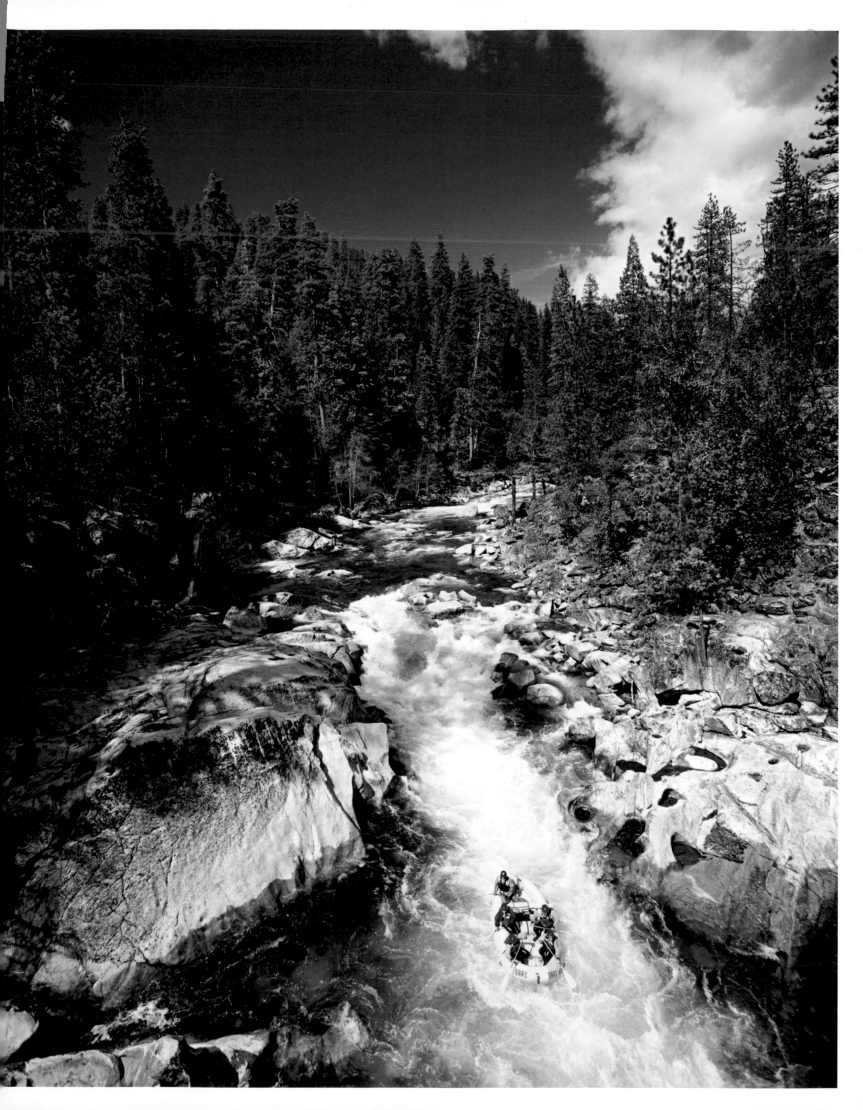

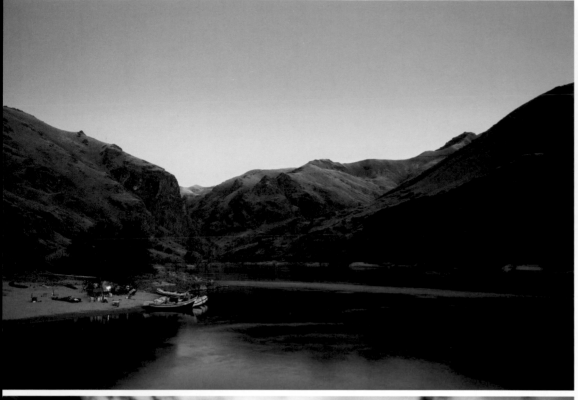

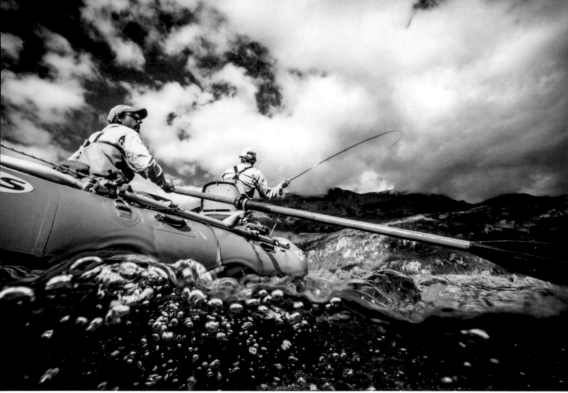

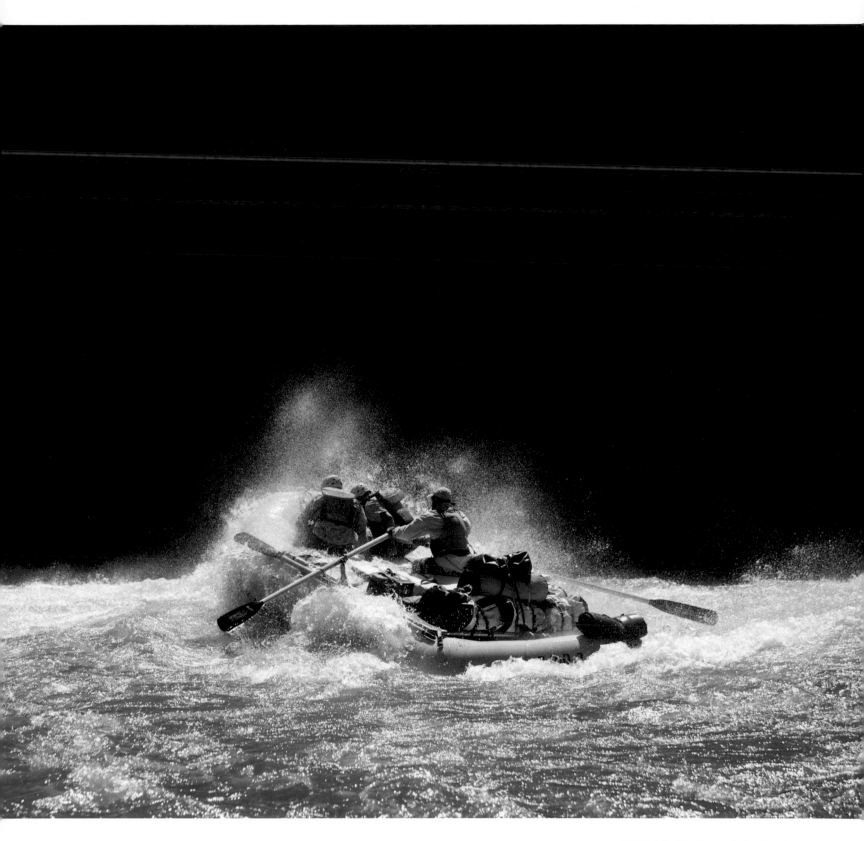

OPPOSITE, TOP: Hells Canyon, Snake River, ID, USA
OPPOSITE, BOTTOM: Anglers casting a streamer on the
Rio Grande River, Patagonia, Argentina
ABOVE: Colorado River, Grand Canyon National Park, AZ, USA

35

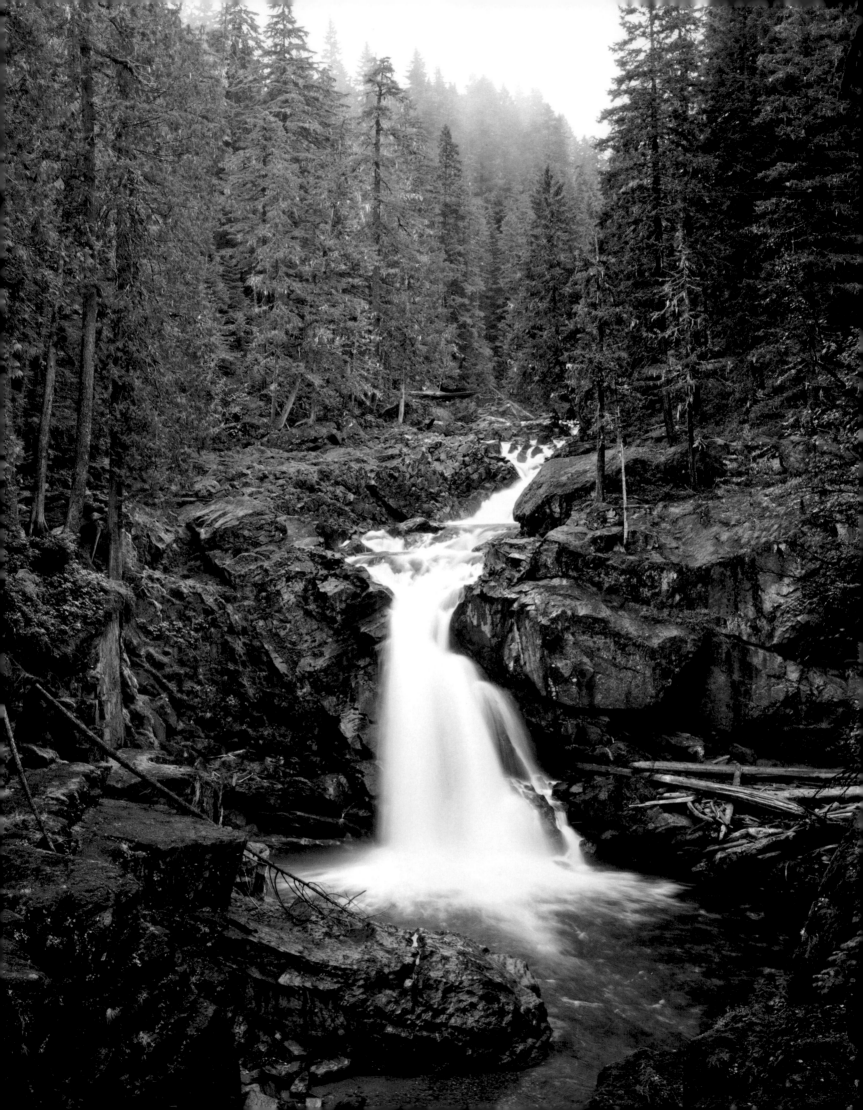

WHERE ROADS DON'T REACH

"IMAGINE THIS," HE SAID, "a big, rowdy, free-flowing river, tumbling down coastal mountains, through old-growth forest where the roads don't reach. And in the winter, up that high, there's big, wild steelhead and nobody there."

It's February, and I'm traveling with a good friend, a professional fly fisherman and filmmaker, and his brother "Sarge" to a remote section of river in the Pacific Northwest.

I had come along to spend time with friends and to fish, but I was just as excited to create photos of the wild places and lifestyle that come with this angling addiction. I grew up fishing. It was my first obsession. Over the years other passions took root. Mountain biking, backpacking, running rivers, climbing, and somewhere in the middle of all that, I discovered photography. In my first year as a photographer, I found *Mountain Light* by Galen Rowell and was blown away. I wanted to be that guy. Running up mountains, traveling to faraway places, creating *National Geographic*–worthy images, and getting paid to do it. That was it for me. What else could you possibly want?

We'd driven more than twelve hours and then hiked in over storm-felled trees and through knee-deep snow at the higher elevations to arrive to a beautiful camp perched above an emerald green river. The plan for the following day was to fish our way up about five river miles, where we would eventually meet up with a trail that would loop us back downstream to camp.

The next day started early with a wet, smoky fire; strong coffee; and breakfast, which always seems so much better when camping. We set out upriver, excited to see what was around every bend. What I remember most was that on every sandbar we came upon, black bears or mountain lions had visited recently and often, leaving their tracks clearly imprinted in the sand for us to find. A testament to just how remote this place was. More than once, off on my own, I found myself nervously looking over my shoulder just to make sure I really was alone.

When I document a trip or photograph a place, I try to convey not only what it looks like but also how it feels. Is it big and open with expansive landscapes that seem to go on forever? Is it a wild, untouched place that will never be the same if not protected? Or maybe the story is more about the people on the trip and the experiences to be had. Usually, I try to create compelling photos of the entire experience—capture the atmosphere of the place we've traveled so far to get to, the laughs we've shared, and the small details or treasures that I might find, such as a fish's beautiful markings or the haunting tracks of a big predator.

I believe in the power of photography and its ability to offer a window into worlds other than our own. A single frame or a body of work can focus on a particular subject, grab the viewer's attention, and plant seeds of interest and wonder. I try to create images that give value to the ancient trees, wild rivers, and fish that I care so much about, and I hope my photos inspire others to come see these amazing places for themselves. Or possibly they spent time there years ago and will remember standing knee-deep in that exact same spot, in that exact same river. Like a sweet, nostalgic smell, they might just remember the magic of the place and how important it is to protect. Other times, the right photo might just inspire people to get off the couch, go outside, and create their own adventure, and that is enough.

—JUSTIN BAILIE
Photographer

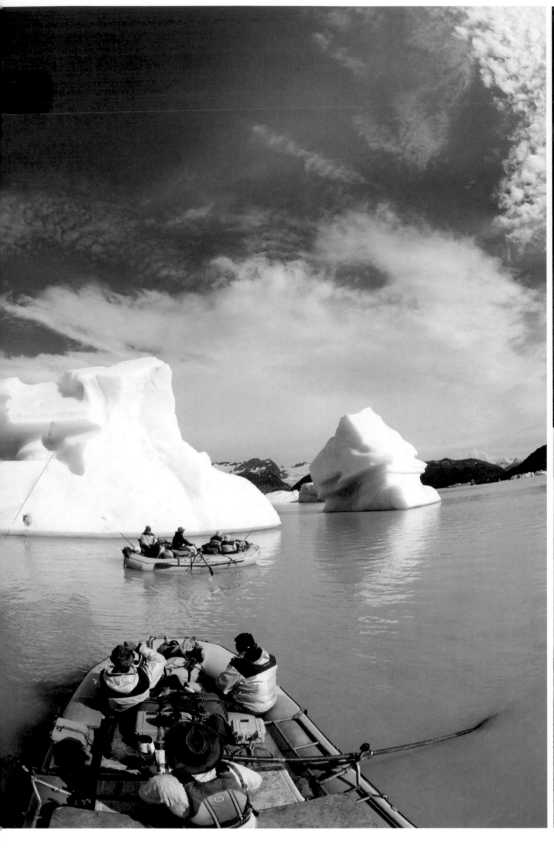

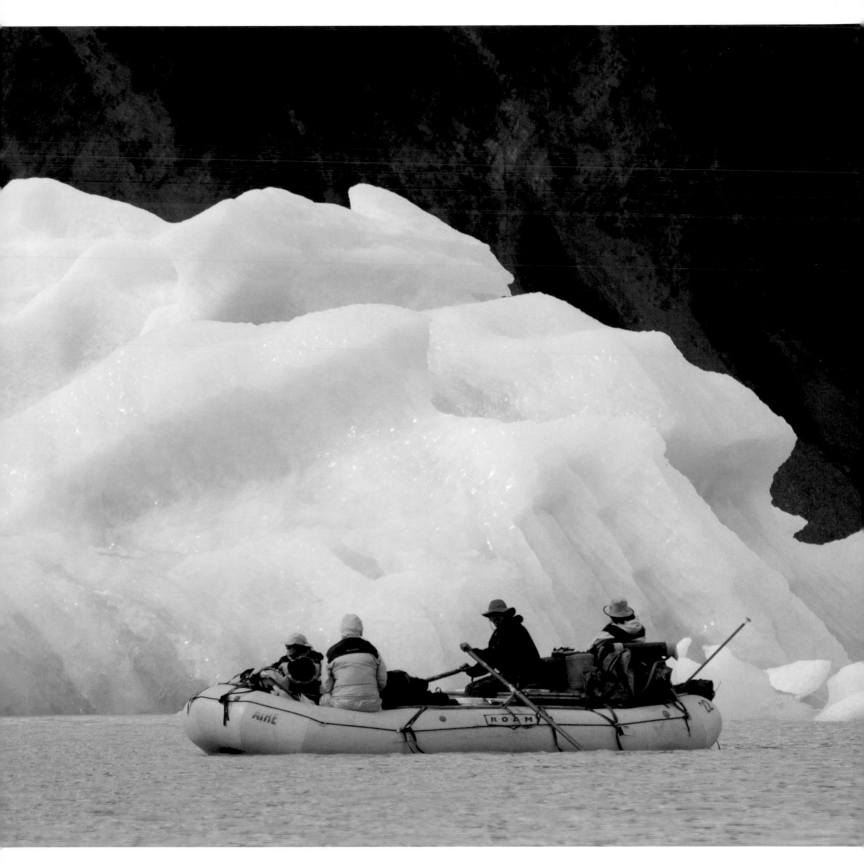

OPPOSITE: Multiday raft trip down the Tatshenshini River,
which flows through the Yukon, BC, Canada, and empties
into Glacier Bay National Park, AK, USA
ABOVE: Alsek River, AK, USA

AN ADDICTION TO INSPIRATION

THOSE OF US WHO PHOTOGRAPH adventure and natural landscapes have an emotional connection not only to the images we create, but also to the subjects—and in many ways the photographs we capture connect viewers to the emotional resonance of that particular time and place and allow us photographers to relive the thrill and beauty we strive to convey. When a photograph achieves this—speaks to an audience on a personal, emotionally evocative level—it transcends the particular moment it documents.

I love being outside. I love being in the mountains and the feeling of joy I have when I'm surrounded by an amazing landscape. I love the sweat and rhythm of climbing, hiking, and skiing in the mountains, and that worn-out and tired feeling at the end of a big day. I began taking photos to bring back some of that feeling for myself. That's where my inspiration began. A lifetime ago, I had a day job and spent five days a week staring at my photos from last weekend's adventure, trying to relive that experience and getting excited for the next.

Now I've been shooting so long it's harder to *not* shoot than it is *to* shoot. Missing a shot with a great moment or spectacular light is painful. Some might ask, isn't it better to just put the camera down and experience the moment uninterrupted? To ask that question reveals the lack of understanding of how much photographers use their cameras to connect with their subjects.

Photographing a sport or landscape makes us look at it closer, see details most people miss, and view it from a different perspective. Recently, I was shooting landscape photos of a river in the Cascades in autumn. When I took my camera out to shoot, I envisioned images of the fall colors reflected in the river. But after wandering around for a while, the photo I spent the most time on was a decomposing leaf on a rock on the side of the river. If I didn't have my camera I likely would not have bothered to look so closely at that leaf—but with a camera in hand it revealed itself as a compelling treasure. I walk through this world seeing potential images all around me. I can't turn it off.

At some point the scales shifted. I was no longer shooting only to capture those personal moments or document the places I had been, but rather striving to perfect the re-creation of the moment. Then the scales shifted again. Like an addict, it's not just the high, but the whole process. Habit. Rhythm. Introspection. I no longer took trips just to be in places that made me happy. I took trips to create images that would stir emotions in others. That became my driving force.

I've become obsessed with the psychology of addiction and have found compelling parallels to drug addiction and the unrelenting need to experience the natural world in new and exciting ways—whether it be for a jolt of adrenaline or a soul-stirring glimpse at a wild landscape. You have to keep upping the dosage to get the same high, and adventure sports feed that. Call it what you want—euphoria, runner's high, adrenaline—they're all the same thing in different clothing, all tickling a need, and satiating it only temporarily. For me it's photography. Keep me away from shooting for too long and I go through withdrawals. The urge to create is an addiction. The camera is my delivery device.

—STEPHEN MATERA
Photographer

OPPOSITE: Photographer Stephen Matera hiking below Skógafoss, Iceland

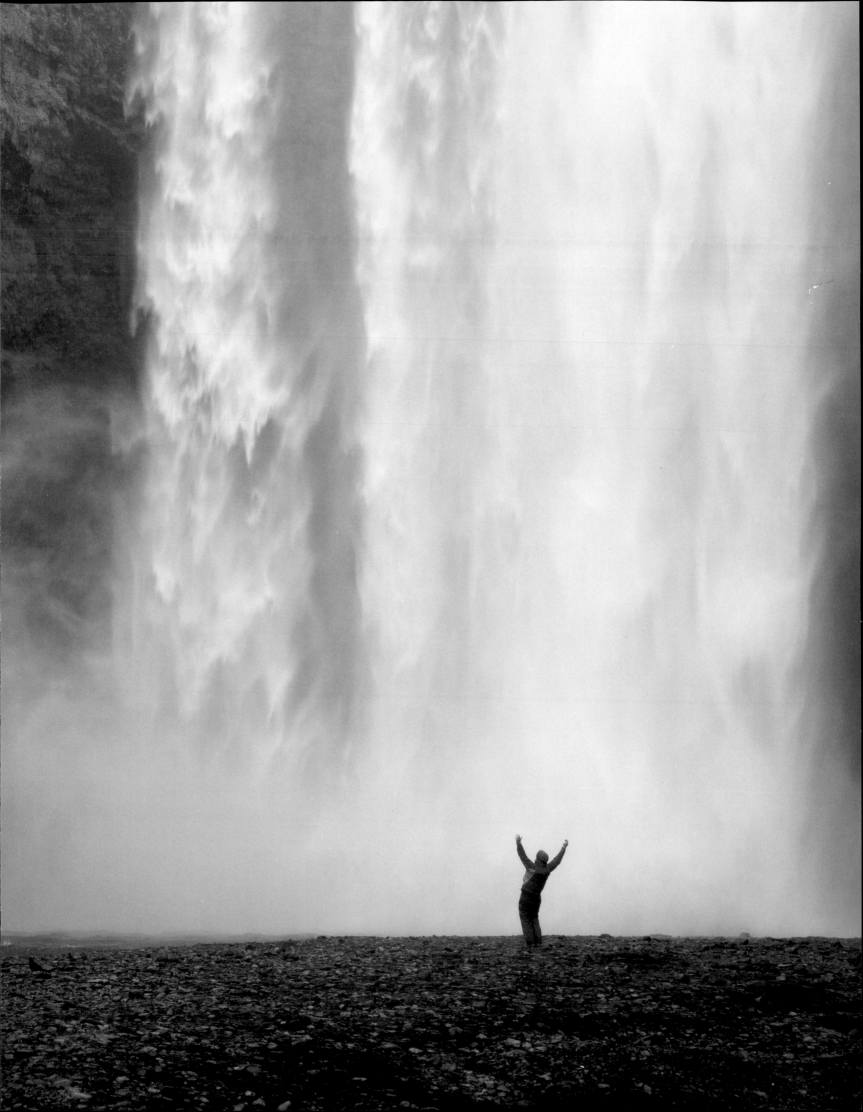

SURFING

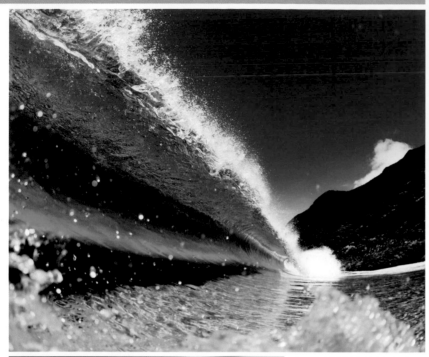

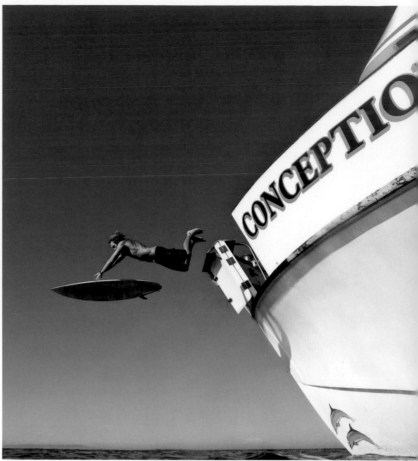

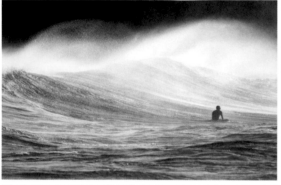
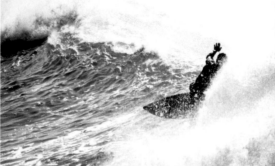

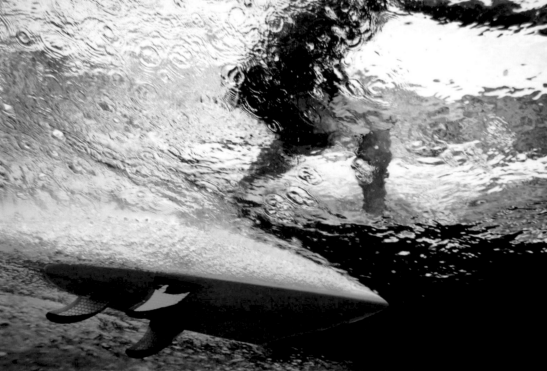
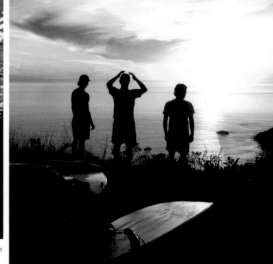

ABOVE, LEFT TO RIGHT, TOP TO BOTTOM: Wave breaking over white coral sands, Oahu, HI, USA; A deckhand for the Santa Barbara–based dive boat *Conception* takes a leap into the refreshing waters off Santa Catalina Island, CA, USA; North Shore, Oahu, USA (middle left and middle); Shaper Jacob Ells in his home shaping bay; Surfing Honolua Bay, Maui, HI, USA; Surf check, Central California, USA · OPPOSITE: Surfing Northern California, USA

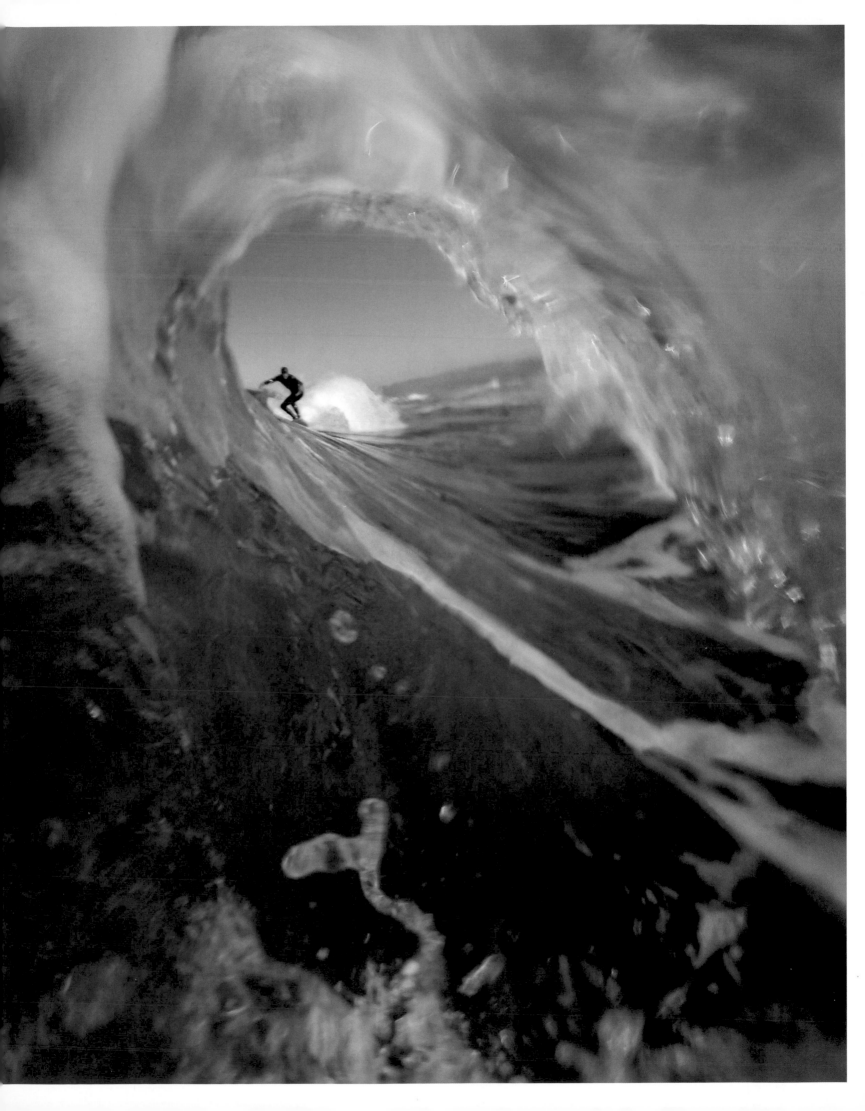

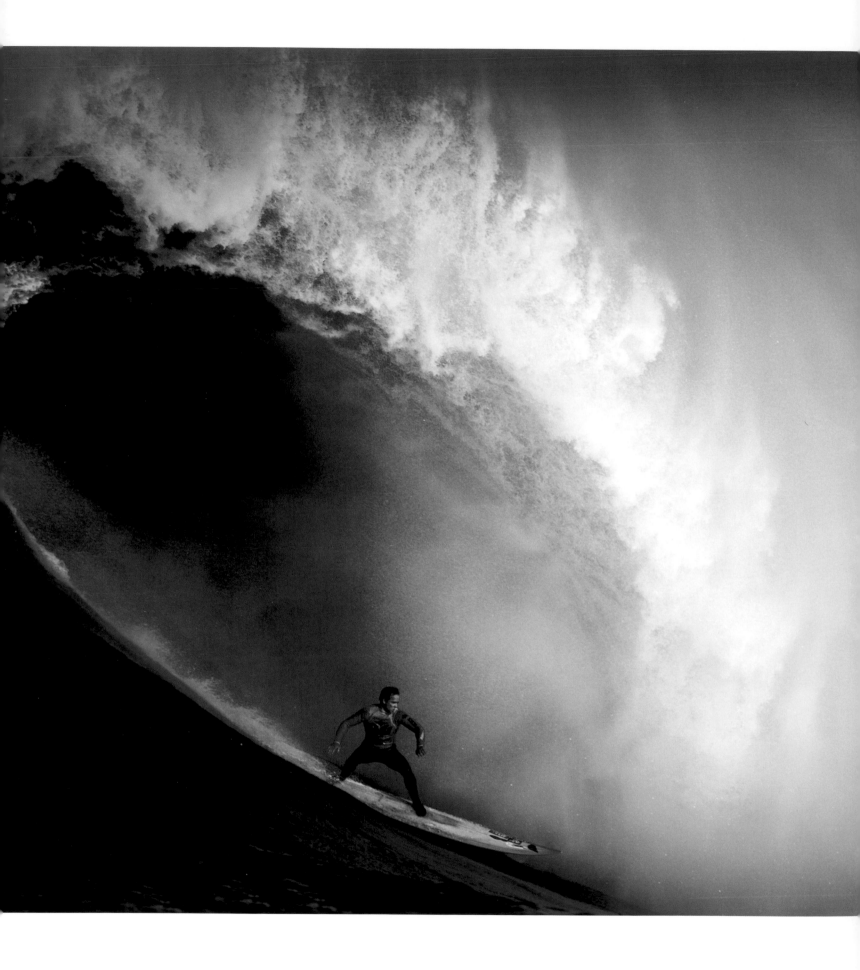

Maverick's, Half Moon Bay, CA, USA

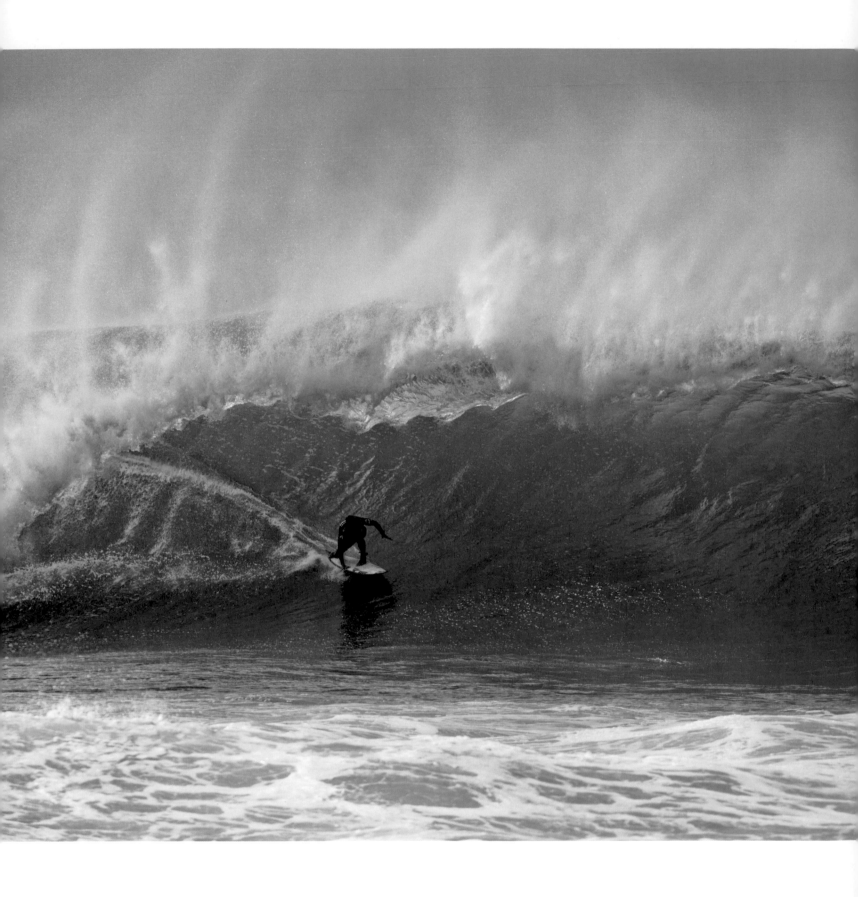

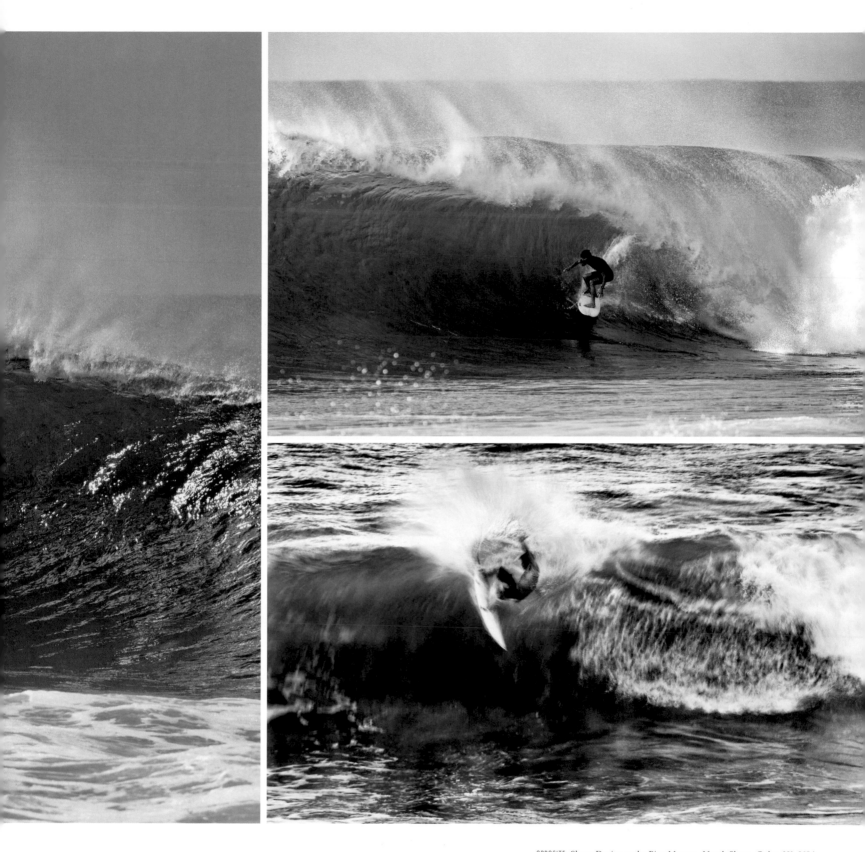

OPPOSITE: Shane Dorian at the Pipe Masters, North Shore, Oahu, HI, USA
TOP: Backdoor Pipeline, North Shore, Oahu, HI, USA
ABOVE: Surfer laying down a powerful turn at high speed, Maui, HI, USA

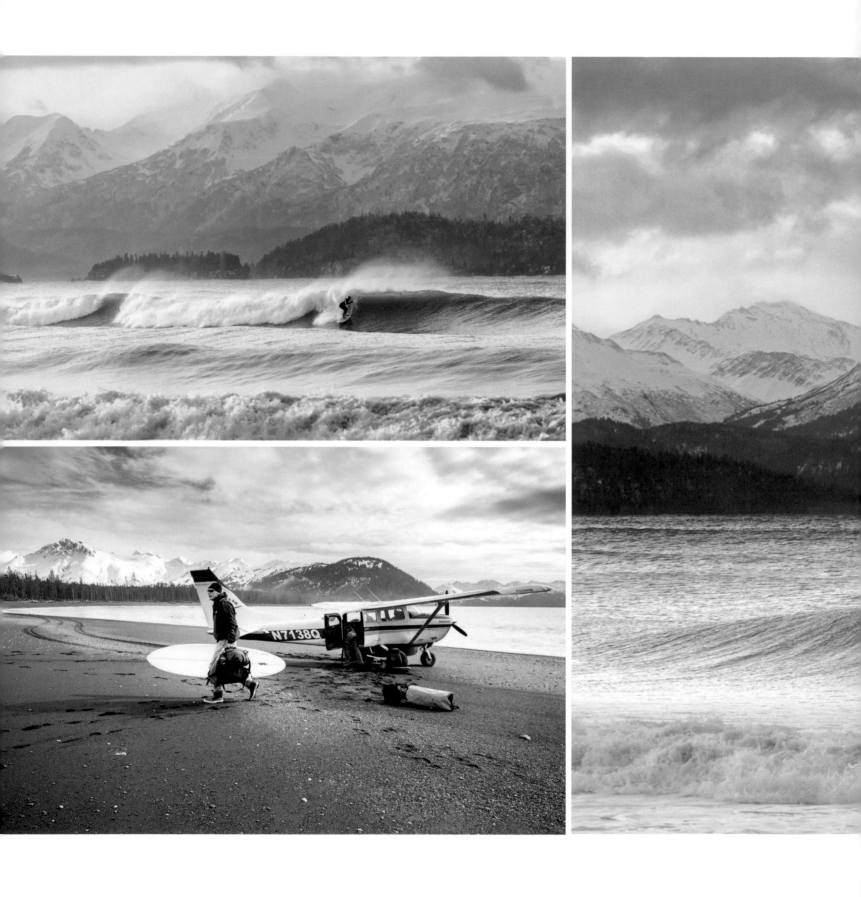

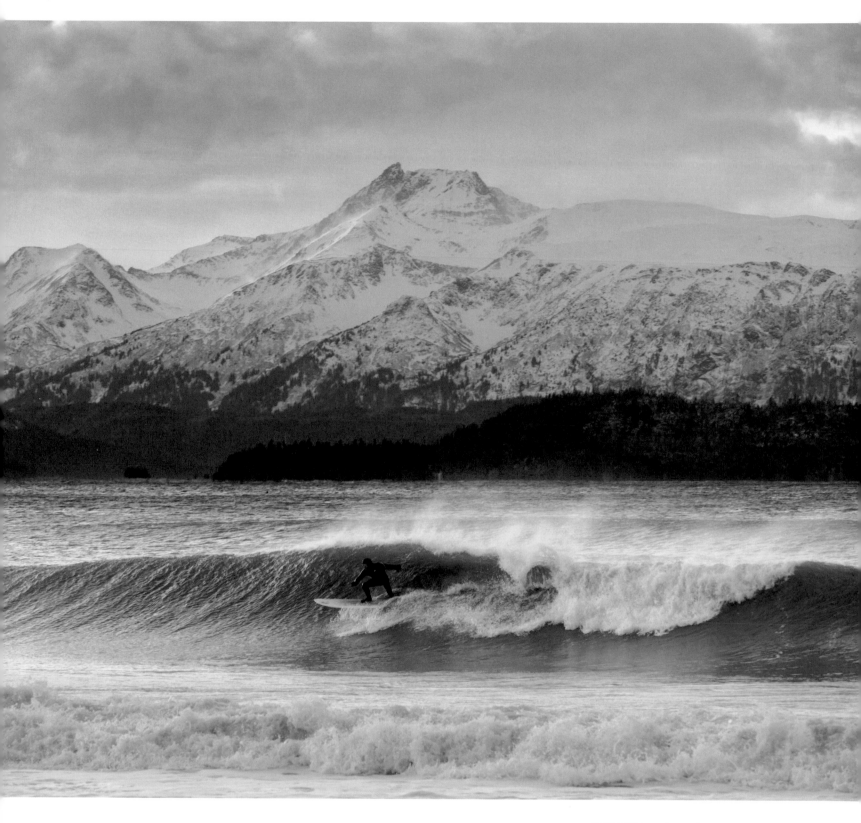

OPPOSITE, TOP AND ABOVE: Surfing Kachemak Bay, AK, USA, with the Kenai Mountains rising in the background
OPPOSITE, BOTTOM: Bush plane surf excursion to a coastal wilderness, AK, USA

 # STAND-UP PADDLEBOARDING

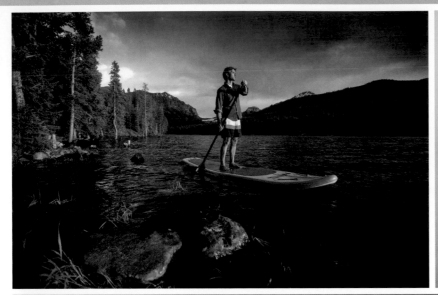

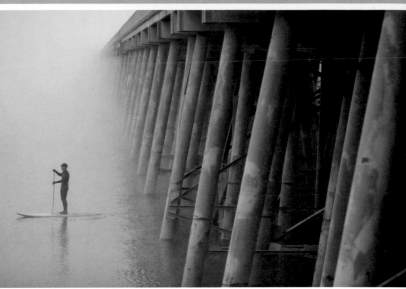

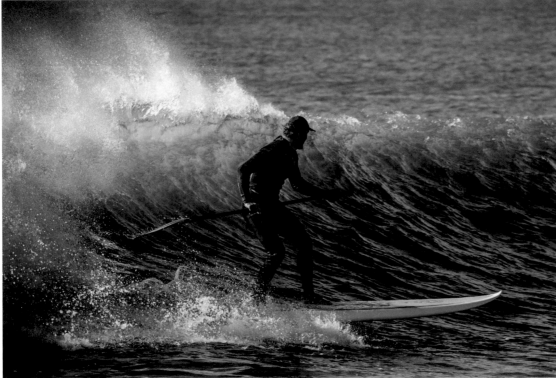

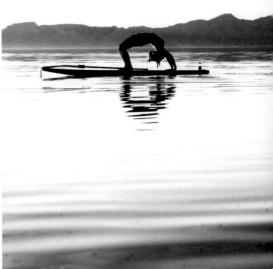

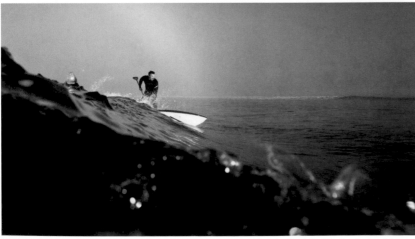

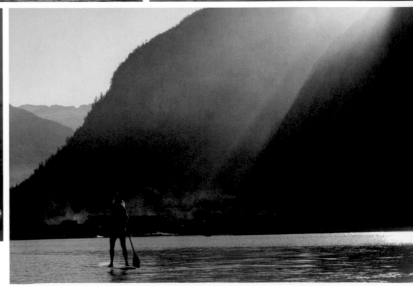

ABOVE, LEFT TO RIGHT, TOP TO BOTTOM: Hyalite Lake, Bozeman, MT, USA; Lake Pend Oreille, Sandpoint, ID, USA; Long Beach Island, Beach Haven, NJ, USA; Yogi SUPing in the Great Salt Lake, UT, USA; San Onofre, CA, USA; Early morning SUP cruise in Squamish, BC, Canada · OPPOSITE: Stroking over a set wave off the island of Tortola, British Virgin Islands

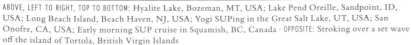

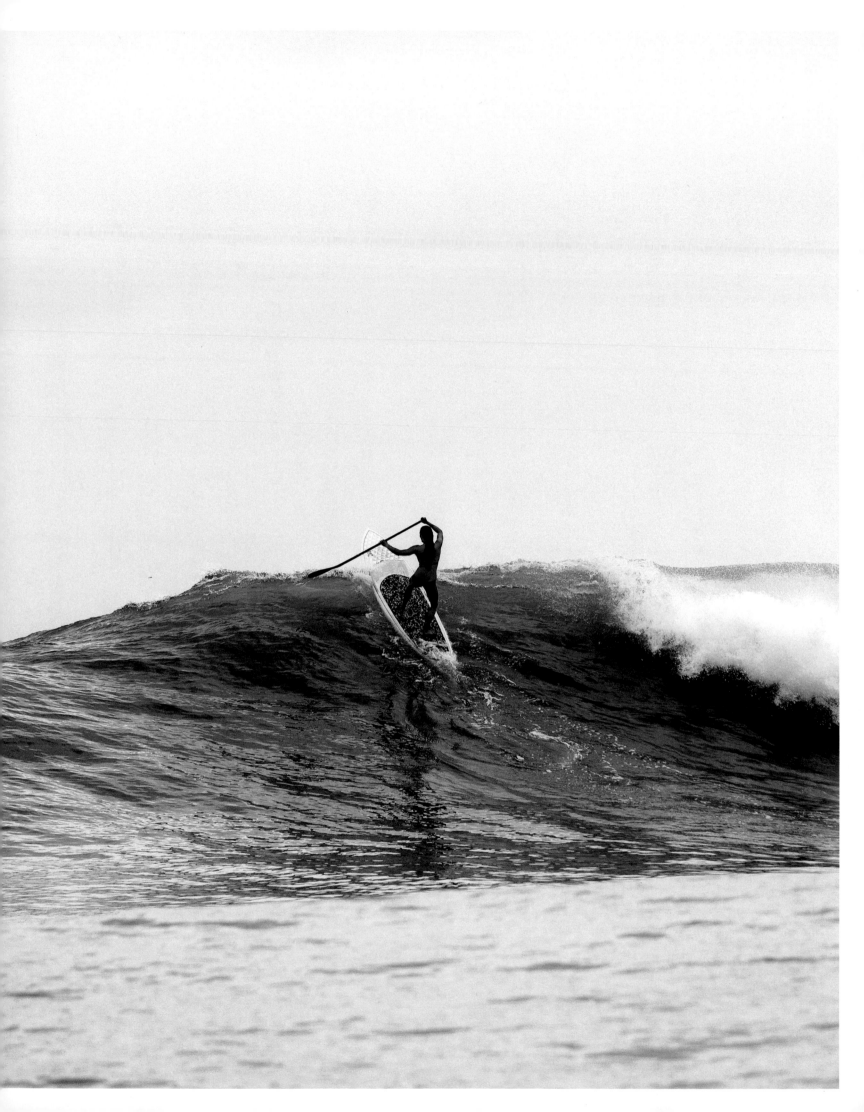

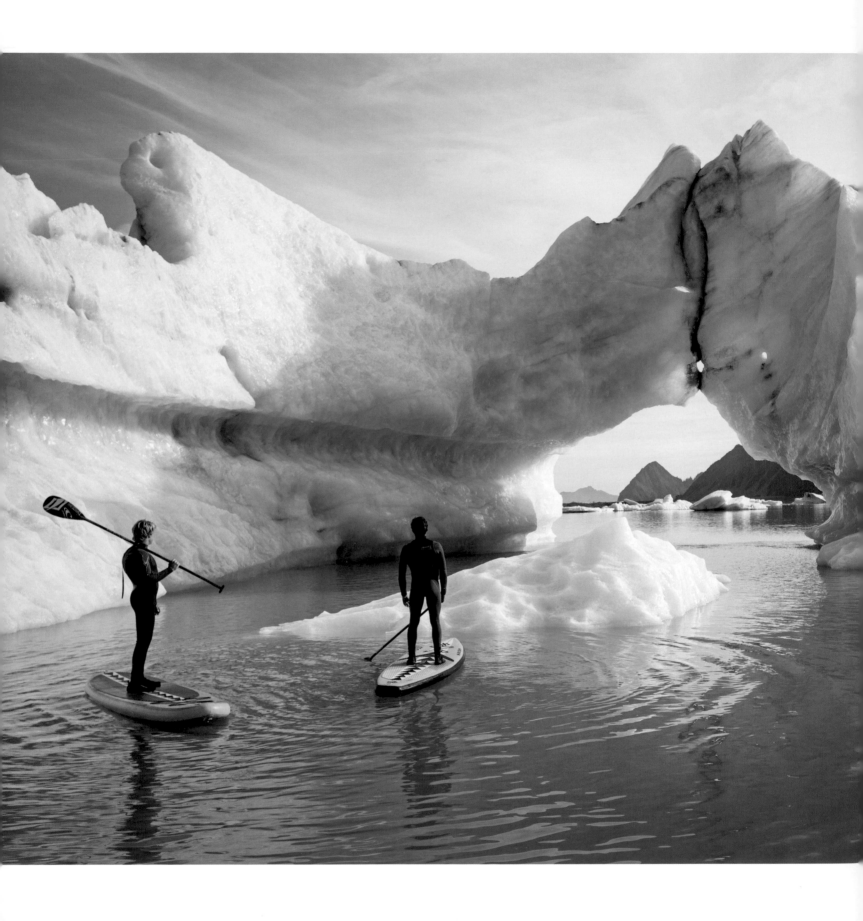

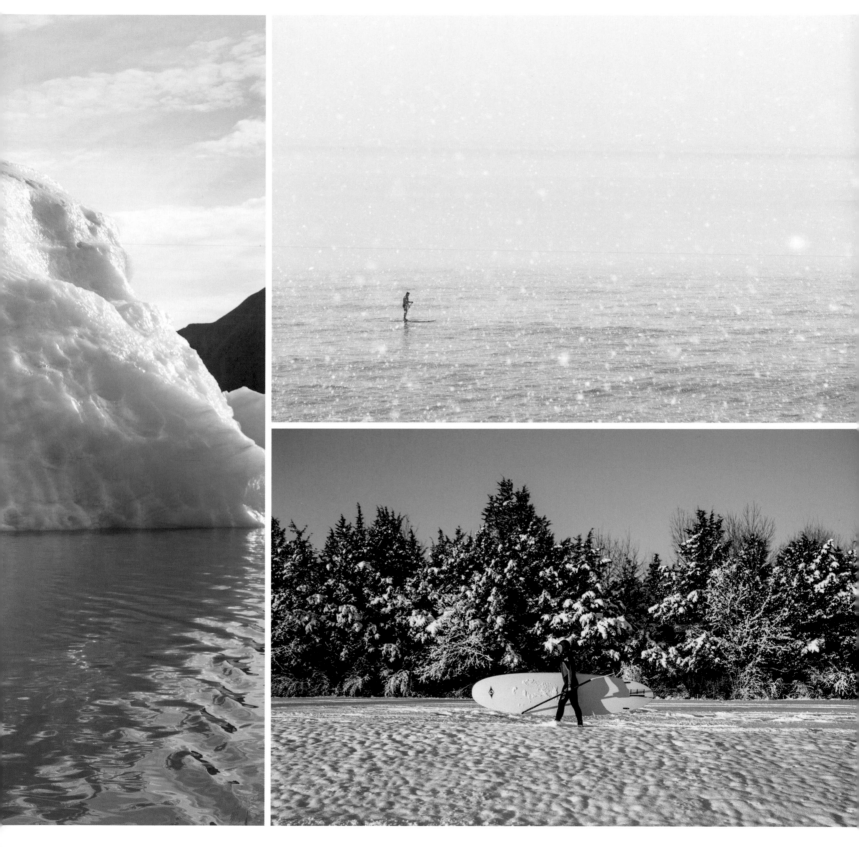

OPPOSITE: Kevin Langeree and Kai Lenny SUP around a large iceberg in a glacial lake, AK, USA
TOP: Ty Gates SUPing on Kachemak Bay, AK, USA
ABOVE: Trekking through snow for a winter SUP session, Bucks County, PA, USA
FOLLOWING PAGES: An aerial view of SUPers riding the Turnagain Arm bore tide in Cook Inlet, AK, USA.
The wave caused by the incoming tidal bore can be ridden for up to five miles.

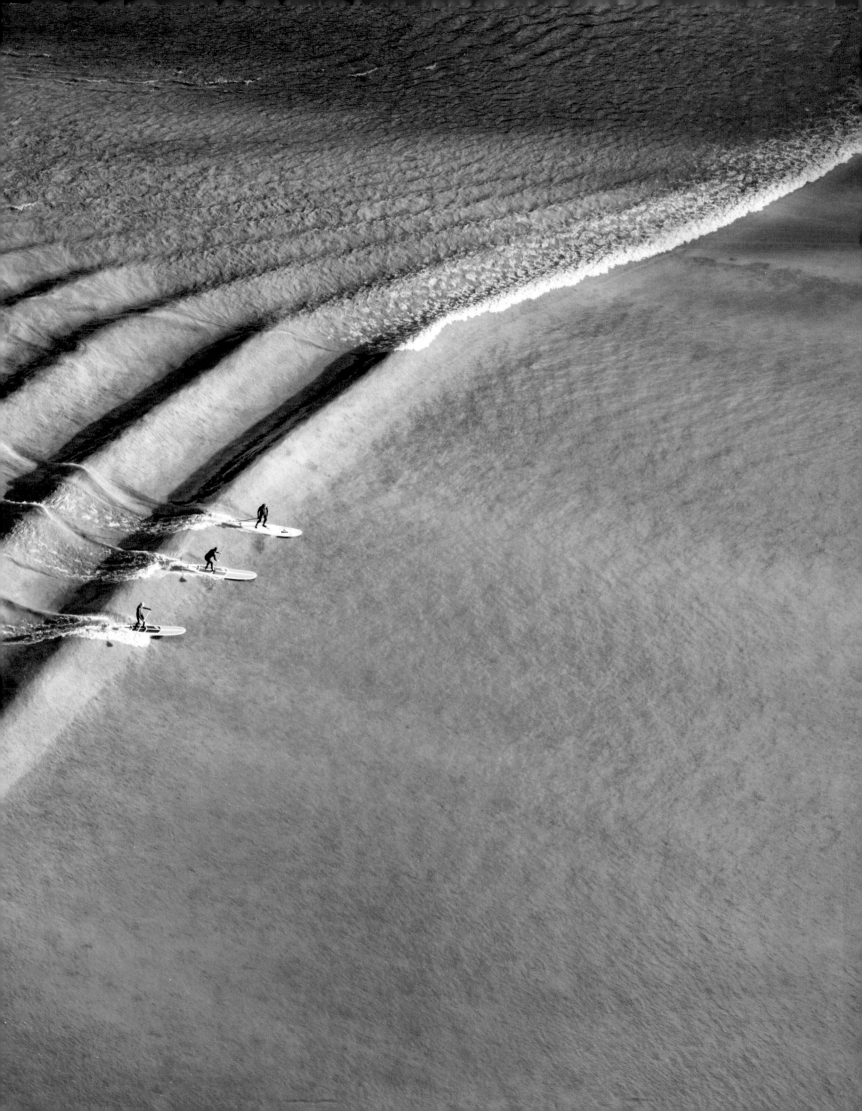

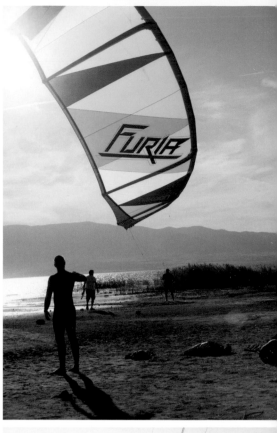

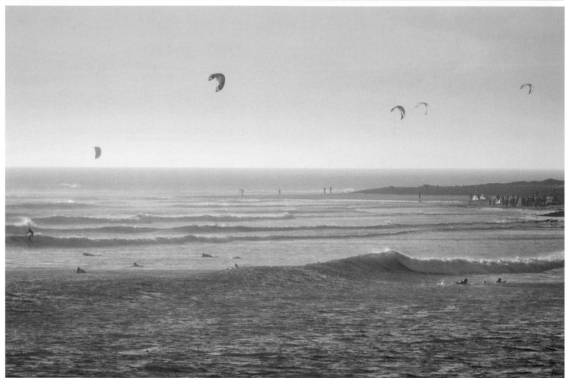

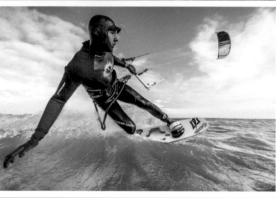

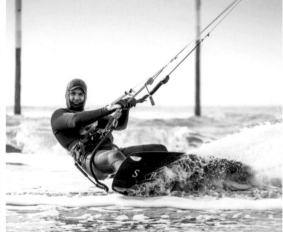

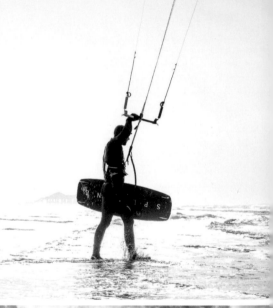

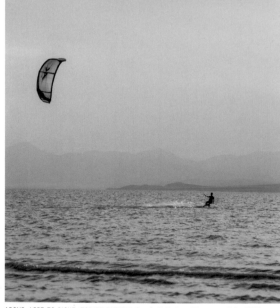

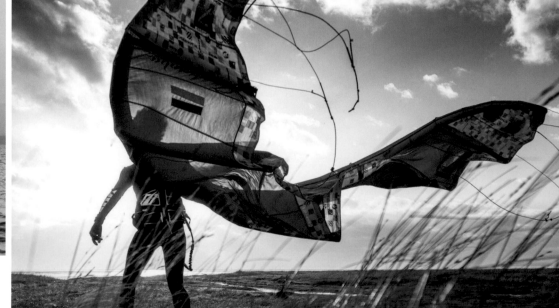

ABOVE, LEFT TO RIGHT, TOP TO BOTTOM: Surfer's Point, Ventura, CA, USA;
Utah Lake, near Salt Lake City, UT, USA (top right and bottom left);
Daniel Schulze-Ardey kitesurfing, German Sea, St. Peter-Ording,
Germany (middle left, center, and right); Joachim Schulze-Ardey with
his kite during sunset, German Sea, St. Peter-Ording, Germany
OPPOSITE: Juno Beach, FL, USA

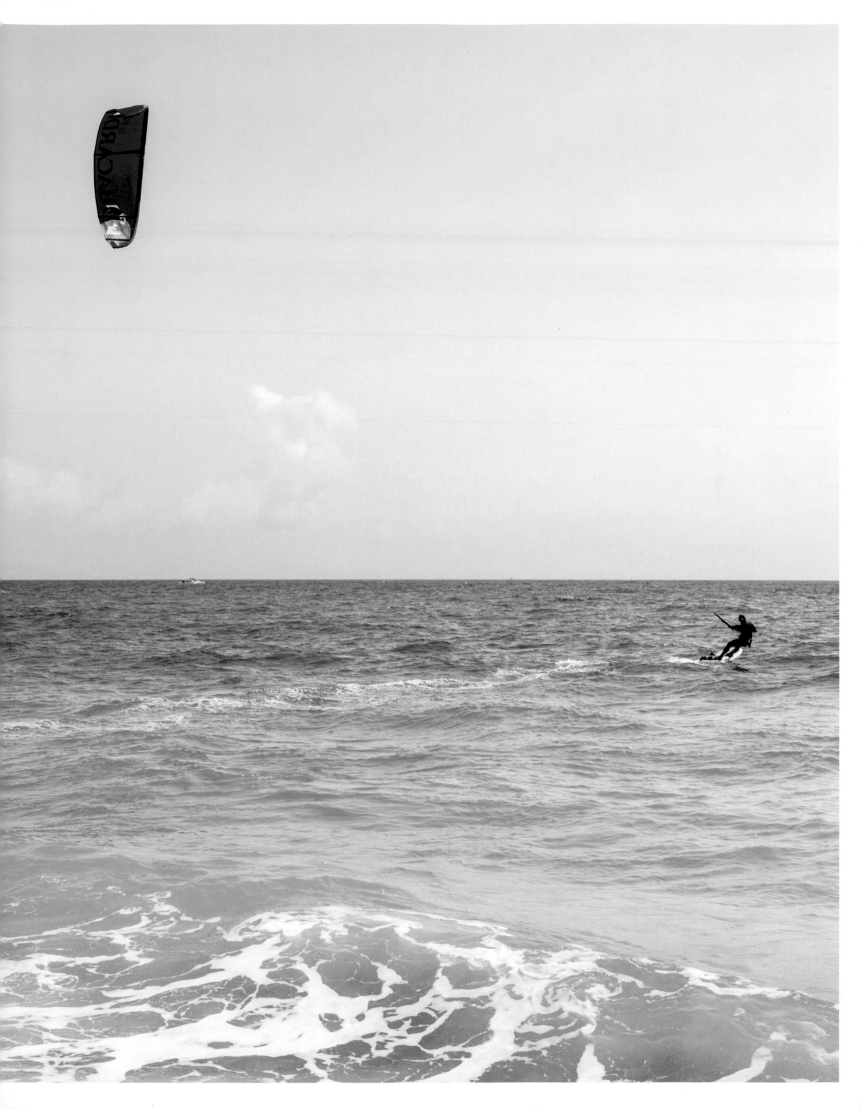

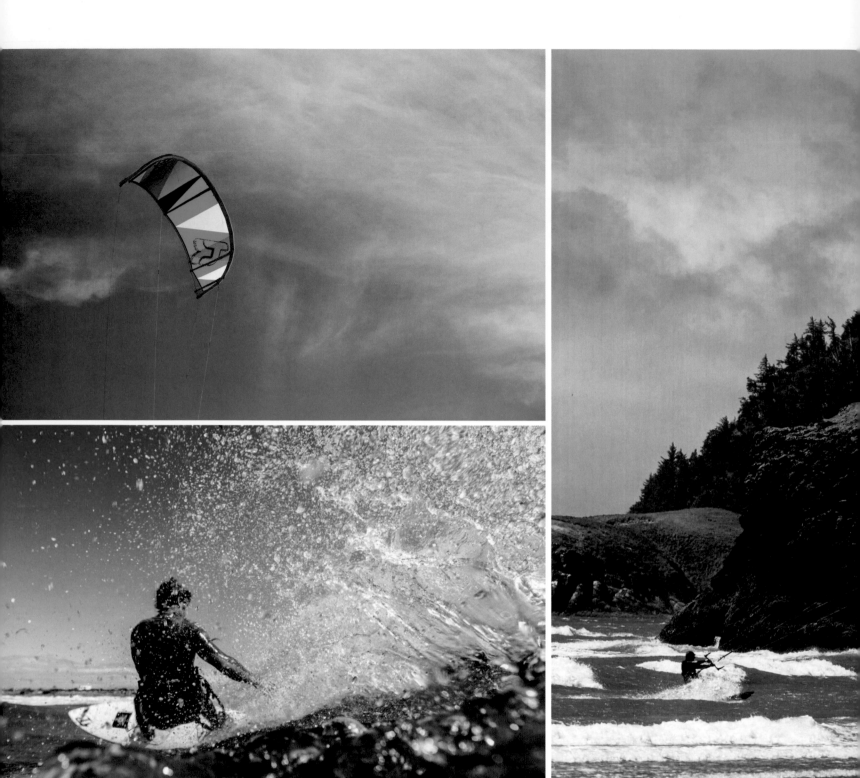

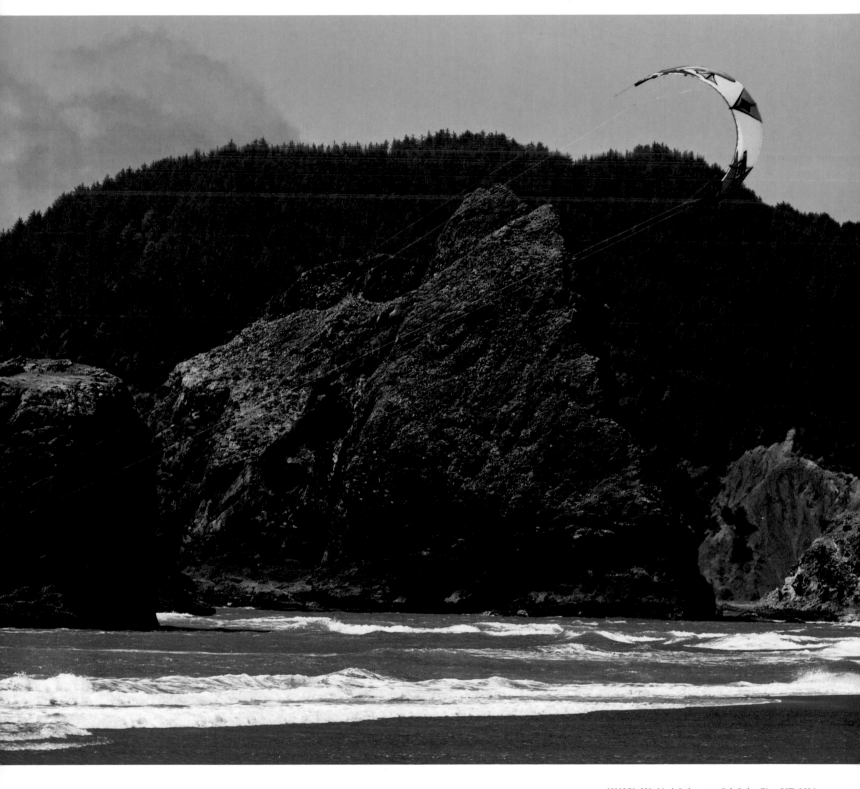

OPPOSITE, TOP: Utah Lake, near Salt Lake City, UT, USA
OPPOSITE, BOTTOM: Jeff Hoke does an aggressive turn while
kitesurfing in Homer, AK, USA
ABOVE: Kitesurfing, Pistol River, OR, USA

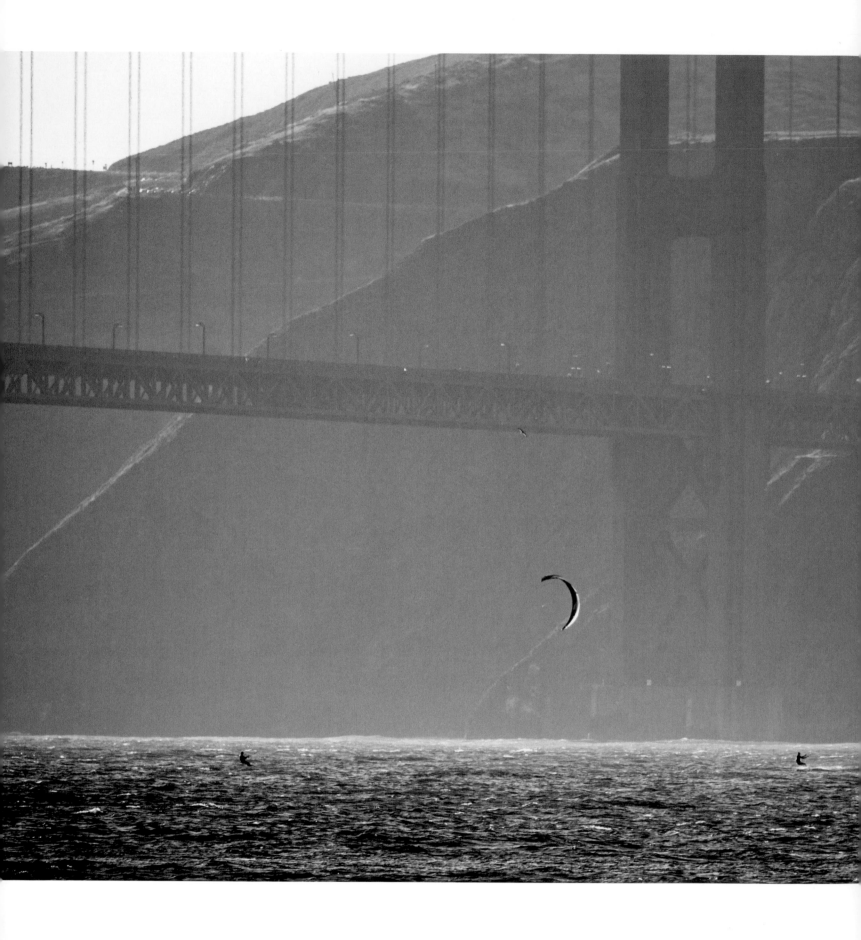

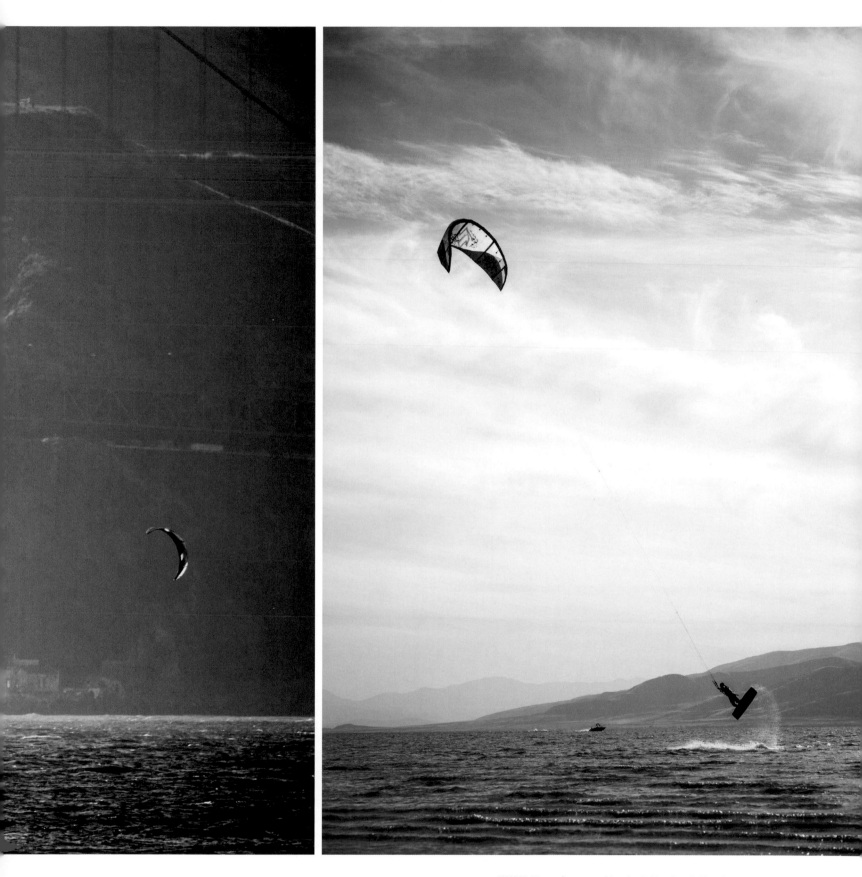

OPPOSITE: Kitesurfers approaching the Golden Gate Bridge, San Francisco, CA, USA
ABOVE: Kitesurfing at Utah Lake, near Salt Lake City, UT, USA

FREE DIVING

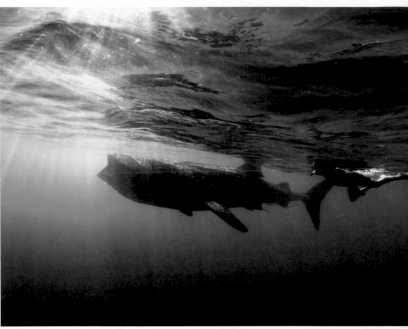

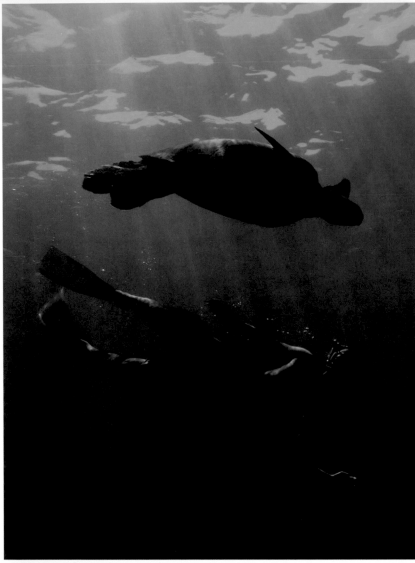

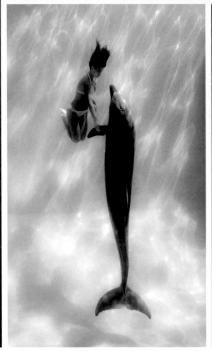

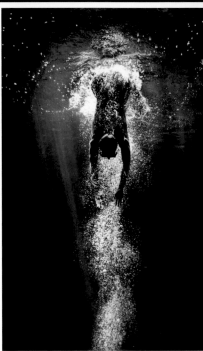

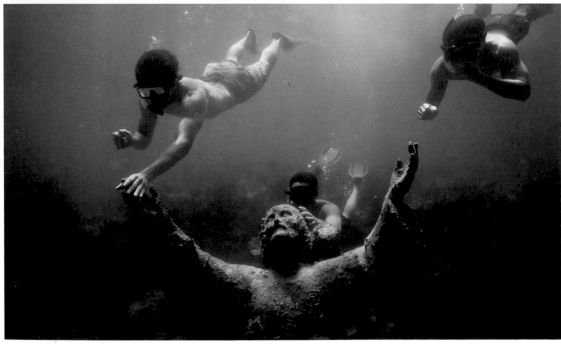

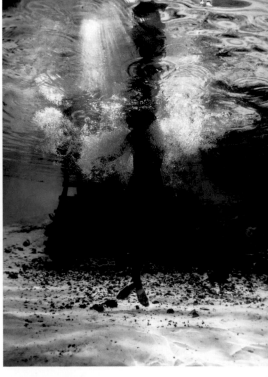

ABOVE, LEFT TO RIGHT, TOP TO BOTTOM: Green sea turtle and snorkeler, Maui, HI, USA; Whale shark and snorkeler off the coast of Isla Mujeres, Quintana Roo, Mexico; Woman connecting with a dolphin; A free diver starts her descent into a cenote in Quintana Roo, Mexico; Free divers descend to the Christ of the Abyss, John Pennekamp Coral Reef State Park, Key Largo, FL, USA; Gran Cenote, Quintana Roo, Mexico · OPPOSITE: Cenote The Pit, Quintana Roo, Mexico

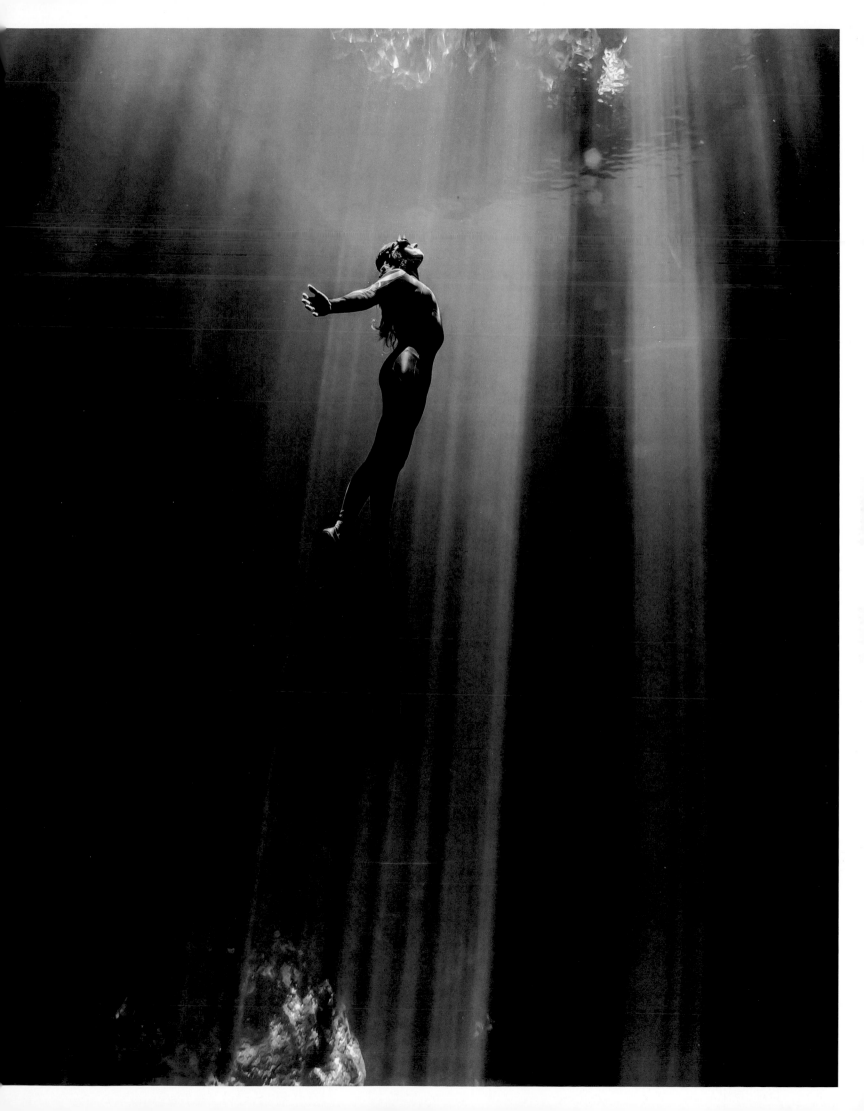

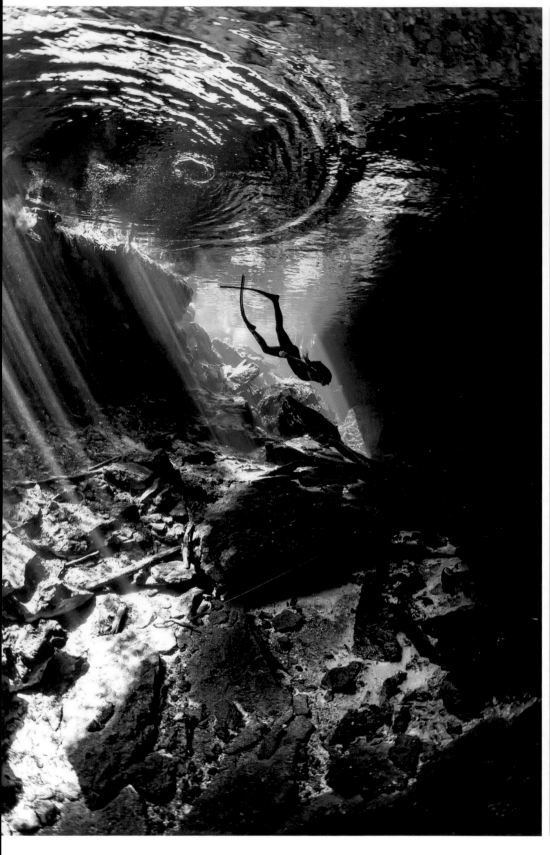

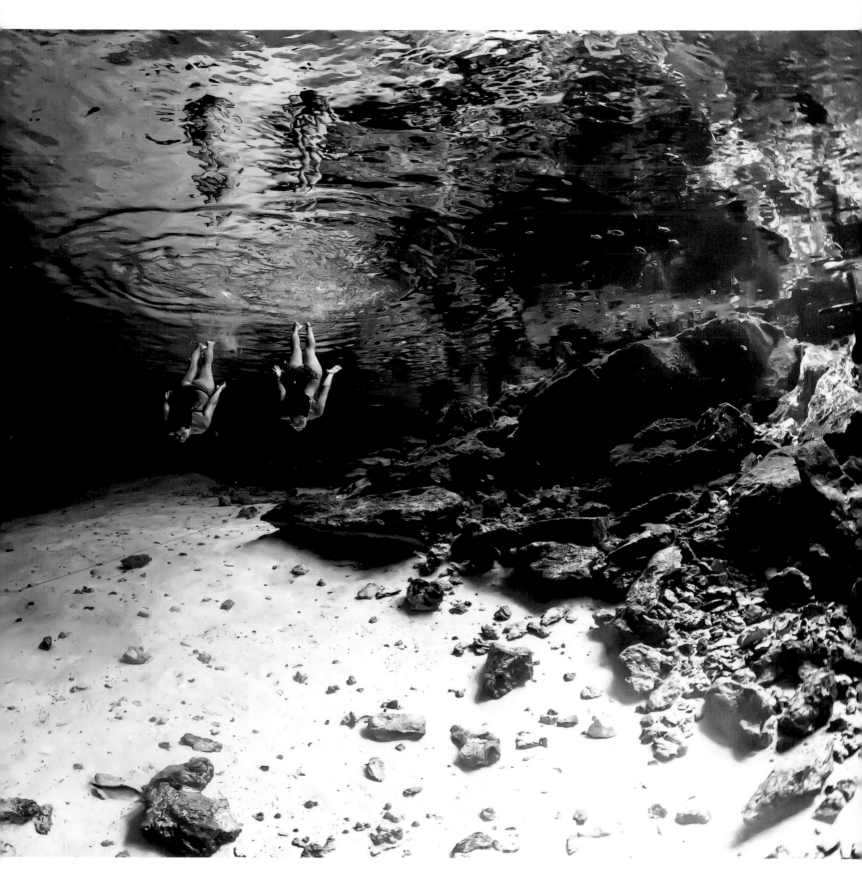

OPPOSITE: Cenote Chac Mool, Quintana Roo, Mexico
ABOVE: Cenote Dos Ojos, Quintana Roo, Mexico
FOLLOWING PAGES: Cenote Aktun Ha, Quintana Roo, Mexico

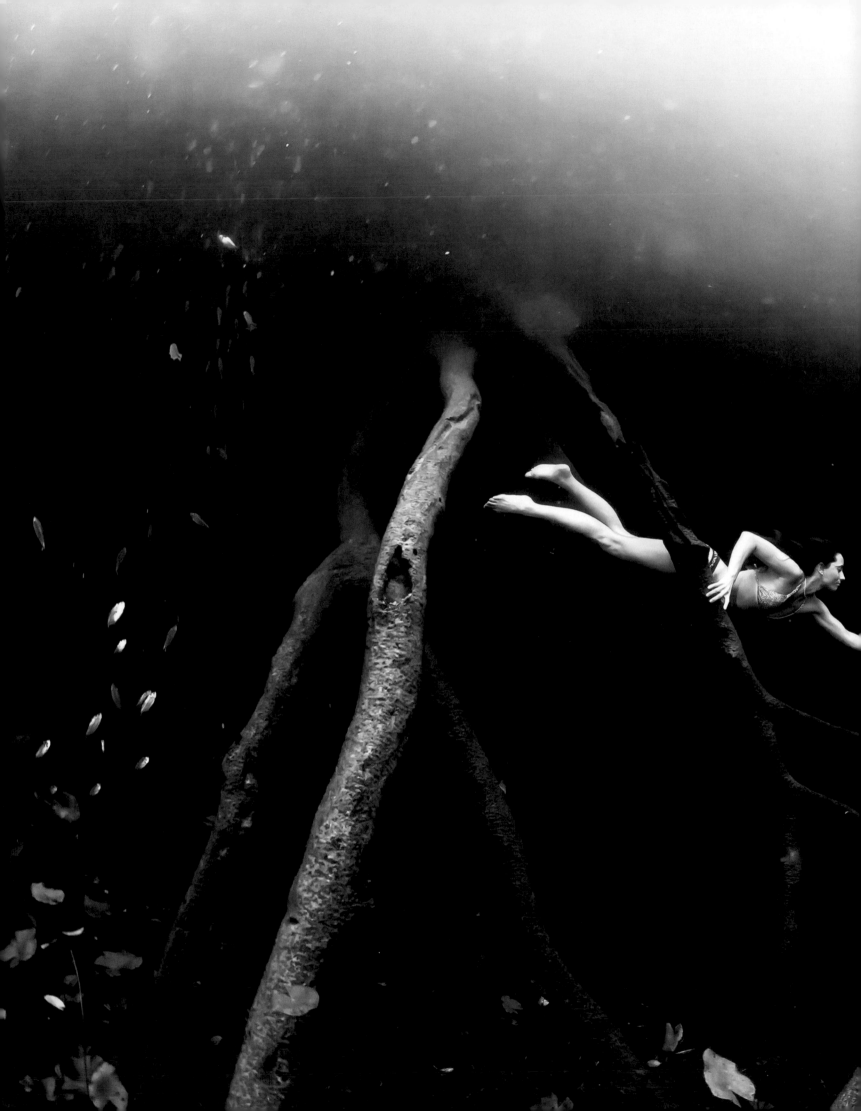

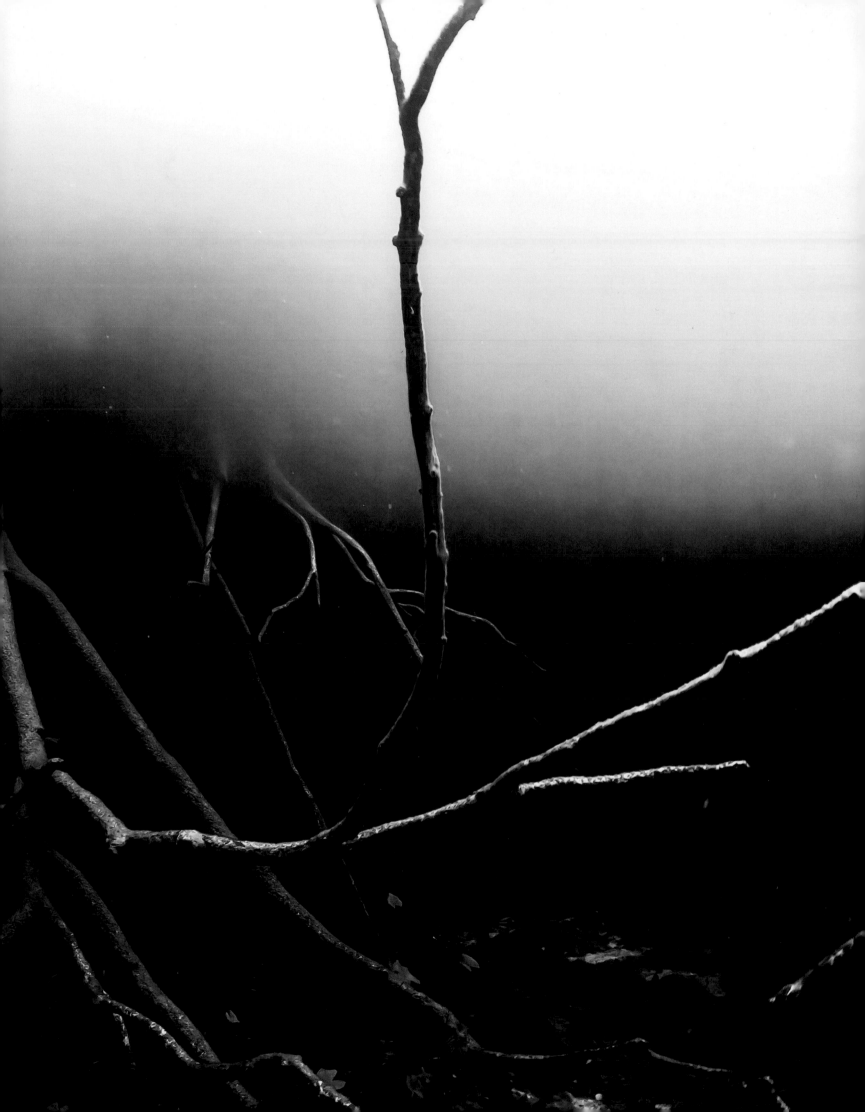

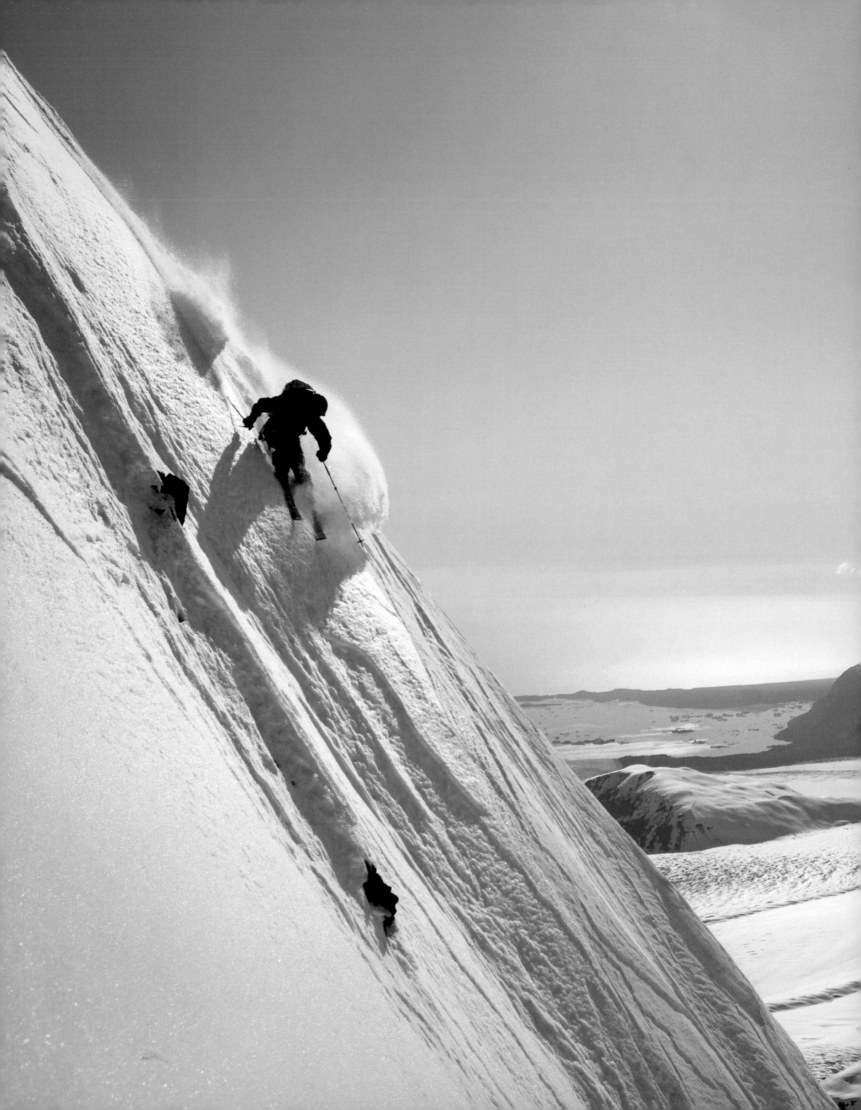

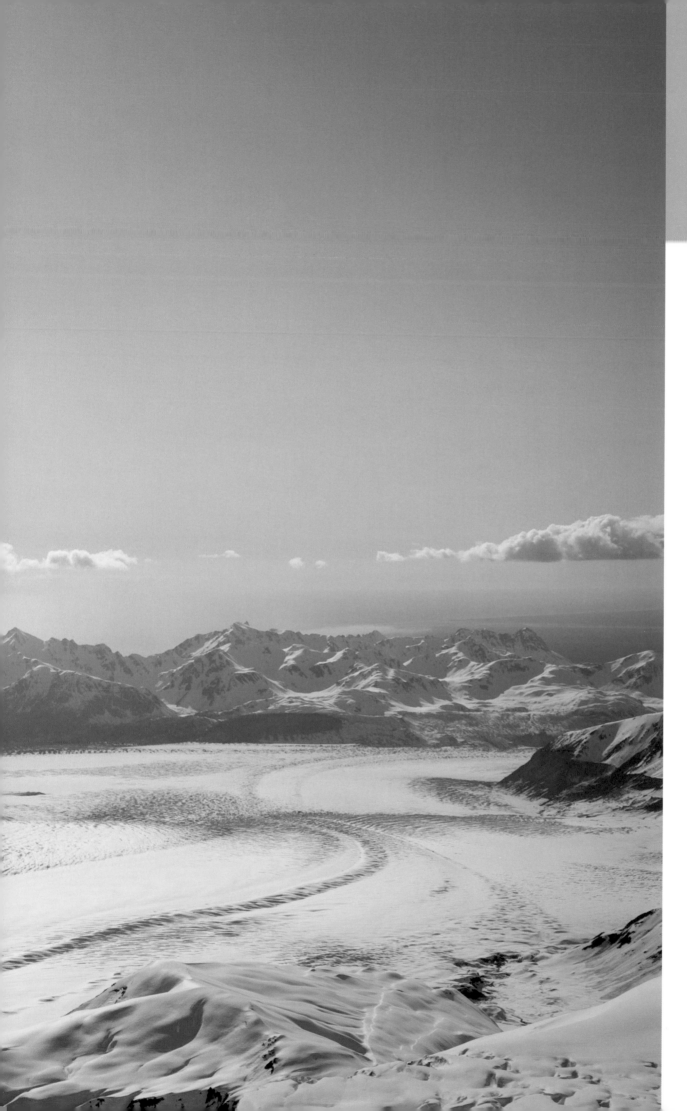

SNOWMONS

SKIING

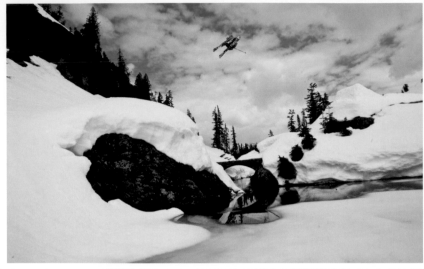

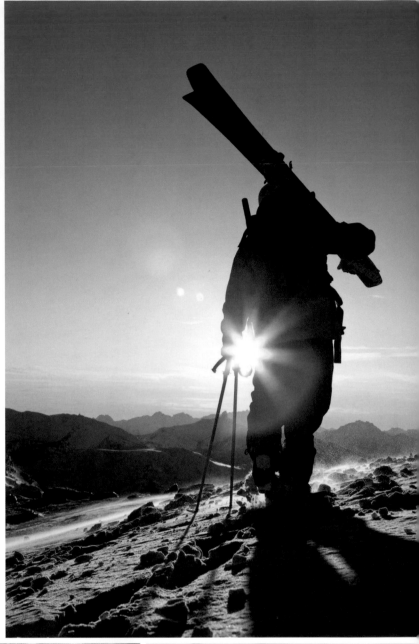

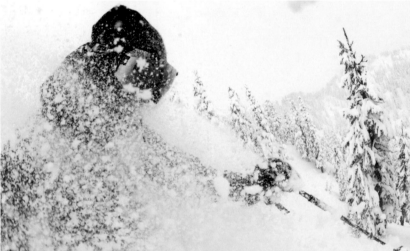

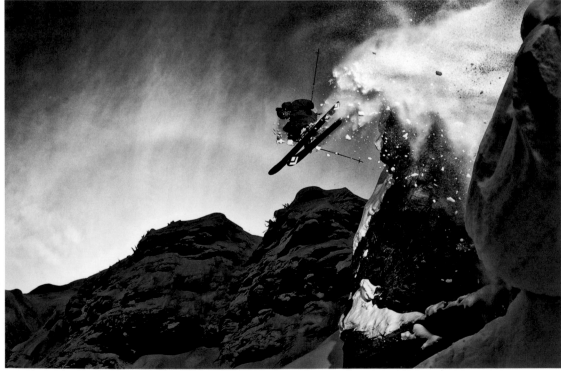

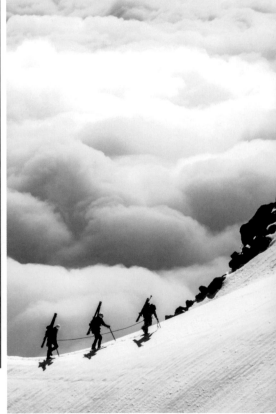

PREVIOUS PAGES: Luke Smith skiing Fairweather Range, Glacier Bay National Park, AK, USA · ABOVE, LEFT TO RIGHT, TOP TO BOTTOM: Mt. Baker Ski Area, North Cascades, WA, USA (top and middle left); Blackcomb Mountain, Whistler, BC, Canada; Revelstoke Mountain Resort, BC, Canada; Skiers traverse toward the summit on Mt. Hood, OR, USA · OPPOSITE: Photographer Steven Gnam treks through the backcountry in search of wolverines in western Montana, USA

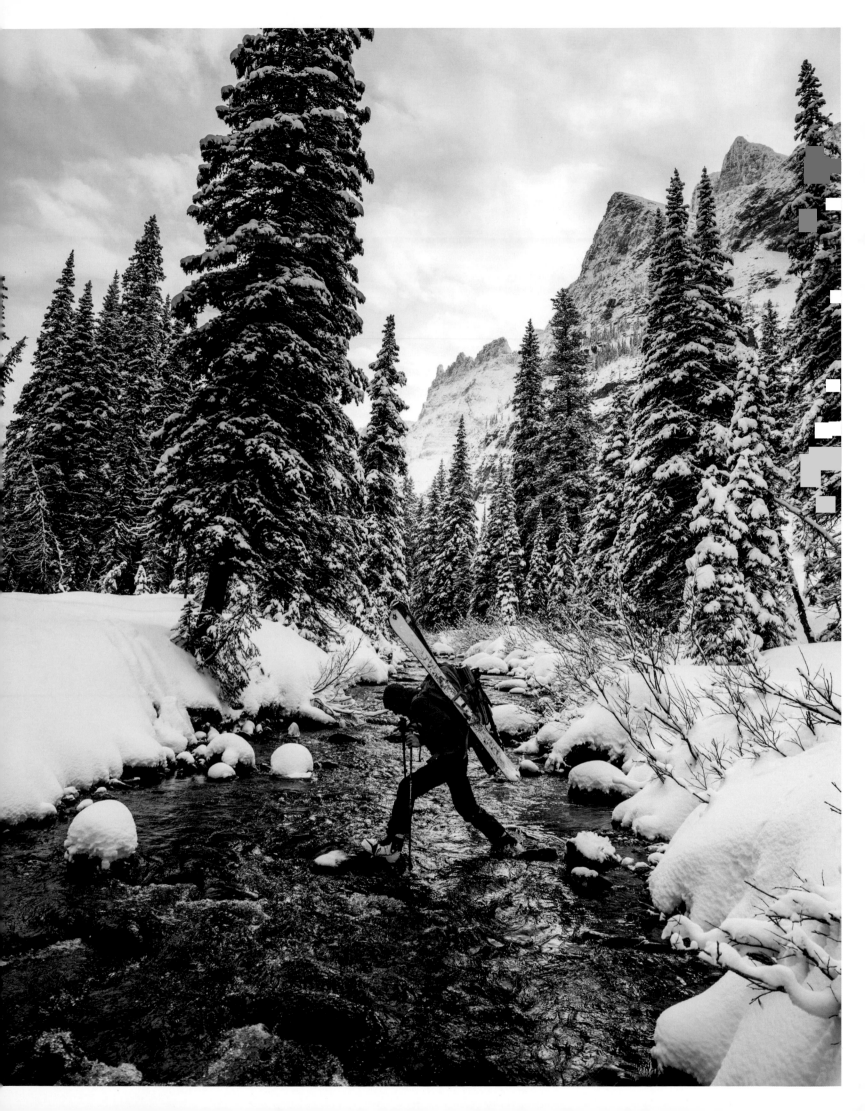

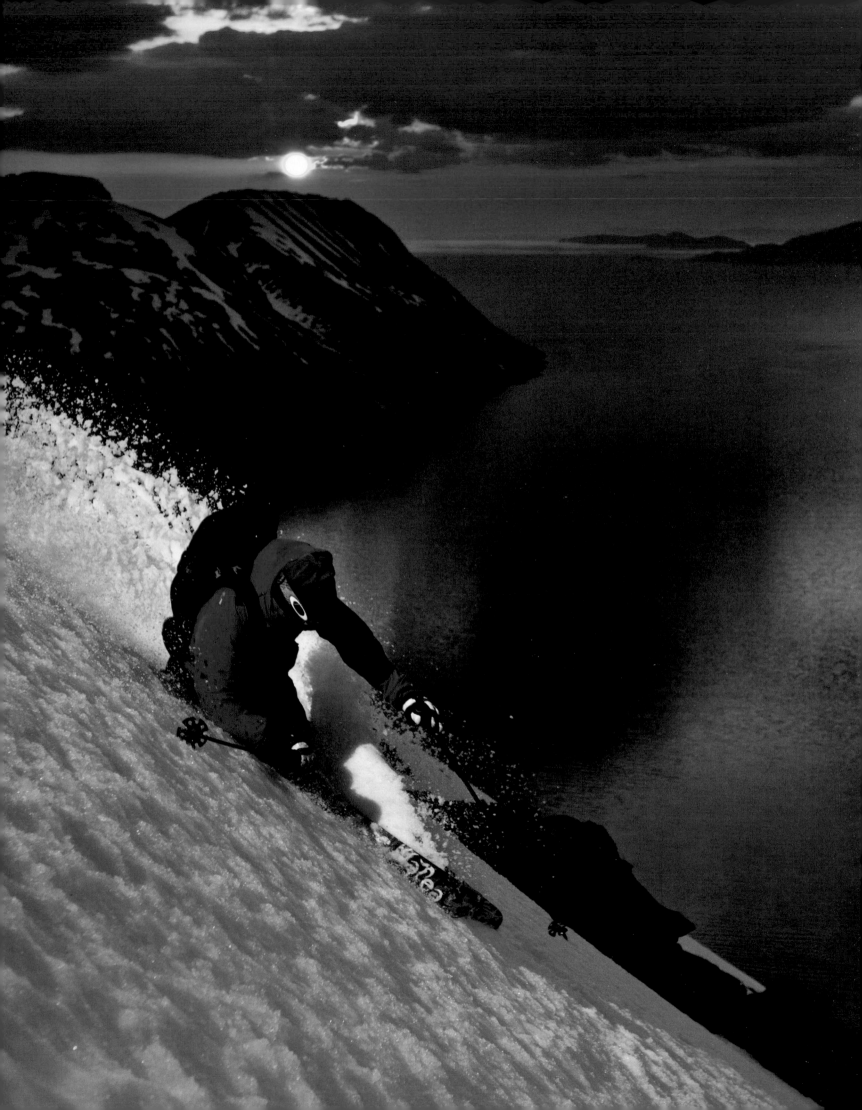

THE POWER OF SKIING

Kori Bassotta, *SKI* and *Skiing*

LOOKING OUT AT THE SCENERY that expanded west of Ski Arpa, I imagined people standing on one of those distant peaks, watching that same sunset. It was a sunset so magnificent that the moment I saw it I stopped, took a deep breath, and felt a surge of blood rush to my chest. Despite being in such a remote location of Chile, and so secluded from the world, I had never felt more a part of it. Santiago was more than sixty miles away, but from more than ten thousand feet above sea level, I could see far beyond the city.

Right in front of me, a group of students sat side by side in silence watching that same sunset. The past ten days I'd been working as their instructor at the Image Quest photography camp. We had spent the first week skiing and photographing Valle Nevado and the last few days at Ski Arpa, a remote ski cat operation north of Santiago. It was there that, on their final night, they sat as the bright colors of the sunset gradually changed from blues to yellows and oranges, followed by deep reds.

The heavy metal door of Ski Arpa's Refugio slammed closed behind them, breaking the silence, yet not a single head turned. They continued to watch as the sun disappeared behind those distant peaks and the stars' glow intensified against the dark night sky. These students sitting in front of me were strangers to one another only ten days ago—each preoccupied by their own interests and thoughts and needs. Today, they were all living the same experience, together, as friends. Witnessing this was just as remarkable as the view beyond. They were not only observing the beauty of their last sunset in the Andes; they were soaking it all in—all the powder, all the

sunsets, all of the laughs shared on that trip. What I witnessed that evening was the power of skiing.

Skiing is more than just a sport. On the surface, we are all on the hunt for those perfect powder days. There's no doubt that the ethereal feeling of carving that first set of tracks across untouched powder is hard to match. But the experiences in between are just as important to our enjoyment of the sport. There's a reason we bear extremely cold temperatures, high winds, icy snowpack, or crowded lift lines to do what we love. Skiing brings us in touch with the environment, each other, and ourselves.

Today's generation lives in an age engrossed in technology, day after day. Some people sit and work at a computer for most of their daylight hours, some start many of their mornings sitting in rush hour traffic. Most of our lives are so busy we seldom find time to stop and take a deep breath. When preoccupied by a list of things to do and places to be, people pass by strangers without even looking up. As those same people venture into the mountains, you see that change. We leave that world behind and the stresses that come with it. People load the lift with a stranger and get to know that person during their ride up the mountain. Those who venture into the backcountry shift their focus to the safety of themselves and those they're traveling with as they evaluate, and often marvel at, the surrounding terrain.

This is why, for those of us lucky enough to grow up skiing, our fondest memories often involve skiing with loved ones. Many of my favorite times spent with friends involve

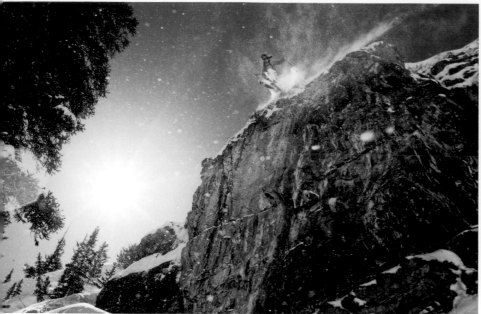

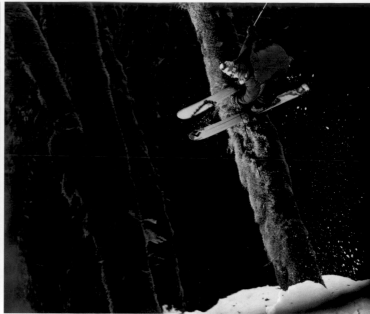

skiing, not just because we're doing something we love, but because when they come to a stop at the bottom of the run, their smiles are the most honest and genuine I've ever seen.

This is what I saw beneath that Chilean sunset that night. That group, all traveling from the same city, were strangers in their day-to-day lives. But after ten days in the mountains, skiing powder, riding lifts together, and exploring the backcountry, a relationship deeper than any of them ever expected had formed. They were now forever bonded to each other and to the soon-distant Chilean Andes.

We don't all get to live these experiences every day. When we're not living in moments like this, we look to our favorite magazines for stories and images that remind us of those experiences and inspire us to strive toward that next fleeting, seemingly miraculous one. The pages are filled with images from many great photographers that are dedicated to chasing storms, documenting the sport, and sharing it with others.

Some images appeal to us as reminders and inspiration. We see a skier engulfed in powder and remember the excitement we felt during our last perfect run. We remember the cold, airy texture of the champagne powder as our body glided through it. We check the snow predictions, hoping to score our next powder day.

A photograph of a skier touring through a pristine mountain landscape blanketed in snow provides a setting for our daydreams. We imagine traveling there one day. We pick out the line we would take down that untouched face, feel the chill of the air and the gentle warmth of the sun hitting our face as it peeks around the clouds.

Not all ski photography will trigger memories in this way. Many great photographers travel with professional guides, mountaineers, and athletes who push the limit of the sport beyond any level we ever hope to experience firsthand. These professionals are continually exploring mountains all over the world, skiing peaks that have never been skied, and traveling into terrain that is far out of reach for the average skier. In 2007, big-mountain skier Chris Davenport completed his mission to ski all fifty-four of Colorado's 14ers in one year. He's now working to top that by skiing all of Colorado's one hundred highest peaks with photographer Scott Rinckenberger documenting each ascent and descent. While these images may not be completely relatable to us on a personal level, they are just as important, providing a window into landscapes and mountain terrain most of us would otherwise never be lucky enough to see. They provide a visual narrative that empowers us to think beyond our own experience of the sport we love.

The power of these images to inspire on many levels is what makes them so amazing to the community that views them. As the athletes and photographers work together to push the limits and create unique images year after year, we continually find ourselves in awe of the art as it develops. Every snowflake is unique, every skier descends the mountain in their own path, and every photographer represents the harmonies between the skier and the mountain, between motion and light, in their own interpretation.

ABOVE, LEFT: Jacqui Edgerly jumping a large cliff in the Snowbird sidecountry, UT, USA
ABOVE, RIGHT: Zack Giffin skiing at Mt. Baker, WA, USA
OPPOSITE: Molly Baker heli-skiing the North Cascades, WA, USA

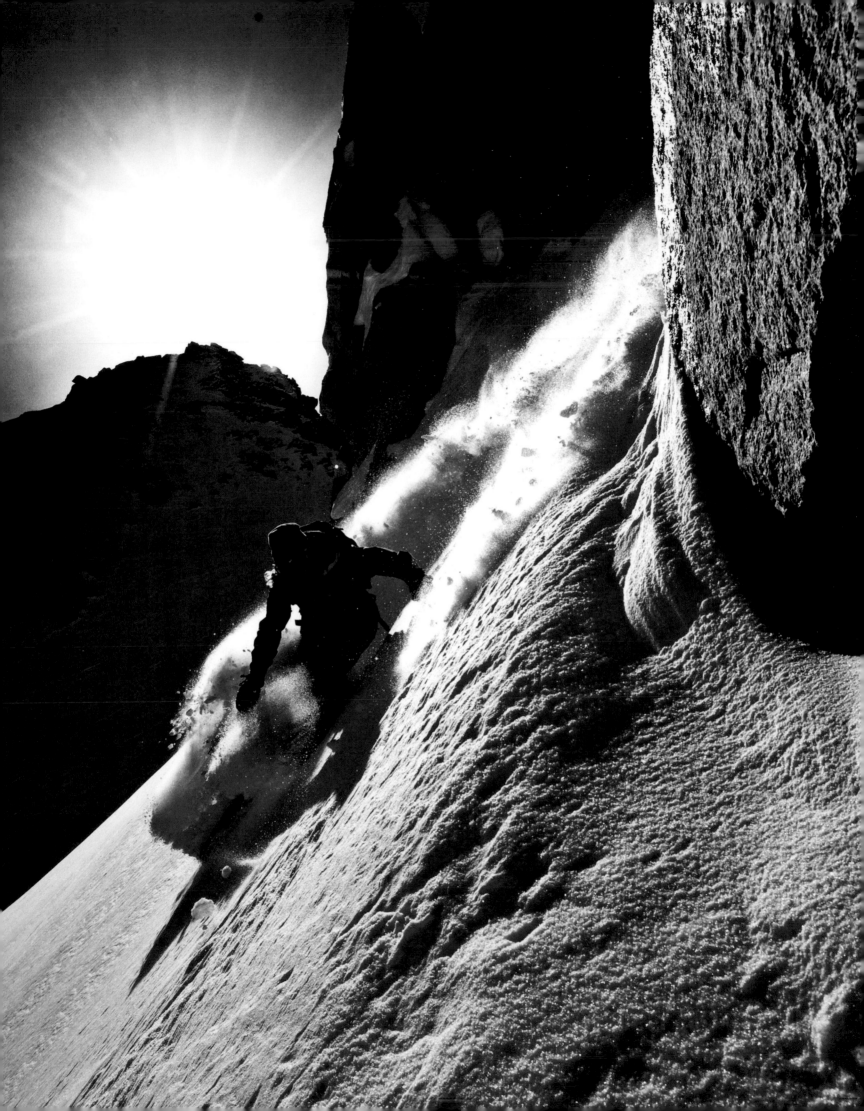

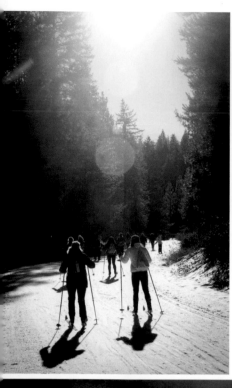

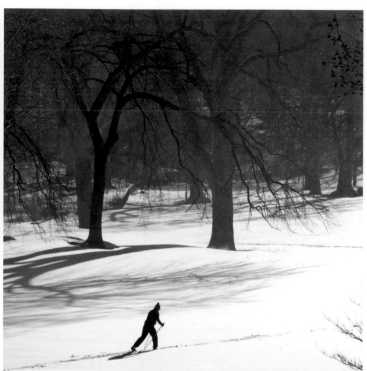

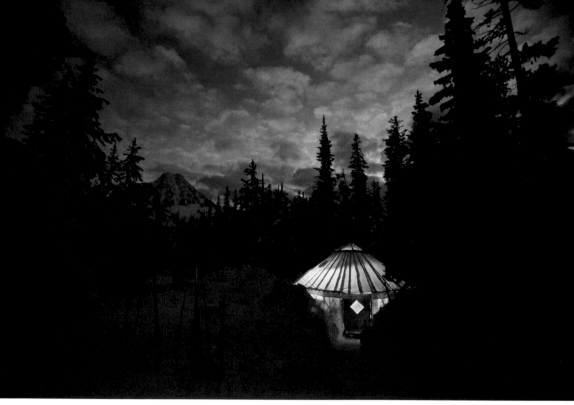

OPPOSITE, TOP LEFT: Cross-country skiing in the Methow Valley, WA, USA
OPPOSITE, TOP RIGHT: Cross-country skiing in Prospect Park, Brooklyn, NY, USA
OPPOSITE, BOTTOM: Enjoying a warm yurt after a long day of cross-country skiing,
Blue Mountains, OR, USA
ABOVE: Cross-country skiing on the Palouse near Moscow, ID, USA

OVERCOMING POWDER PANIC

"I hear and I forget. I see and I remember. I do and I understand." —Confucius

THE COLD, INIMITABLE STING of fresh powder hitting your face. The euphoric high that accompanies a morning trail run through a backlit aspen grove. The adrenaline rush that is mountain biking. Can I even call it mountain biking anymore? For me it seems more like a series of linked recoveries on single track, followed immediately by giddy laughter and a touch of grade-school fear. You know . . . the kind that makes you want to go back for more and push it juuuust a bit further.

These experiences, feelings, and personal, introspective moments are what I strive to communicate through my outdoor lifestyle and adventure imagery. My overarching goal is to reignite those familiar feelings—the love for outdoor sport and adventure—in the initiated and introduce unexperienced viewers to a world of possibilities that they never knew existed.

Capturing these moments is no easy feat. It requires technical prowess, creative ingenuity, and some strange internal wiring.

You must be willing to suffer. You must be willing to get up earlier, stay out later, trek further, pedal harder, and dig deeper. When everyone else is saddling up with their lightest gear, "the photographer" is throwing the heaviest stuff on his or her back. F/2.8 weighs more than F/4.0, and damn it all if I don't reach for 2.8 almost every time. Sometimes I wonder if it's really necessary, but I won't allow myself to cut corners for fear of producing anything less than exceptional. It's a mantle that has more figurative weight than the literal total in my backpack. And if I'm being completely honest, there are times when I wish I could shed it, even for a moment. But I can't—it is a part of me.

You must be willing to sacrifice your own moment to document someone else's. Soon enough, their moments become yours. Their failures, their triumphs, their "best run ever" . . .

It took me a long time to commit to photographing skiing. I had a hard time letting go of my own powder panic. I couldn't look at that crystalline goodness through the lens and not implode. And then, I eyed the stack of magazines in my closet and remembered all of the images I'd stared at over the years and how they had moved me to go and do. And through that doing I came to understand what it meant to get lost in a sea of white, weightless bliss.

Suddenly, I wanted to be the one providing the push. I finally gave in, and it opened up an entirely new world. To memorialize the moment that so many of us talk wildly about at the bar or around the campfire was unbelievable! I (and so many others) could relive it with the turn of a page or the click of a button. The captured moment could bring back everything about the experience and more—light, movement, emotion, detail . . . so much detail that we could never perceive in real time. Now, I find every bit as much pleasure in shooting pow as I do in skiing it. (But that doesn't mean I don't sneak a run in here and there in the name of "work"—just don't tell the wifey.)

In the end, I hope my imagery serves as a portal to that part of people's brains that stores away all those "best moments ever." I want people to see and remember. But even more so, I want them to do. Go and get it. Run free, ski hard, climb high. Don't worry—you can leave the camera at home if you want. Just don't forget the photographer.

—ADAM BARKER
Photographer

OPPOSITE: Parker Cook skiing Snowbird, UT, USA

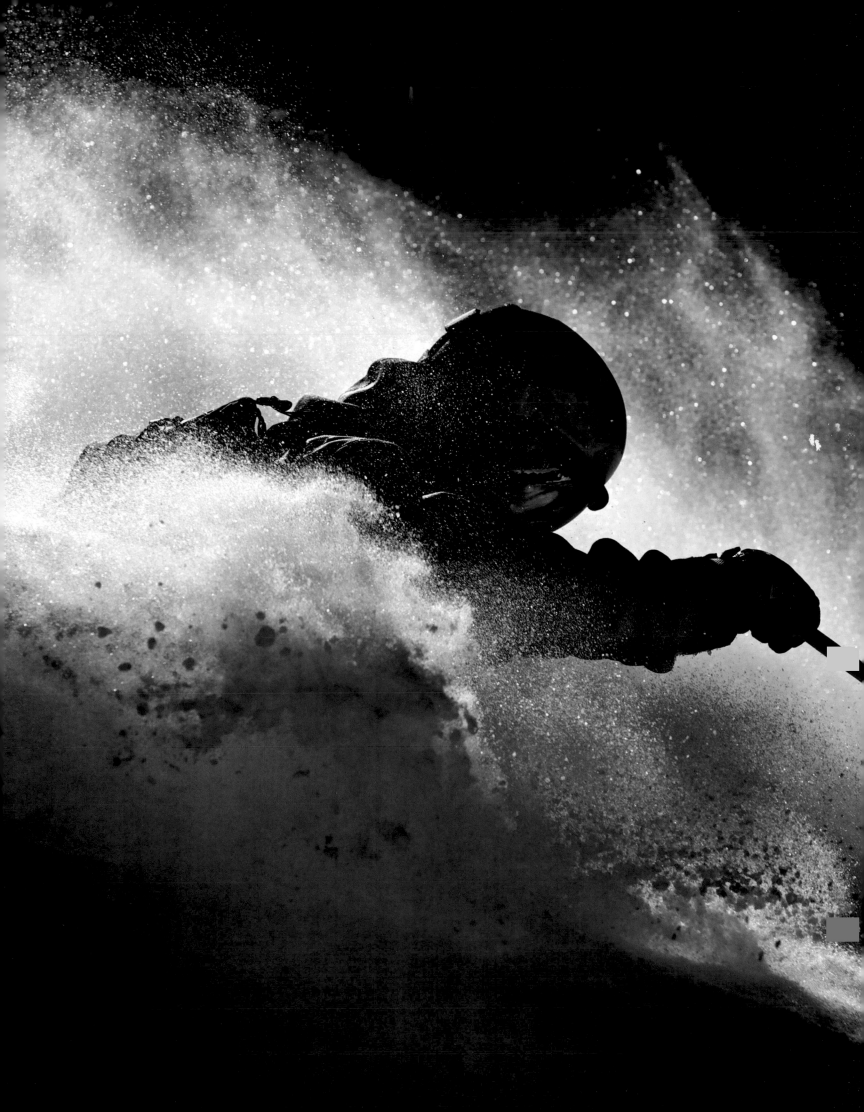

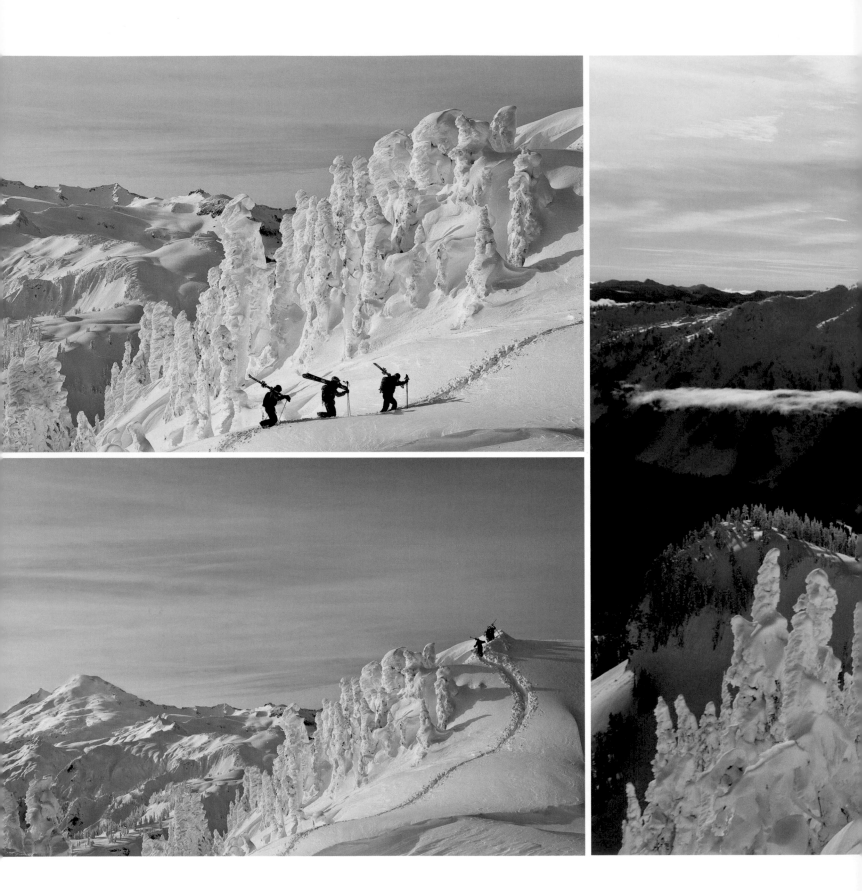

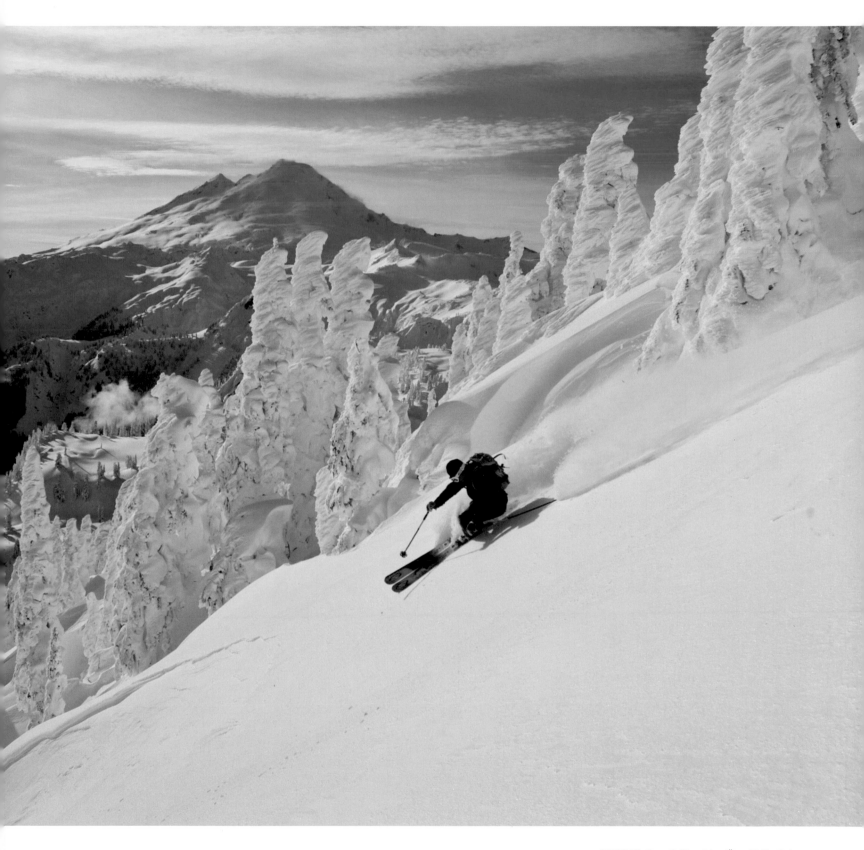

THESE PAGES: Dean Collins, Adam Ü, and Mike Steinman backcountry skiing in search of a fresh powder run, with Mt. Baker in the background, WA, USA

CHASING THE LIGHT

I'M OFTEN ASKED what drives me as an adventure photographer. What motivates me to take risks to create and capture imagery from obscure places with virtually unknown athletes?

The short answer is light. Light is the common thread, the element that connects everyone. Light can be appreciated by anyone, photographer or not, in a conscious or unconscious way. It is the one true constant, and whether brilliant or lacking, it is always present.

As a photographer specializing in adventure, my goal has been to inspire and motivate the viewer. In the end, it is light that has the greatest impact. Above all, light is what shapes the viewer's experience. Light can add drama or warmth, comfort or, perhaps most important to this genre of photography, uncertainty, because in essence, that's what adventure is—experiencing the unknown and facing uncertainty.

The longer and less visibly tangible answer to the question about my motivation is the creative process. A tremendous amount of creativity is required to be successful, to realize the vision you set out to capture. You have to settle on an objective, find a partner who shares your vision, plan the excursion, initiate it, and then problem solve along the way.

My partners in the mountains often become my subjects. These collaborations lead to images that tell a story of a moment in time. The hope is to shoot when emotion is raw and light is at its peak. In such a confluence of circumstance, light, and emotion the story captured in the image will be authentic but still open to interpretation by the viewer. But it's the process of getting to this moment—the anticipation and planning—that excites me and fuels my passion.

It is a rare occasion when this all falls into place and an opportunity presents itself, pure and genuine. I can remember one such day, midwinter with a clearing storm. My partner and I headed to a zone we call "the spot." It's a nondescript powder stash in the middle of the Wasatch Mountains outside of Salt Lake City, Utah. I had scouted and even done test shots on this slope several times, knowing that if all the components came together it would have the potential to yield amazing end results.

The Wasatch is known to shake off storms around 4:00 P.M., what locals call the 4 o'clock clear. Earlier in the day I started to feel "the clear" coming on. Spend enough time in an environment and you pick up on the signs—a certain taste to the breeze, telling characteristics in the makeup of the clouds, a sudden rise or drop in the moisture of the air—countless minutiae that work to tip those tuned to them. Anticipating the potential opportunity, I persuaded my ski partner/model to dip out of work and race to "the spot." It was all over in a matter of minutes, one lap, one chance to get it right before the light failed. The end result was a striking image that satisfied my internal vision—a rare and ecstatic occurrence, and affirmation of the planning and preparation on the front end.

For the viewer, the end of my process is the beginning of theirs. I find it amazing that a single image can transport someone to a time and place in their own life, often completely unrelated to the image. It can release an emotion that has long since passed or been forgotten—one of art's great gifts.

The uncertainty of the outcome and the unpredictable response to the finished product is similar. There are no clear

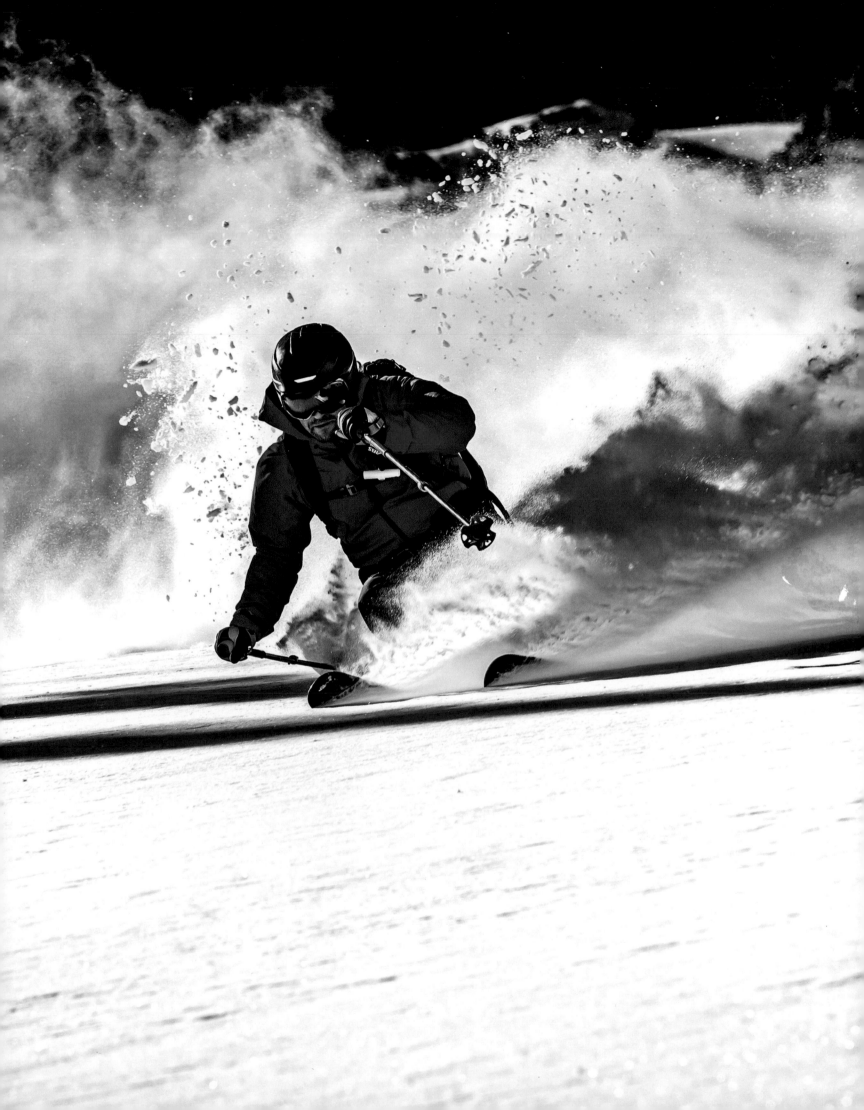

outcomes to this type of photography, it is not controlled or predictable, and it does not happen in air-conditioned, windless studios. A perfect photo opportunity can present itself at inopportune times and can vanish as quickly as it appeared. Capturing these types of images requires respect and motivation. They are a reflection of the person creating the image, just as the response from the viewer is a direct reflection of the person seeing them.

In the end, my drive comes from the hunger to experience the unknown and the desire to share that experience with others. It does not matter if the viewer can relate to the actual activity; it is more important that the viewer can relate to the energy behind it. Light is the tool that helps me tell that story; light is what I am constantly chasing, and it's the process of finding it that drives me.

—TOBIAS MACPHEE
Photographer

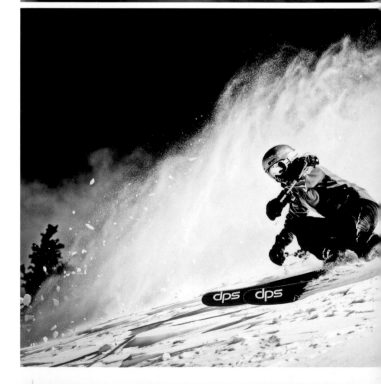

THESE PAGES: Backcountry skiing, Little Cottonwood Canyon, Salt Lake City, UT, USA

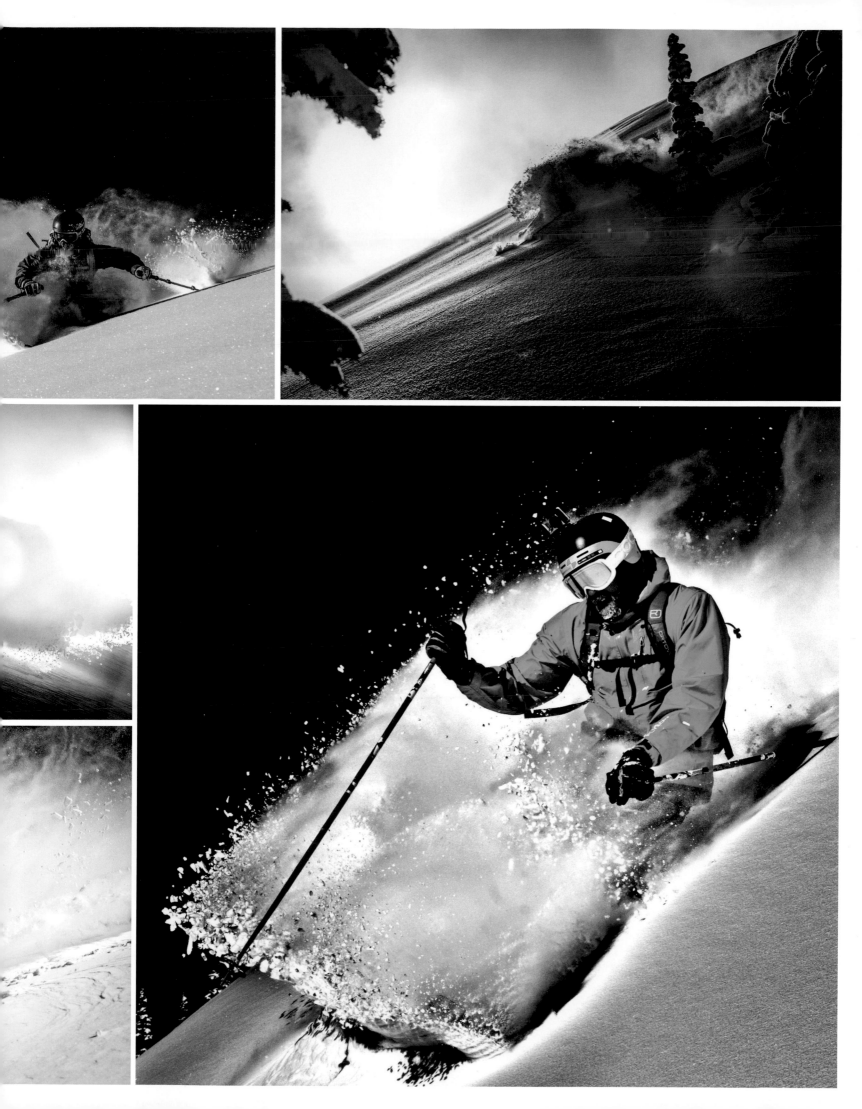

SNOWBOARDING

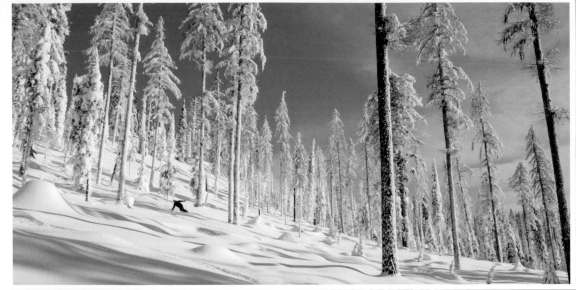

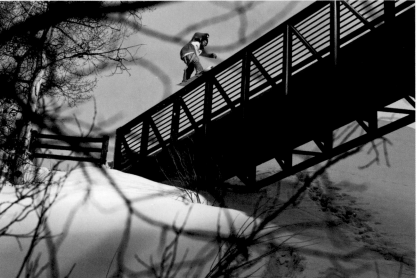

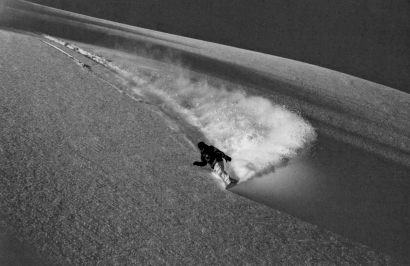

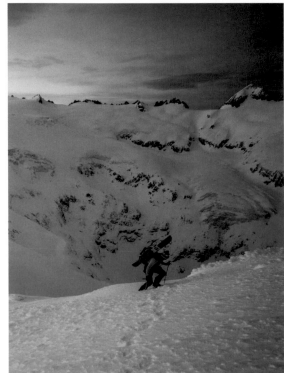

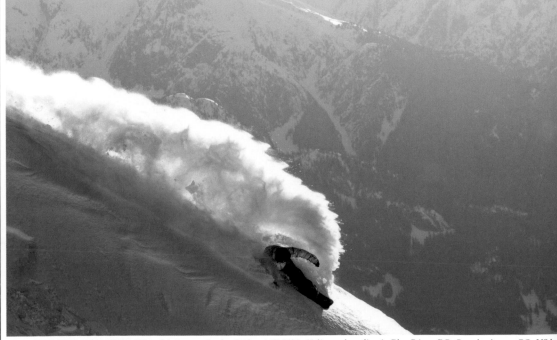

ABOVE, LEFT TO RIGHT, TOP TO BOTTOM: Whitefish Range, Stryker Ridge, MT, USA; Heli snowboarding in Blue River, BC, Canada; Aspen, CO, USA; Jason Speers snowboarding fresh powder in the Mt. Baker Ski Area, North Cascades, WA, USA; Splitboarder in North Cascades National Park backcountry, WA, USA; Throwing powder in Whistler backcountry, BC, Canada · OPPOSITE: Park City, UT, USA

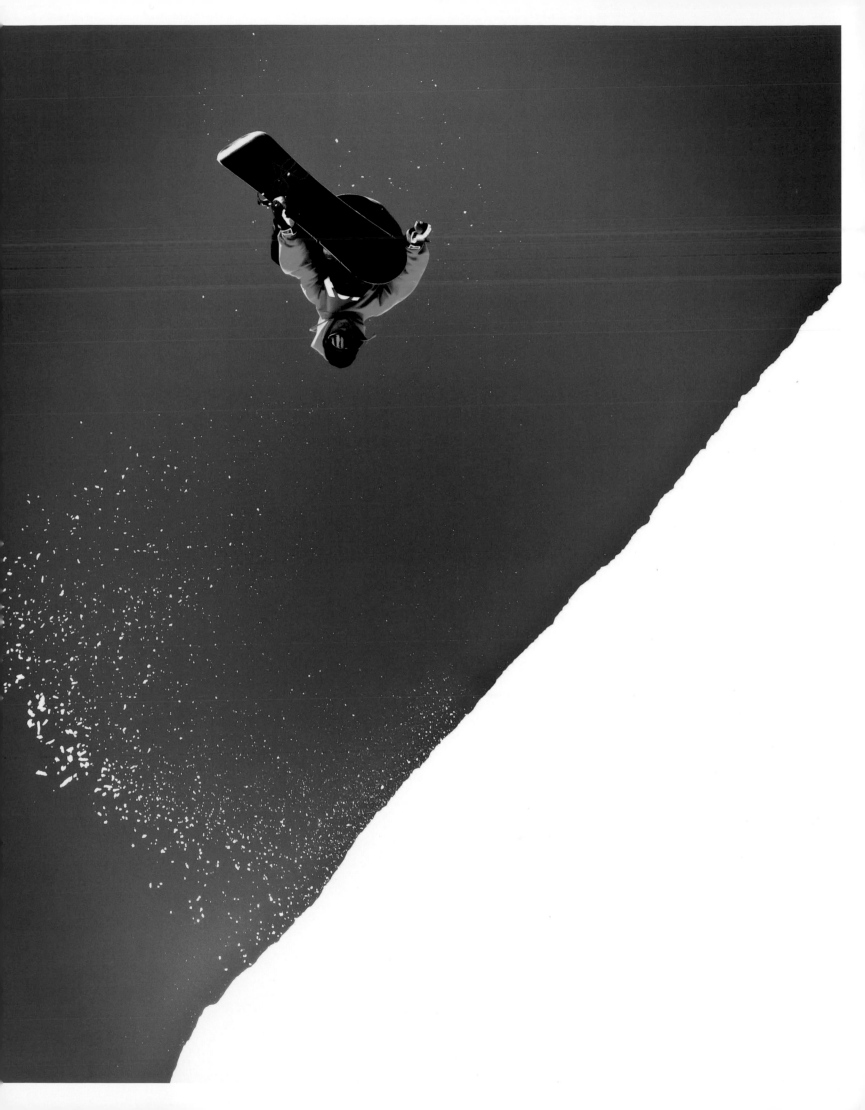

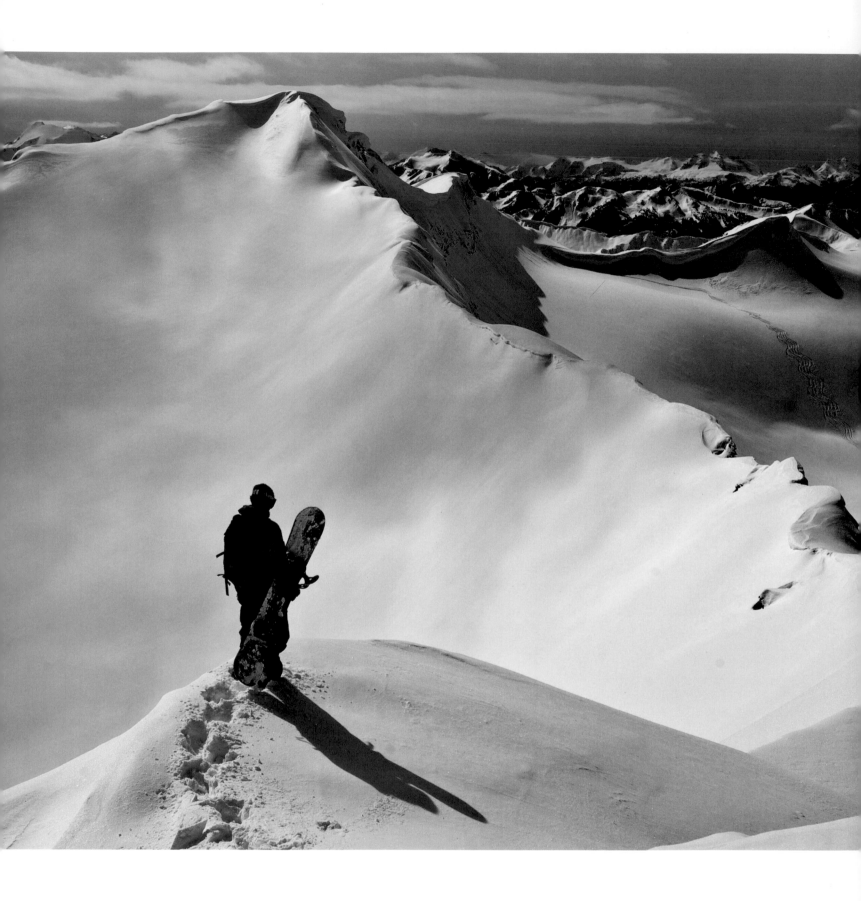

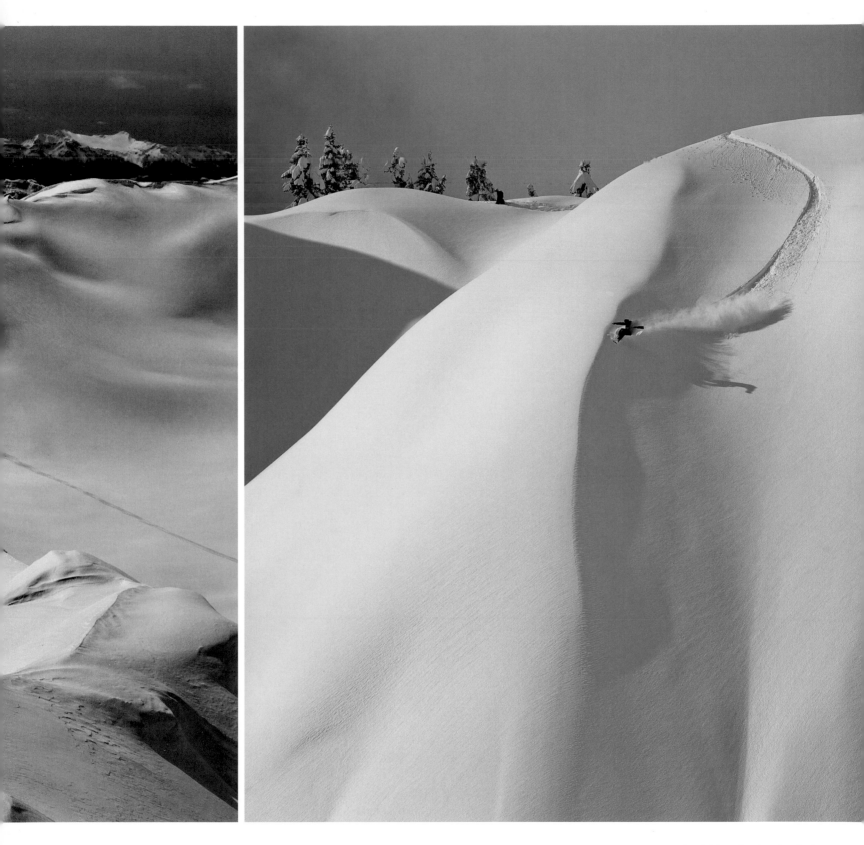

OPPOSITE: Joey Vosburgh hiking for a line, Revelstoke
Mountain Resort, Revelstoke, BC, Canada
ABOVE: Mt. Baker backcountry, WA, USA
FOLLOWING PAGES: Sunset run, Whistler, BC, Canada

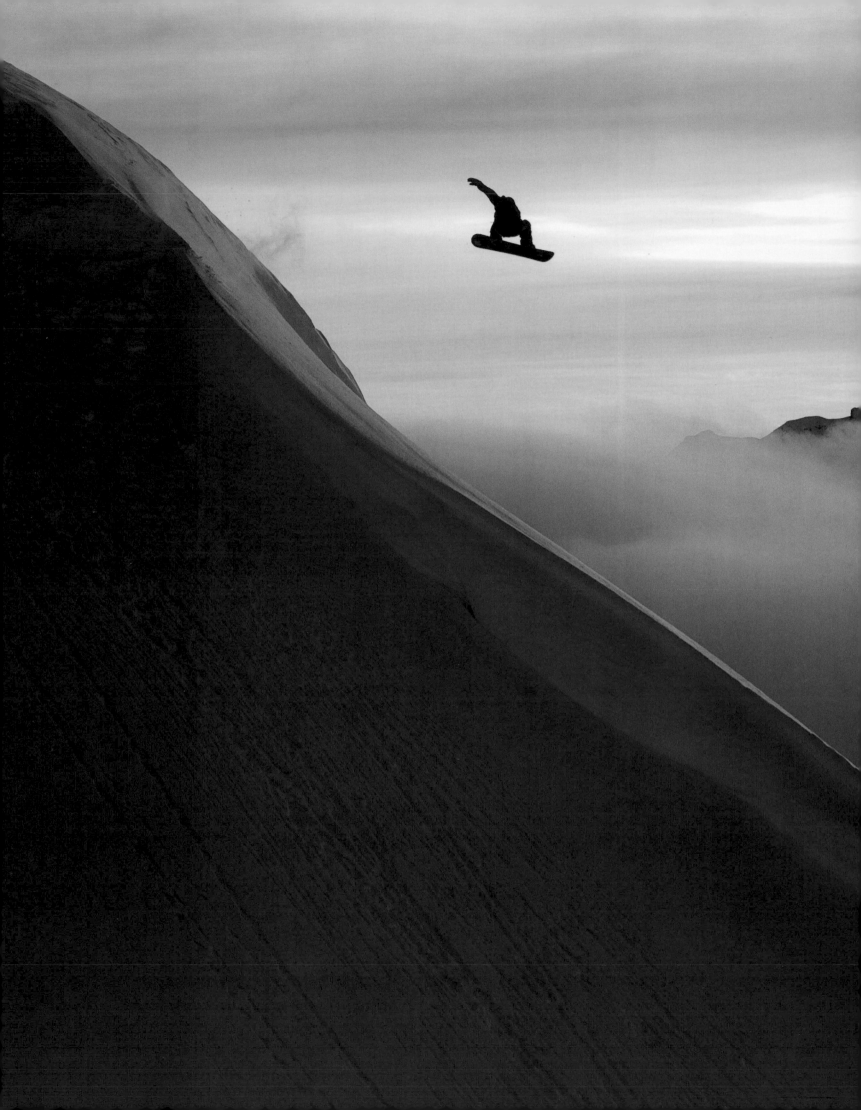

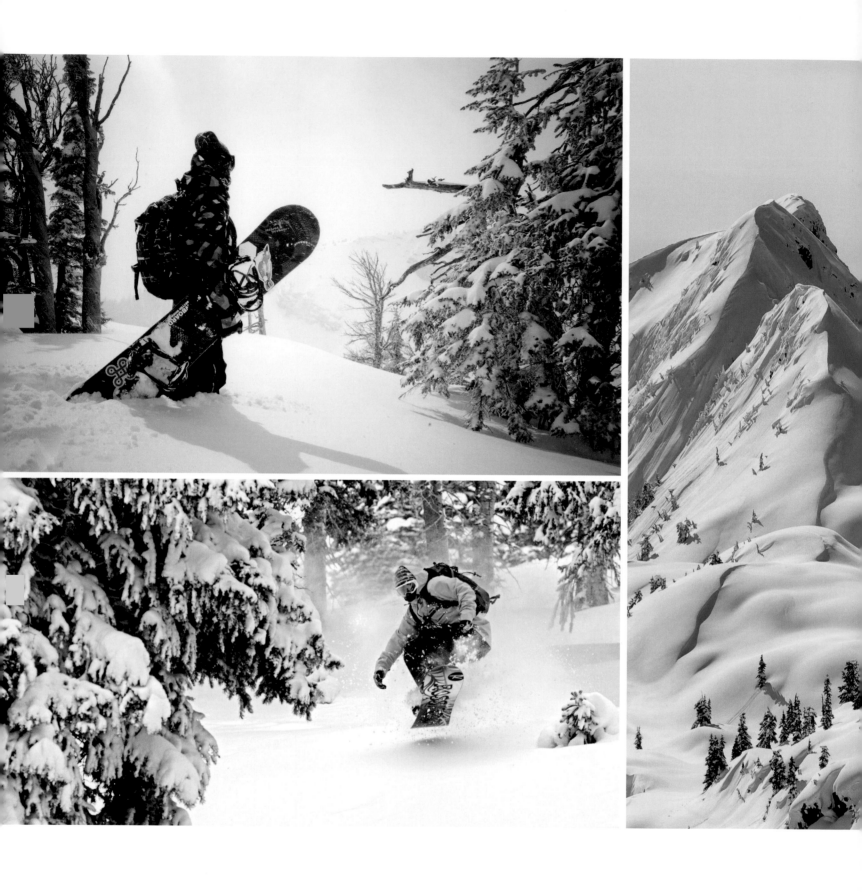

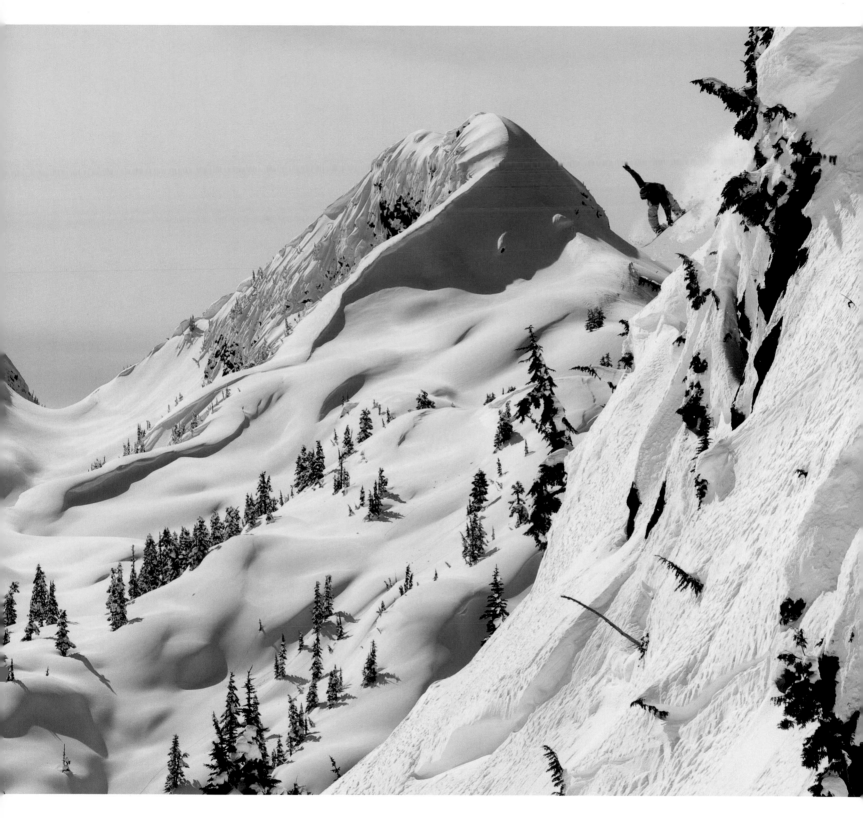

OPPOSITE, TOP: Jackson Hole backcountry, WY, USA
OPPOSITE, BOTTOM: Little Cottonwood Canyon
backcountry, Salt Lake City, UT, USA
ABOVE: Whistler backcountry, BC, Canada

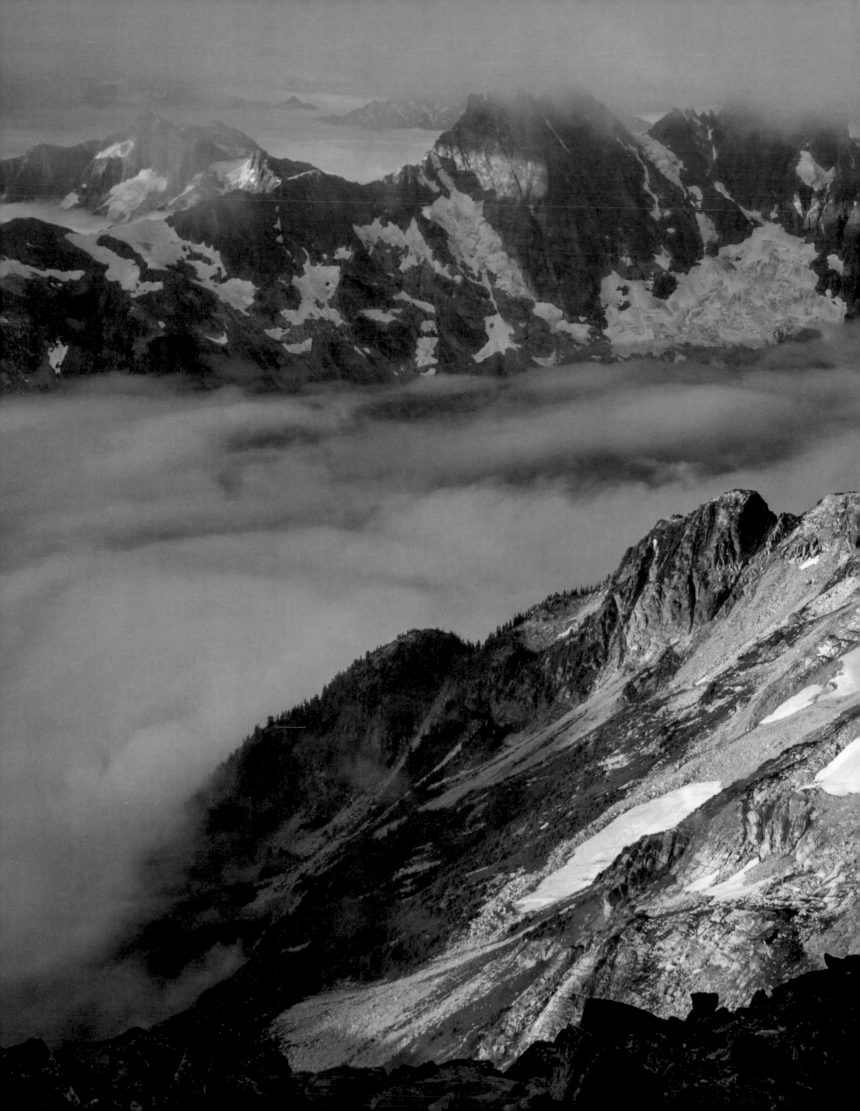

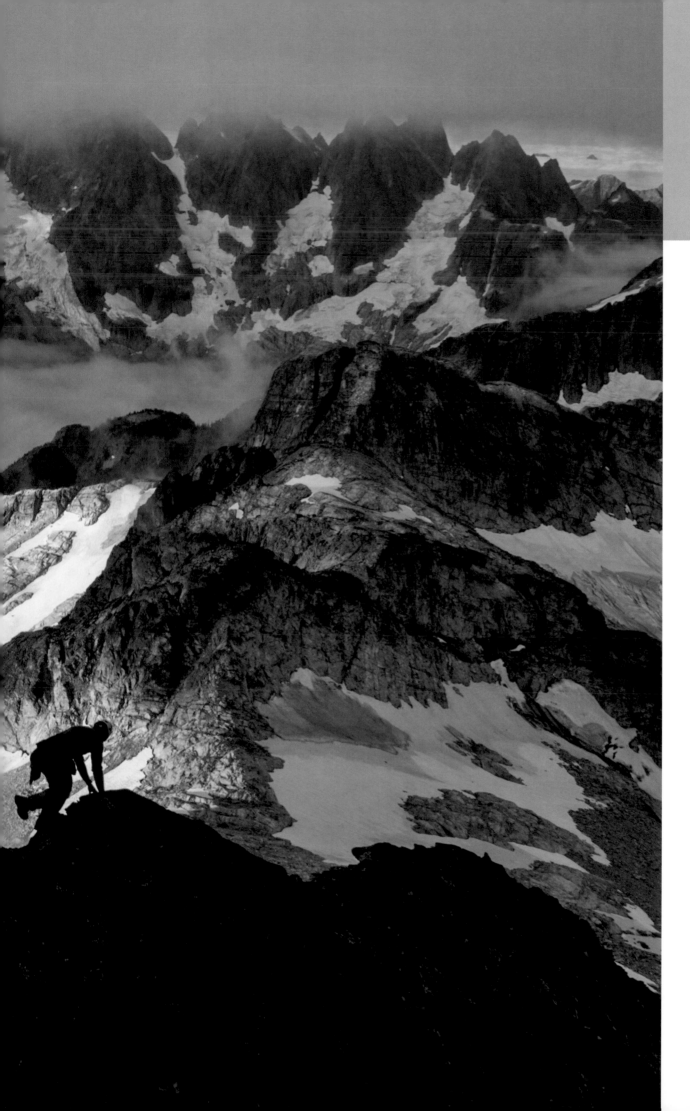

SUMMITS

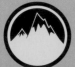
ROCK CLIMBING

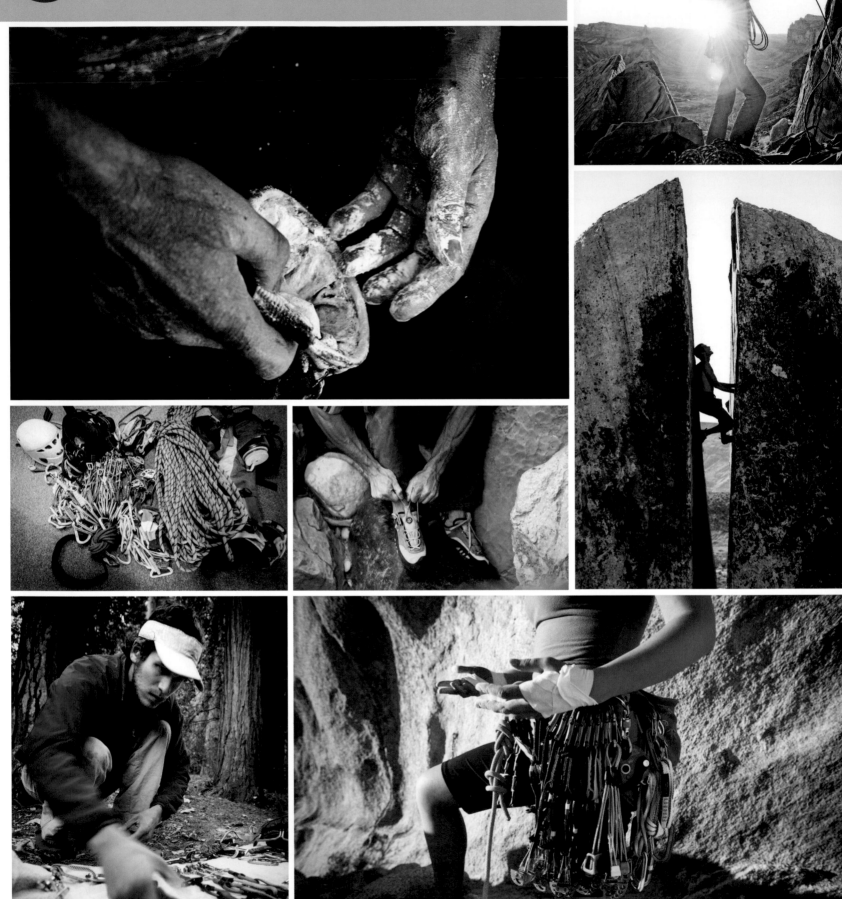

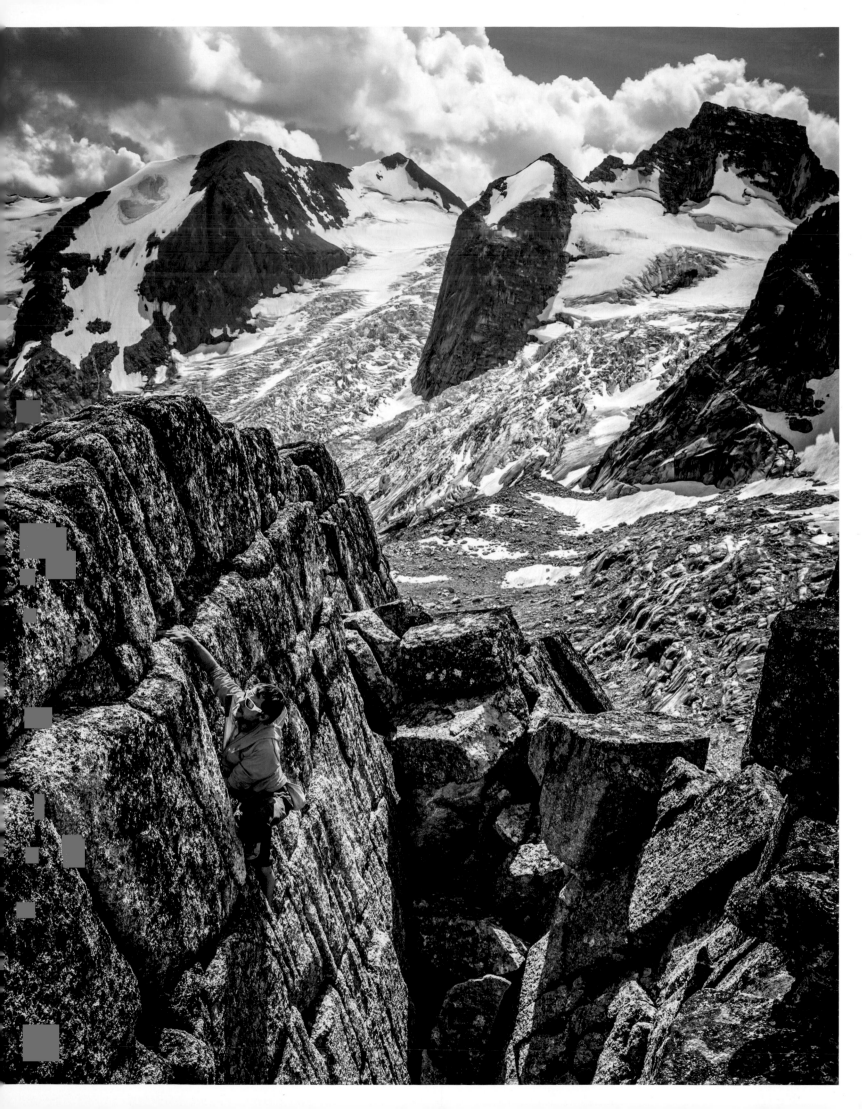

IN THE BEGINNING

Julie Ellison, *Climbing*

DESPITE TWO THOUSAND FEET OF AIR below her and her hair whipping around her face in the wind, Lynn Hill looks cool, calm, and collected as she nears the top of Yosemite's El Capitan on the groundbreaking first single-day ascent of the Nose. A ropeless John Bachar makes it look easy in purple Lycra as he free solos the Gift, a scary-hard 5.12d route in Red Rock, Nevada. And of course, the *Climbing* magazine cover heard round the world: Rikke Ishoy on some lowball boulder in a bikini, a shot that prompted diehard followers to question the entire publication.

As a young teenager growing up in the relatively flat state of Alabama, I used to sit in the one bookstore in town after school and on weekends and immerse myself in all the beautiful pictures in *Climbing* magazine. These images, sometimes dulled by the crappy paper they were printed on, were the only connection between me and a world of climbing that was much larger and more beautiful than my young mind could comprehend. (More than a decade and a half later, I still can't wrap my mind around the size and scope of this thing we call climbing.)

As a boulderer and reluctant toproper at the time, I didn't know what a cam was or an ice ax or even what multipitch meant, and I had no clue about places like Rocky Mountain National Park, Yosemite Valley, the Himalayas, and Chamonix, but I knew by looking at those pictures that I *wanted* to know. I wanted to visit those places and be part of this culture and these people. I barely even read the articles because I didn't understand half the words, and the stories themselves made climbing seem intimidating, like I would never ever get to where the climbers in the mag were. But the pictures. Man, the pictures. That was a universal language that I understood loud and clear.

Now, as the senior editor for *Climbing* magazine, I get to be part of the publication's legendary history as a leader in climbing media and help make that exact magazine I drooled over so long ago. My favorite part is still the pictures. I see thousands of climbing images on a weekly basis, some bad, some good, some jaw-droppingly great, and I still get excited every time I get to review a new submission. Sometimes I save it for the end of the day, when I've done a ton of other work and I want to reward myself with something that's pleasingly visceral. I sit with a cup of coffee, breathe deeply, and click through each photo, waiting for that feeling in my stomach and the light bulb in my brain that instinctively goes off as if to say, "Yep. That's it." After years at the magazine and traveling the world to climb, these pictures still get me psyched to go outside and tie in, whether the photo is of a tiny crag no one has heard of in Minnesota or a bucket-list vista in a place like Spain or Australia.

Without these images, my identity as a climber, my career path, and even my chosen home would be completely different. I wouldn't be who I am today. For giving me a goal to aspire to and a clear-cut path in life, I have to thank the photographers, the unsung heroes of the climbing world. I think climbing photographer is a misunderstood job; outsiders romanticize it, seeing the job as simply jet setting from one beautiful locale to another to photograph professional athletes doing what they do best. In reality, climbing photography

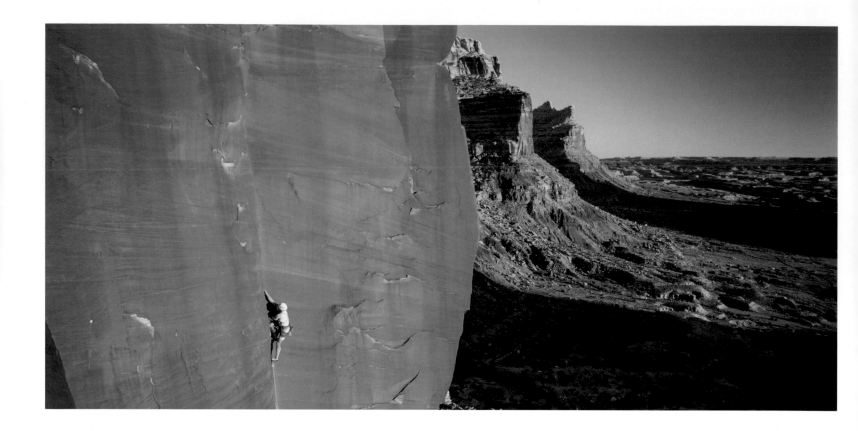

is a full-commitment, demanding, kick-you-in-the-pants profession where you never *quite* get a day off. The work of a climbing photographer is never truly done; there's no punch clock on your way out of the office that lets you stop thinking about work responsibilities, turn your mind off, and relax. Now that I rely every day on photographers to contribute to the magazine, I am even more grateful that they're as committed and passionate as they are. I've had a photographer drive three hours one way at 2:00 A.M. in middle-of-nowhere South Africa just to get Wi-Fi so he could e-mail me a high-res photo. Another time, I called a photographer at 10:00 P.M. the night we had to get our magazine to the printer, and he was out at a bar several states away with his friend who was in town for only one night. Not only did he pick up his phone knowing full well it was an editor at *Climbing* magazine asking him for something, but forty-five minutes later the high-res was sitting in my inbox.

These dedicated professionals bust their asses day in and day out, carrying sixty-five-pound packs filled with fragile camera gear straight uphill for two hours to get to the location, dealing with the elements, and shooting the same subject over and over until it's perfect. Plus, this all happens at 5:30 A.M. because that's when the light is just right. Then there's the "down time" of a climbing photographer; every waking hour not spent shooting is spent in front of a computer screen:

transferring, organizing, and editing images until the eyes are strained and the brain is fried. "Days off" are consumed with answering endless e-mails, scouting locations, planning shoots, booking travel, arranging schedules, researching the latest equipment, backing up hard drives, crafting pitches, making phone calls, and invoicing clients. And, in spite of all that time invested and hard work, they don't make that much money (most of it will be spent on expenses for the next shoot anyway), and they're rejected by clients and photo editors on a daily basis. Moral of the story? Go hug some climbing photographers because they could probably use it. Or just realize the amount of work that goes into every image in a book like this. They're passionate enough about the people, places, and stories of climbing that they will wade through all the soul-crushing and back-breaking work that goes along with it just to get a beautiful image. They do it because they love it.

And we love them for doing it. So crack open a cold beer, and salute the photographers as you sit back with this beautiful photo book that was compiled by other editors and photographers who are just as psyched as you and me. I hope it will inspire you the way *Climbing* magazine inspired me so many years ago, to not only get out and climb, but to live the raddest life you can.

ABOVE: Mike Friedrichs climbing the 5.12b route Blood on the Tracks, Dylan Wall, San Rafael Swell, UT, USA
OPPOSITE: Nick Martino trad climbing in Indian Creek, UT, USA

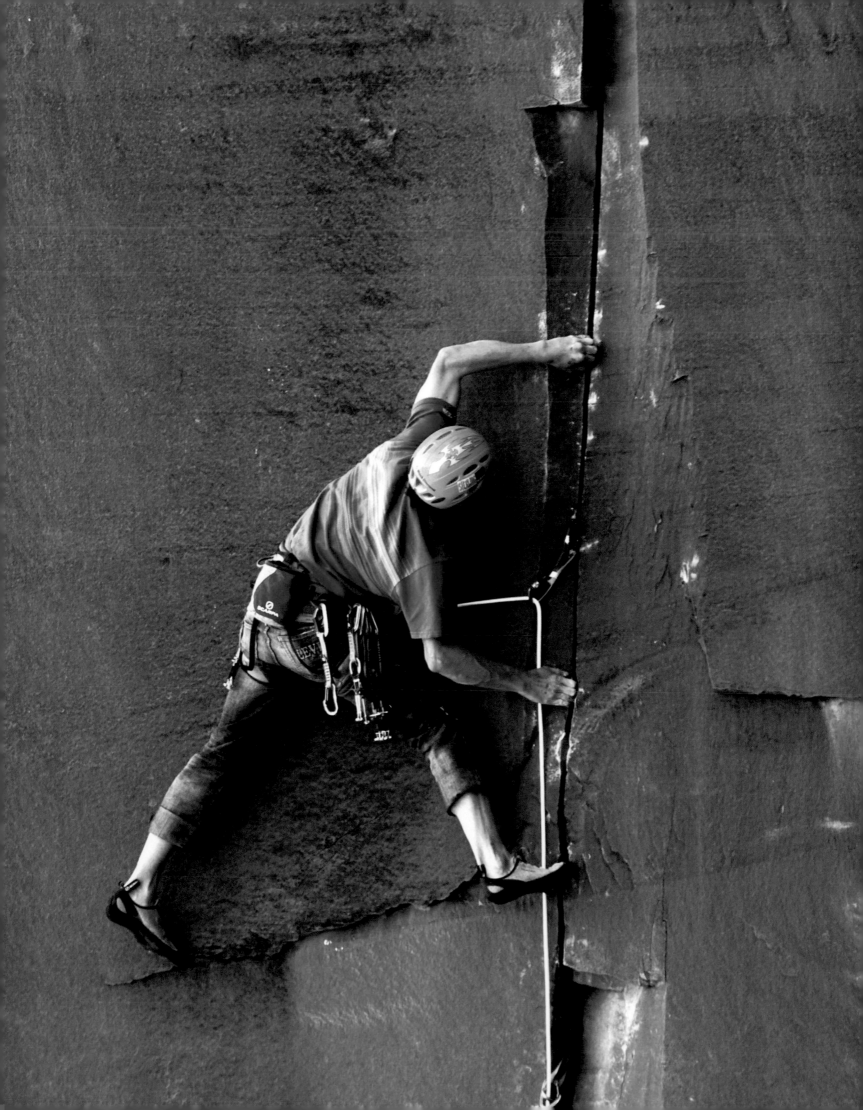

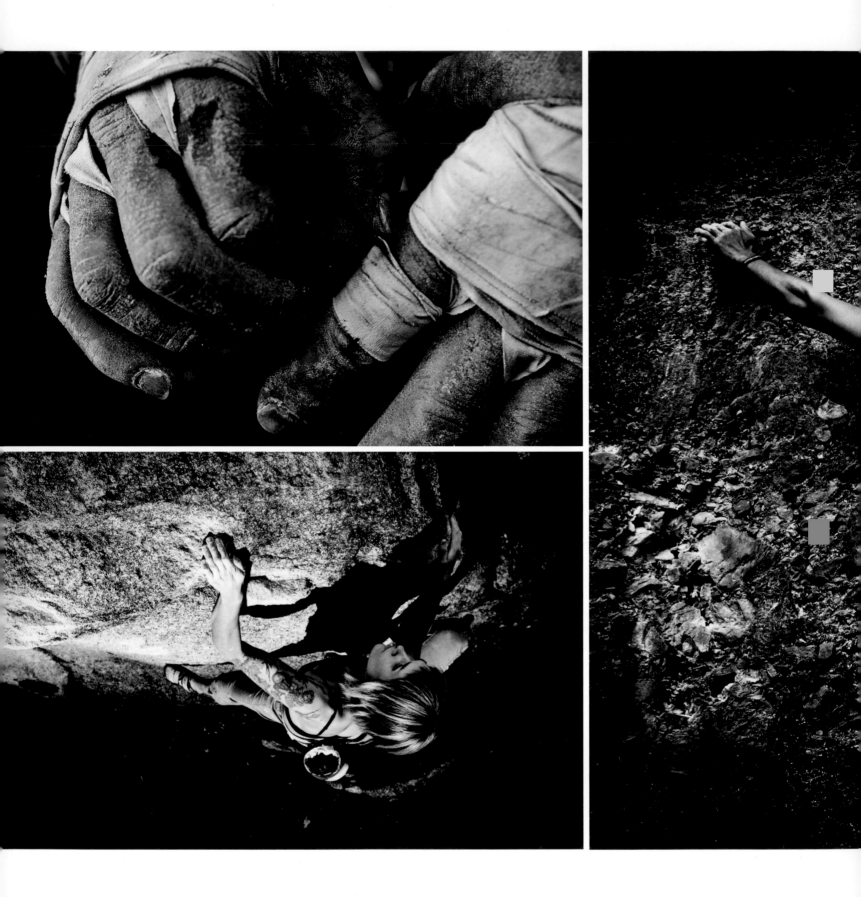

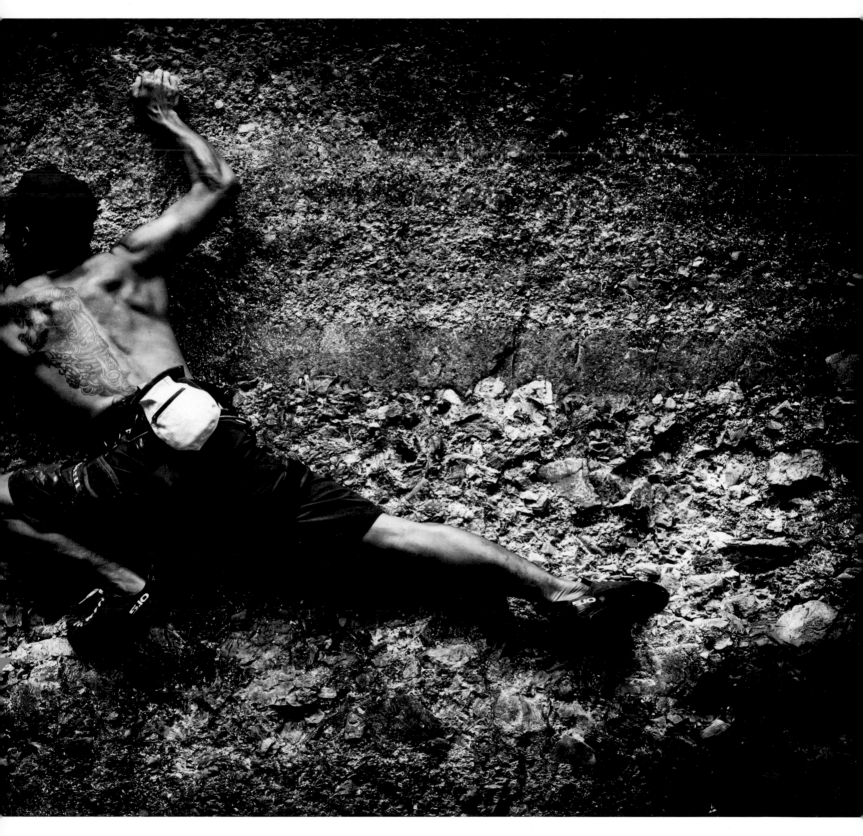

OPPOSITE, TOP: Hands of climber Rob Pizem after climbing
the 5.12 route the Evan, South Platte, CO, USA
OPPOSITE, BOTTOM: Christina Durtschi bouldering on Jim V4,
Little Cottonwood Canyon, Salt Lake City, UT, USA
ABOVE: Local climber Alphin Alfiandi warming up on
Echo Wall, Harau Valley, Indonesia

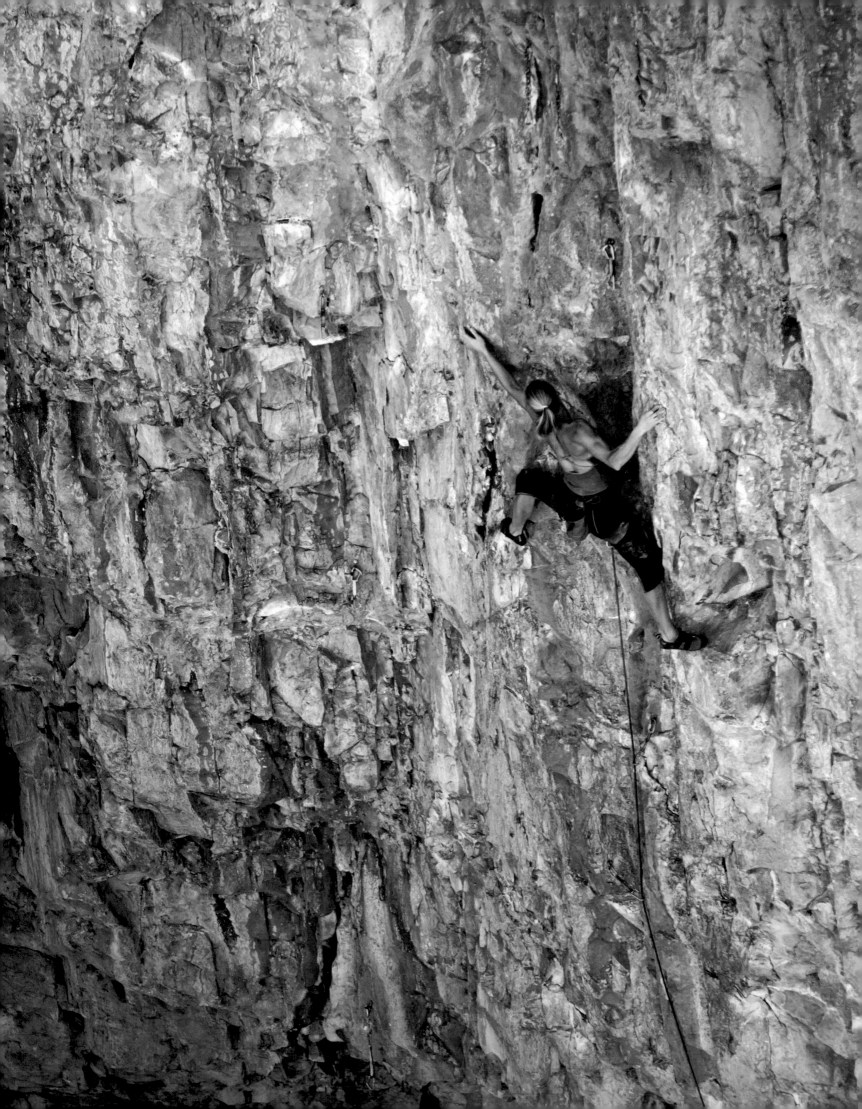

A DANCE BETWEEN LIGHT AND DARK

IMPOSSIBLY FAR FROM THE LAST BIT of protection, a tipped-out TCU is nestled in a greasy crack. Her eyes scan the wall, trying to decipher the code. Hips shift, then ever so slightly pivot over her toes, establishing their purchase before a controlled arm leads her fingers to a micro edge. It's no thicker than a credit card. With aperture wide, I train my lens on her eyes; they burn with such intensity, it's as if she is willing the stone into submission. And she seems to be winning. I press the shutter and activate the strobe—just a single Speedlite rigged a few feet off the wall and hundreds of feet above the ground. It's enough. The shot is made.

As athletes reach into the depths of their courage and heights of their ability, there are moments in which the magnitude of their strength and will align, their "lightness of being" revealed. These fleeting moments often fuel athletes to push themselves ever further. Witnessed from the ground, these achievements are exciting. As I dangle only a few feet above a climber, these moments are shared. And that's pretty damn inspiring.

Photography is, in general, about capturing the intricate dance between light and dark. Duality also exists on a route, climber and rock playfully challenging each other. Relationships develop between artists and their cameras, subjects and their environments, climbers and sequences of holds.

Athletes who push themselves to extremes are intimately familiar with the delicate balance between strength and ease and the inevitable definition of character that results. As a photographer who documents their adventures, I am constantly immersed in a similar process: adapting myself and my camera to new and changing environments, witnessing and experiencing the momentary self-realizations that change a person forever.

Sure, getting up before dawn to haul heavy equipment hundreds of feet up a wall—often in adverse weather conditions—and then dangling from a 9mm cord for hours on end isn't for everyone. For me, it's a dream. I thrive on hitting the edge of my physical, mental, and sometimes spiritual boundaries and moving past these perceived limits.

More often than not, the dark means bitter cold—and as a team huddles around a small stove watching the barometer drop and the next storm roll in, sometimes all you can do is laugh. There is art in suffering. The natural rhythms of this earth pay no attention to human yearnings, and the daily cycles between light and dark never cease.

To make an image that captures these moments is forever inspiring. To have an understanding of the constant play between light and dark translates into all other parts of my life.

As a climber, I find the sport to be as much about freedom of expression as a test of personal fortitude. Through a specific sequence of holds, a puzzle is decoded—and each climber experiences a different personal journey to the top.

As a photographer, I am always exploring self-expression and pushing the limits of what I—and my camera—can do. My personal journey includes alpine starts, extreme weather, and harness-chapped cheeks.

What does yours include?

—DAN HOLZ
Photographer

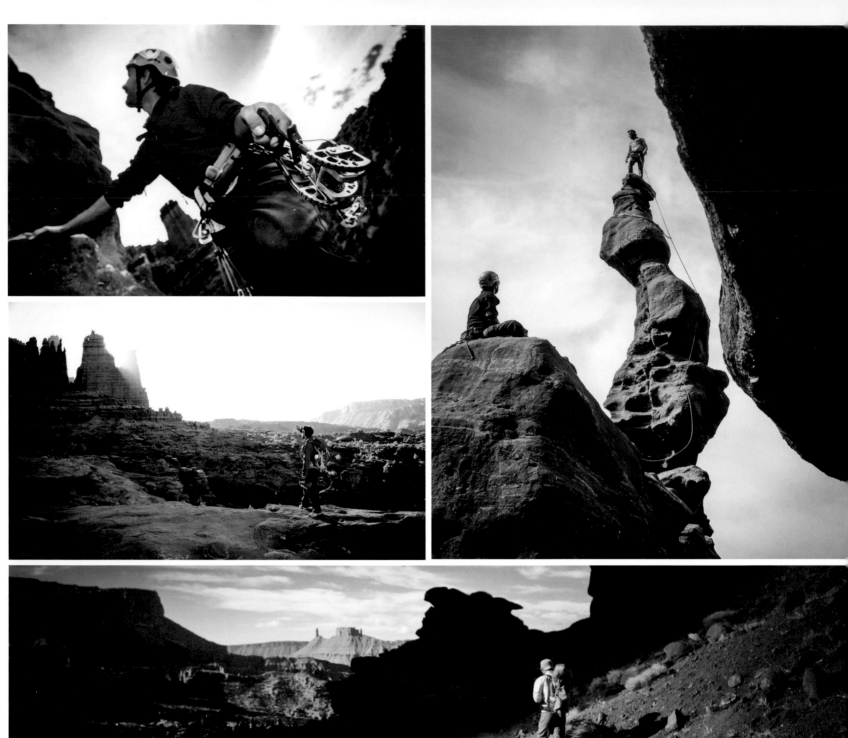

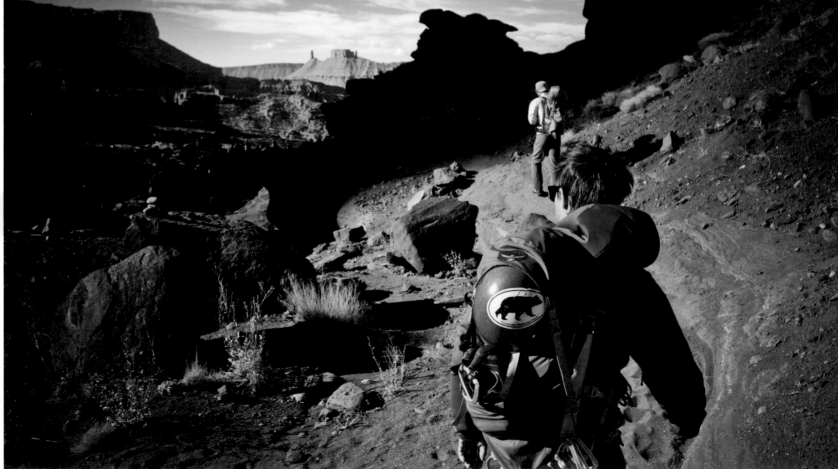

ABOVE, LEFT TO RIGHT, TOP TO BOTTOM: Kaare Iverson racks up his gear at the base of a tower climb with Fisher Towers in the background, Moab, UT, USA; Sam Feuerborn on the final pitch of the classic tower climb, Ancient Art, Fisher Towers, Moab, UT, USA; Kaare Iverson on his approach, Fisher Towers, Moab, UT, USA; Sam Feuerborn on his approach, Fisher Towers, Moab, UT, USA · OPPOSITE: Sam Feuerborn climbs the 5.11a single pitch mini-tower Cobra, Fisher Towers, Moab, UT, USA

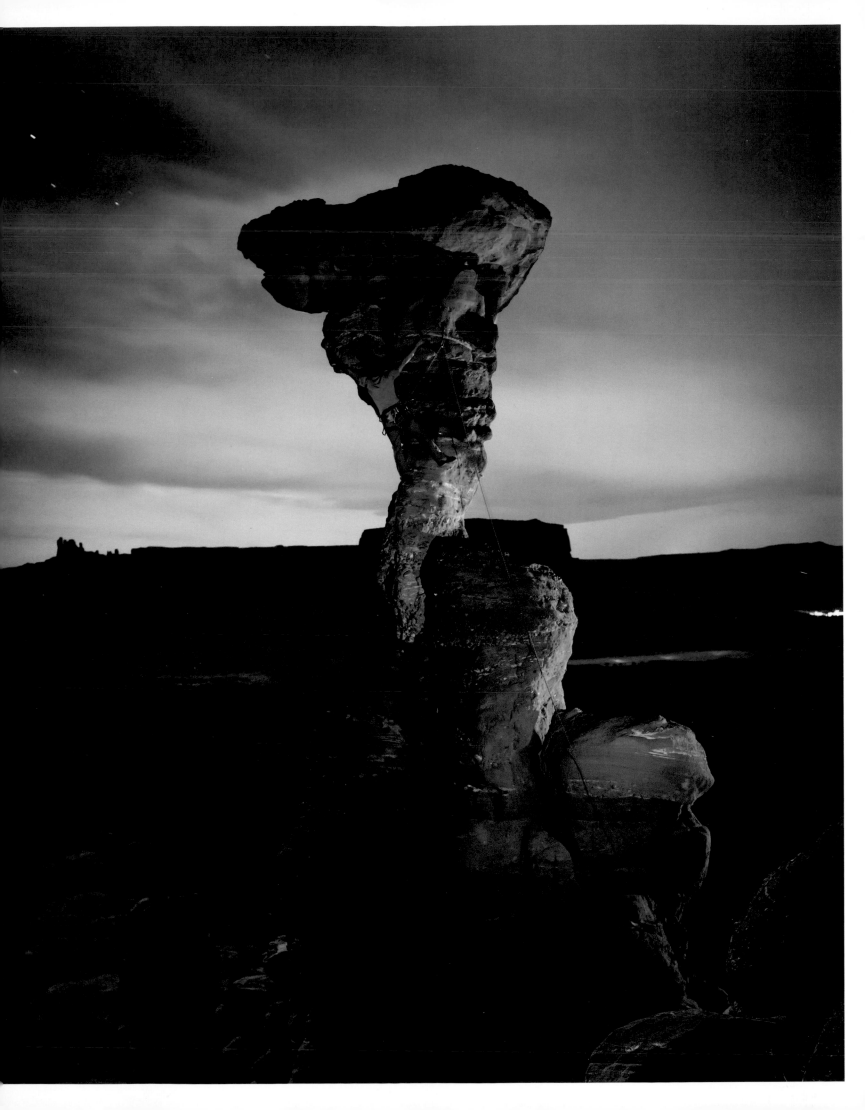

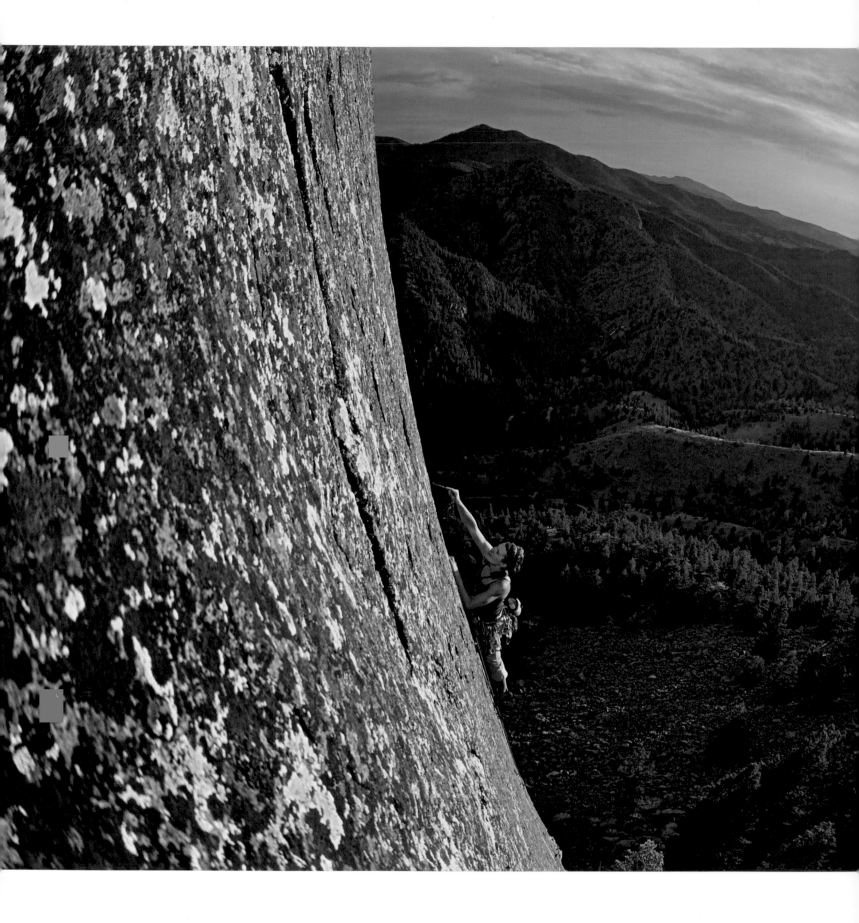

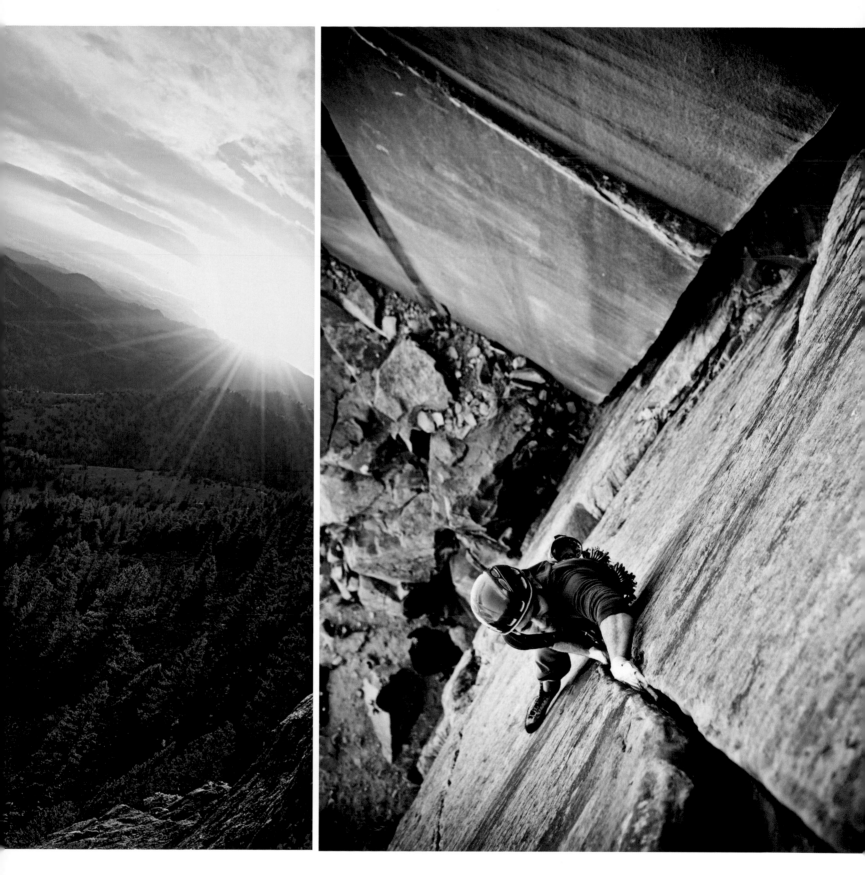

OPPOSITE: Majka Burhardt climbing Over the Hill, a 5.10b
route on the Rincon Wall in Eldorado Canyon, CO, USA
ABOVE: Reaching for interesting angles on a 5.10 crack in
Indian Creek, UT, USA

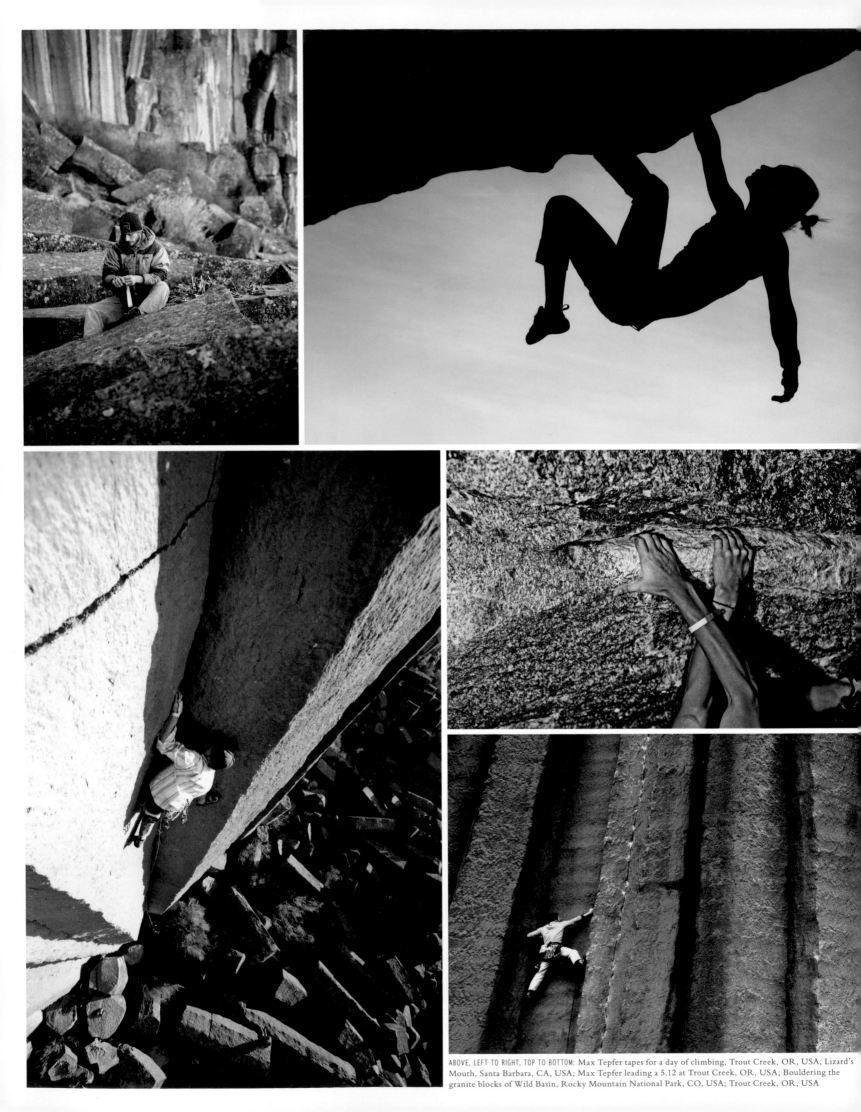

ABOVE, LEFT TO RIGHT, TOP TO BOTTOM: Max Tepfer tapes for a day of climbing, Trout Creek, OR, USA; Lizard's Mouth, Santa Barbara, CA, USA; Max Tepfer leading a 5.12 at Trout Creek, OR, USA; Bouldering the granite blocks of Wild Basin, Rocky Mountain National Park, CO, USA; Trout Creek, OR, USA

IMAGES AS CONDUIT

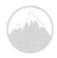

WHY DO I SHOOT PHOTOS? Why do I continually engage wildernesses as a photographer, guide, writer, traveler, and dreamer? Because I have no choice. . . .

Every hiatus from the outdoor life leaves me starving for the renewed connection. It is sustenance on a cellular level. When I crossed an invisible threshold into the world of technical rock climbing two decades ago, I could not transit back to the "normal" world for long. . . . My soul had been willingly sold. The door does not swing both ways for me and remains eternally open—an invitation to continually plan and engage the next steps into the unknown.

Climbing in remote regions, deciphering the lessons learned in the afterglow of the experience, and then applying these lessons are sacred activities. A meditation. Climbing has become a dialogue with my own fears and lurking anxiety. *Will this kill me?* No. Press on. This ability to persevere, to identify risk, and to stay calm by dint of hard-won perspective in the swirl of life-extinguishing extremes has offered illumination. It operates and delivers on so many levels—community, flow, trust, connection, exploration—the simple act of climbing and the desire to "be there" continues to drive and inspire me as intensely as ever.

In successful climbing, anticipation of potentials and being alert to changes, combined with dogged perseverance, creates "luck." I believe this is true for a successful image as well. I am not looking to create moments, but to be attentive to the unfolding of diverse elements and a perceived potential harmony in convergence. If I can place myself at this nexus, I can be successful. In this way, both photography and climbing

become an act of dynamic creation far larger than myself and the individual pieces. This I strive for both as climber and documenter.

Holding a camera in intense situations provides an opportunity to step outside of my own fears and doubts and better engage the world on a more elemental level. It has a calming effect and allows me to be more objective and mechanical—and not be overwhelmed by "what ifs?" Perhaps it is counterintuitive, but it allows for a convergence of focuses rather than a divergence into distraction. The camera in the right circumstance becomes a tool to better engage the unfolding moment and anticipate what may happen next.

Is it restless DNA? Have I been bitten and infected by wanderlust? Is it the albatross around my neck that pulls me ever further? Perhaps it is that my wilderness muse and siren will not be silenced . . . I really have no good answer, excuse, or reason. No other justification for my selfish desire to suffer, sweat, bleed, spike adrenaline, engage endorphins, and document—except that I simply must. Sharing assuages some of the guilt of sacrificed relationships in the "average" life that I have had to let go of. I admit, this exploration is fuel for forgetting, reinventing, and renewal.

The sharing of worlds and experiences that are so distant and seemingly intangible for so many, yet so precious and so threatened, drives me to want to document and share. Whether it's trekking to ancient villages in the high Andes and striving to gain a personal and shared understanding of issues tied to climate change and ecotourism, or more recently working with nonprofits and communities in conflict in Africa to empower

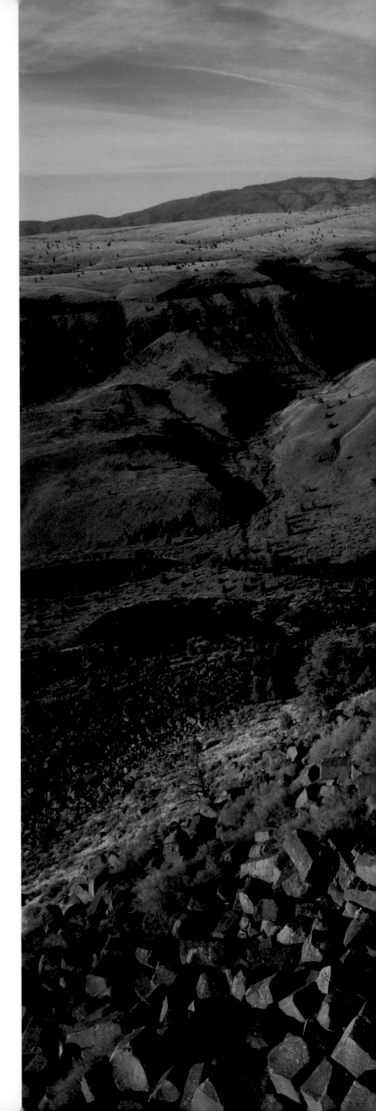

extremely economically challenged youth, I am engaging the same basic philosophy of more than two decades that came from tying in and lead climbing for the first time.

As an outdoor and experiential educator and backcountry guide, my goal has been to empower clients by helping them build confidence and added fluency in the language of wilderness adventure through personal engagement and connection. I dream that the sharing of my images can do this, too—or at least offer a conduit, build a synaptic thread that will spark the leap from the ordinary and the known into a crucible where magic can happen—that threshold crossed where we step into new spots on the map of our collective experience. I want to reach the slumbering feelings and emotions trapped in the suffocating comfort that is so intrinsic to the urbanized and modern world.

When wonder, beauty, awe, fear, and joy are undeniably reinvigorated and sought after, a necessary conversation begins again. Then the real work of conservation and preservation of these feelings, and by extension these places and populations, begins. This is my ultimate goal, that I will inspire intelligent dialogue and drive the viewer to his or her own explorations, that will by extension drive awareness and conservation on a much larger scale—to help others "see," and to spark action with my images and work.

—BENNETT BARTHELEMY
Photographer

OPPOSITE: Trout Creek, OR, USA

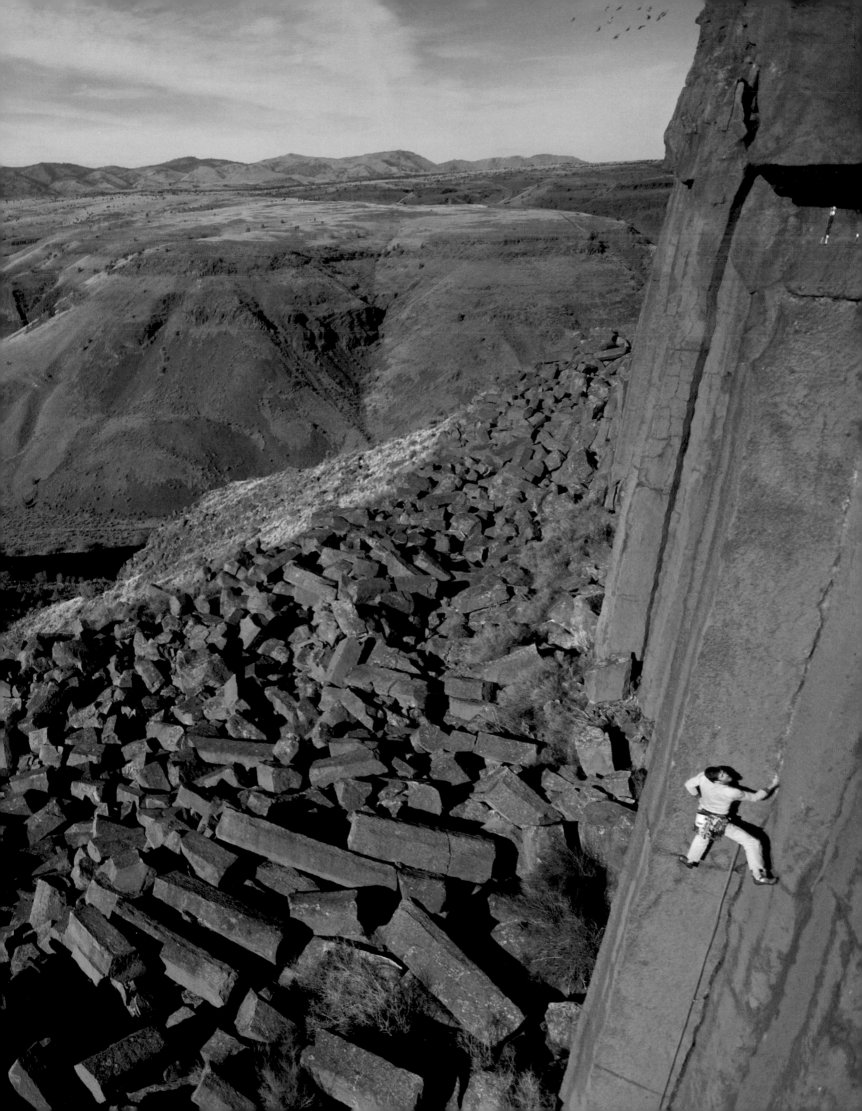

 # MOUNTAINEERING

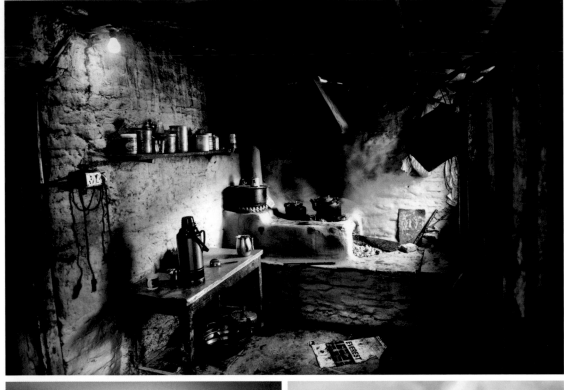

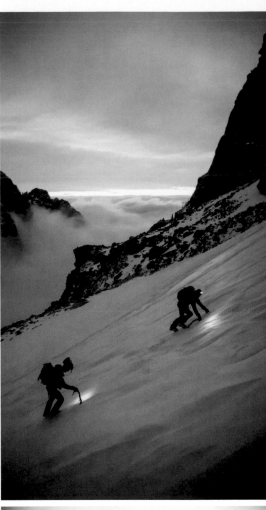

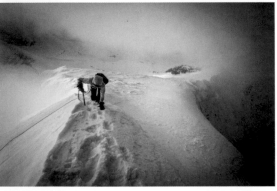

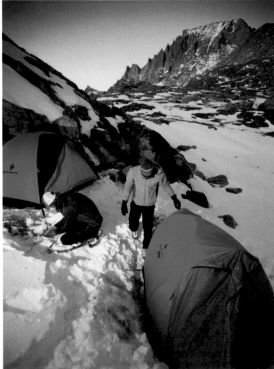

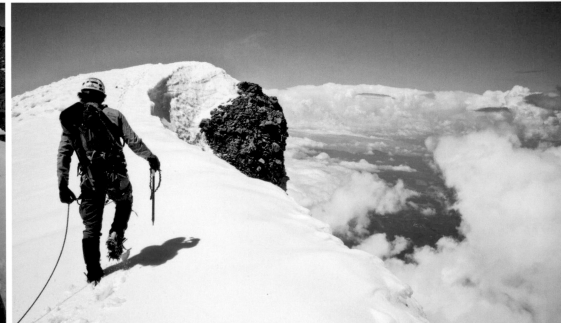

ABOVE, LEFT TO RIGHT, TOP TO BOTTOM: Shelter on the path to Mount Everest base camp, Nepal; Winter ascent of Nez Perce, Grand Teton National Park, WY, USA; Winter mountaineering deep in Glacier National Park, MT, USA; Sagarmatha National Park, Himalaya Mountains, Nepal; Everest base camp, Khumbu Valley, Nepal; Titcomb Basin, Wind River Range, WY, USA; Cooper Spur, Mt. Hood, OR, USA · OPPOSITE: A group approaches the Lyell Glacier, Icefall Lodge, BC, Canada

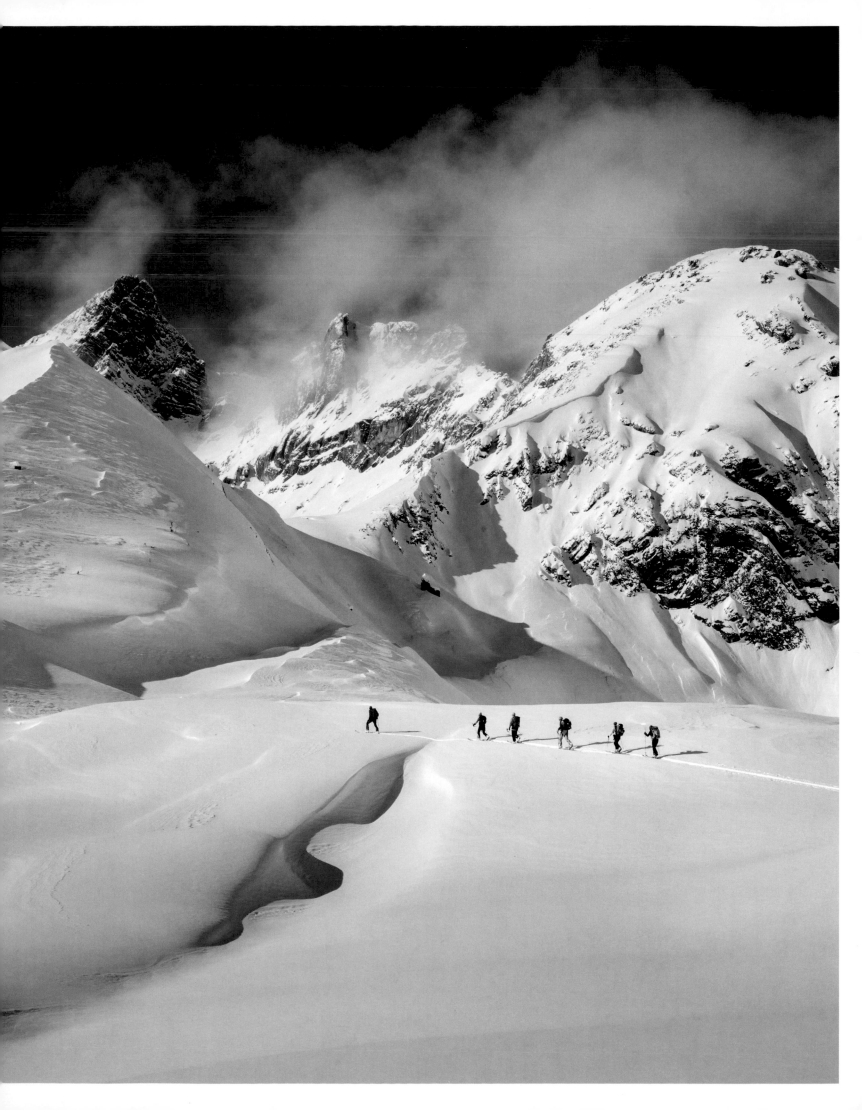

SCARS FROM FALLING DOWN

Dave Cox, *Mountain*

A TRIP WEST FINDS ME STANDING at the peak of Broken Top staring up at the Three Sisters. I had hiked up the more charitable South Sister the day before and wanted to tag all three, but I was talked out of becoming a peak polygamist by an alpinist. The North Sister, known as Faith, stood beyond Sister Hope and was a technical climb not suited for a guy in soft-soled shoes and a flatlander's optimism, I was warned.

But the long ochre glow of midsummer evenings and a low snowfall year had made me cocky. How bad could Broken be? The top of it was blown off. I made my "summit bid" before first light. I enjoyed the view for a bit, then made my descent. After stumbling over more than a few stubborn scree fields, my tired legs came up with a great idea, essentially vetoing my brain's vote: I would glissade down snowfields on my back. Perfect. I'd slide a stretch of snow, arrest by digging in my heels, get up, stumble over the next rock garden, repeat.

Did I mention I was cocky? I hit the next bigger snowy patch and suddenly gathered luger velocity. Time for a speed-checking heel strike, but my Scarpas failed to make purchase. As my speed increased, my digs into the snow became more frantic and pronounced, but each one shot my knee straight up and into my chest. A rock band, which just moments before loomed in the distance, suddenly rose up, its jagged teeth opening for me like an emaciated mountain lion. I started swimming with frantically flailing arms, and my pack ripped off my back. I realized I was slowing as my pack passed me and was ultimately stopped with a sudden violence by the rock's awaiting jaws. I gasped. Both arms were burned, bruised, and bloodied from my wrists to my armpits.

I stumbled into the camp of a couple from Portland. "Where are your crampons and ice ax?" I lied and said I lost them in the fall. They cleaned up the burns on my arms and offered me a cold MacTarnahan's. The wounds have healed over the past nearly twenty years, but I can still see faint marks. Scars from falling down serve to remind me of just how little I know.

When I graduated from Northwestern in the mid-'90s after studying magazine publishing, the logical move was to head to New York, but I made a left turn. Two paths did in fact diverge, and the one least traveled chose me. I'd like to tell you that there was a certain purity in my thoughts and actions. That I would have devoted my career to documenting the natural world and the people interacting within it regardless of circumstance, and that creating *Mountain* magazine was the zenith of my craft. But in reality, I might just be here in a cabin in the pines alongside the Santa Fe National Forest because I wanted to make powder turns and ride uncrowded single track.

The magazine industry has gone through a dramatic contraction over the years, and the role and workload of the magazine art director has echoed the industry. There are fewer magazines, and therefore fewer of us working on them, and we are asked to do more. In the past when I worked at *Outside* magazine there were four art directors, three photo editors, and two production people.

At *Mountain*, those fellow art directors, photo editors, and production people are all gone. I gather most of the photography—I even photograph some myself—I make

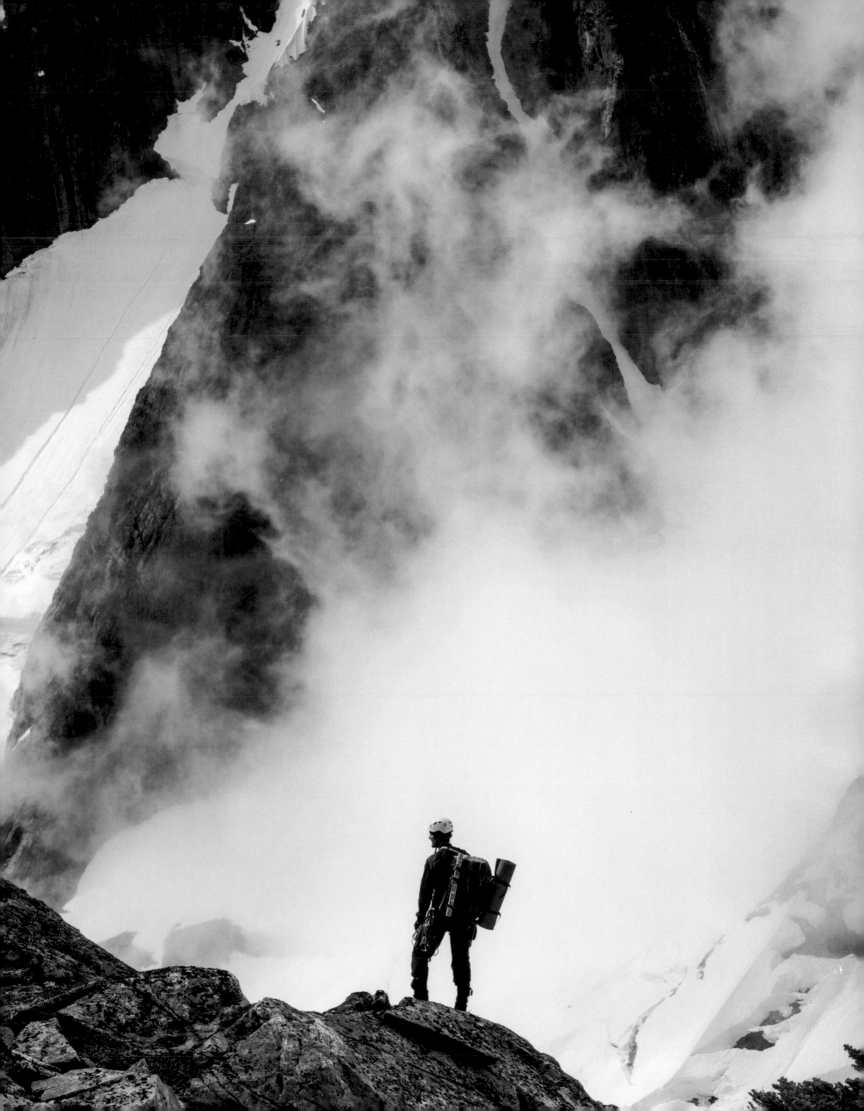

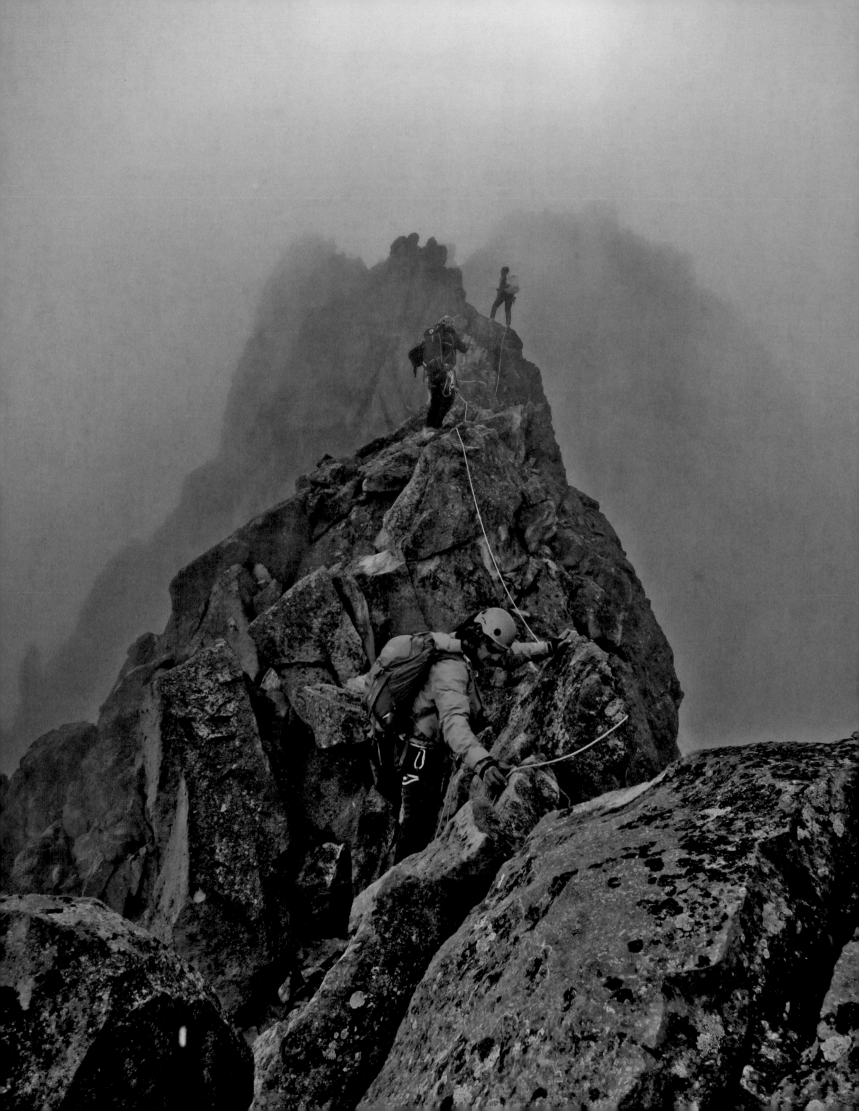

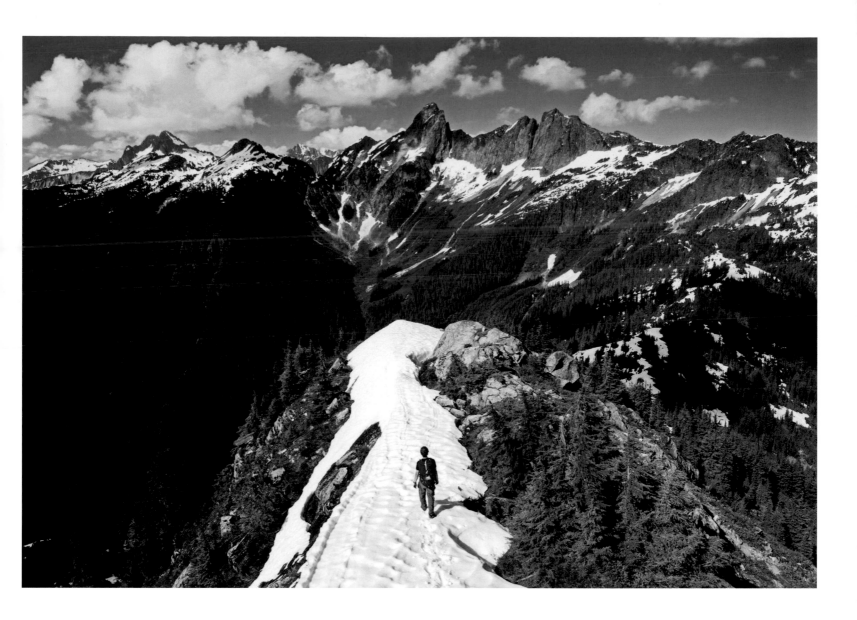

adjustments to the imagery and make press-ready pages. The chain-smoking photo engraver, who knew exactly how much yellow to take away from the sky, is on a beach somewhere, or working at a Walmart, more likely—and I am designing and producing the entire magazine with a safety net that's too small to catch a butterfly.

But don't ask me to hit the rewind button. I don't want to go back. In fall 2013 I was on a trip testing and photographing bikes in Moab, Utah; our 2013 Early Winter issue had a feature I assigned myself—touring and heli skiing in British Columbia; and I'm always scheming up other trips. Meanwhile, I'm learning new skills. Last year I created the tablet/iPad edition of the magazine, and perhaps that will be the catalyst for the growth of small, niche magazine like ours that are devoted to big photographs and long reads, but I'm not certain. It seems to me there will always be people who will want to disconnect from the electric devices that pull our

eyes out of their sockets like tilted pinballs and turn to the tactile experience of flipping through a printed magazine or book. But perhaps I'm merely nostalgic.

Or maybe it doesn't matter how the source of inspiration is delivered, just that it is. And maybe all that matters is placing yourself where you need to be to do what you love as often as you can.

As the long cold nights of winter recede with the snowpack and lengthening days greet another New Mexico spring, ski lines give way to red rock single-track ribbons. A Santa Cruz Bronson—one last holdout from the Moab test—waits outside along with my two psychotic birddogs, Hank and Daisy. With luck, there'll be no crashes today—I'm a passionate if not fluid mountain biker who has collected more than his share of scratches and dents along the way.

OPPOSITE: A team climbs the technical Batian summit ridge, Mt. Kenya, Kenya, Africa
ABOVE: Damnation Peak looking toward Mount Triumph, North Cascades National Park, WA, USA

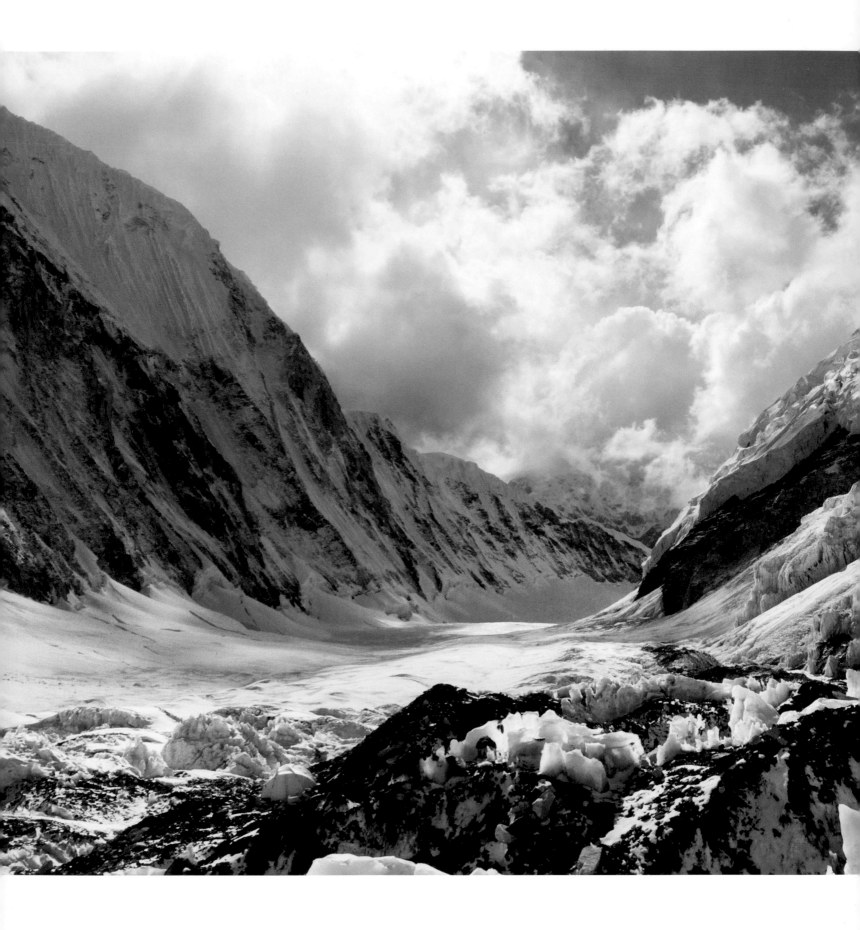

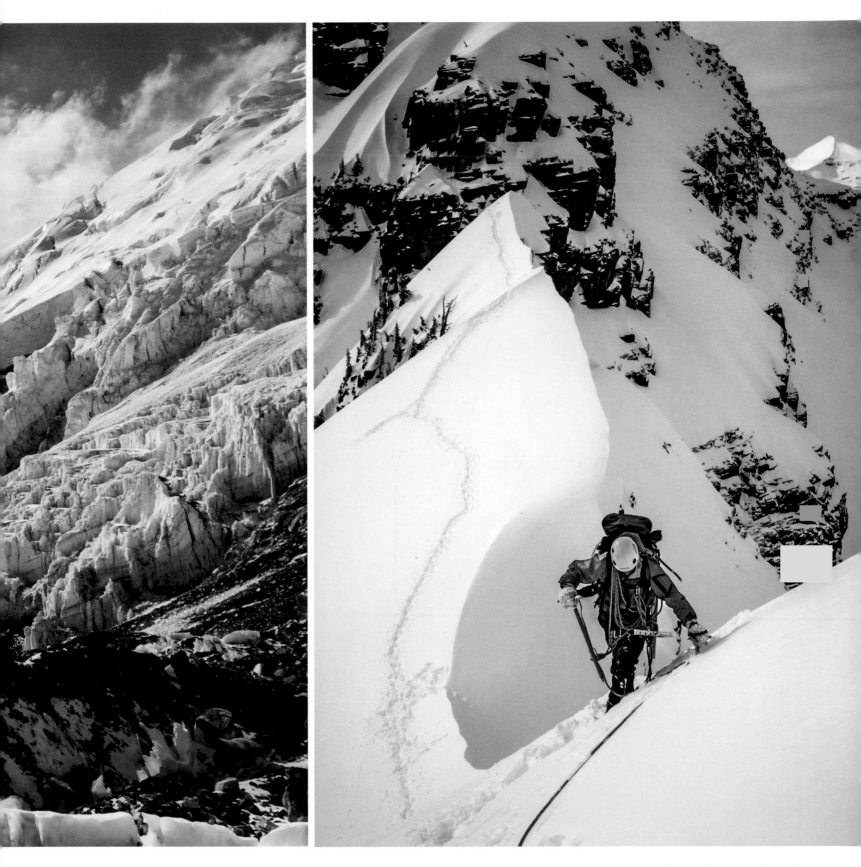

OPPOSITE: Upper Khumbu Glacier, Mount Everest, Nepal
ABOVE: Photographer Ben Adkison climbs a snowy ridge
above Swan Valley, MT, USA
FOLLOWING PAGES: Sunset ridge assent, Lake County, MT, USA

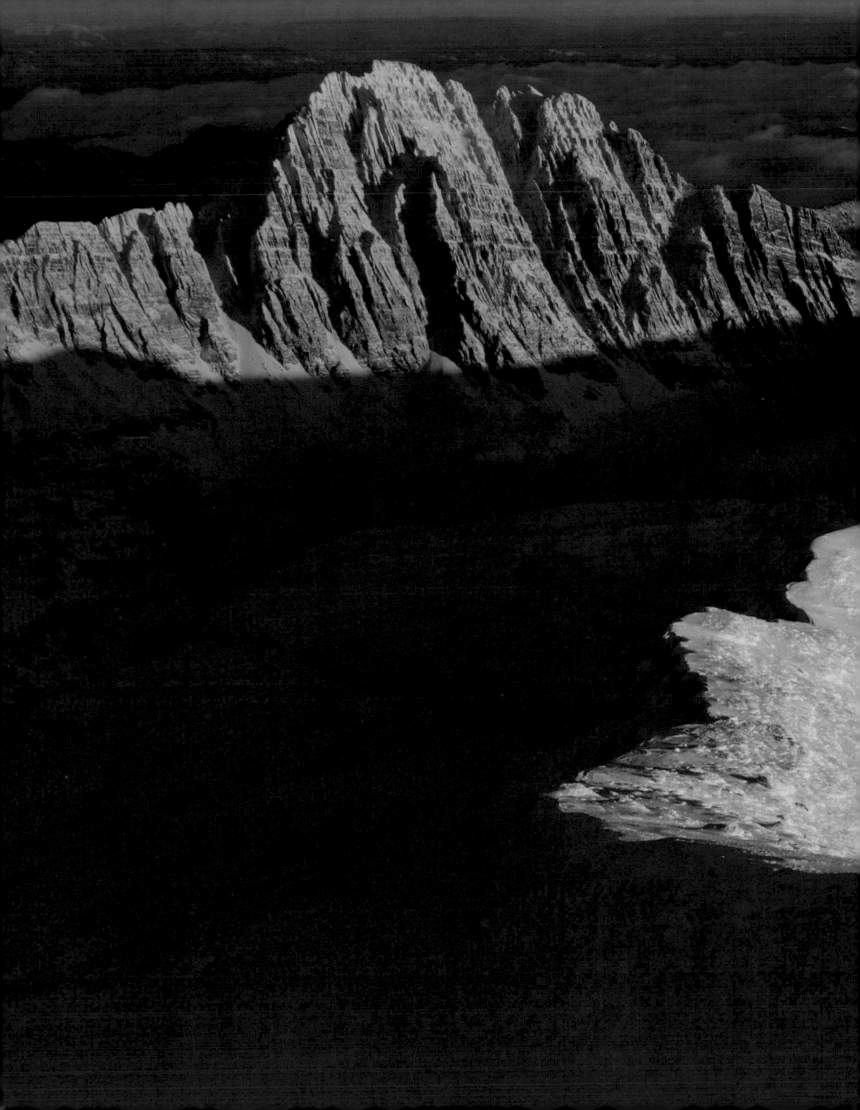

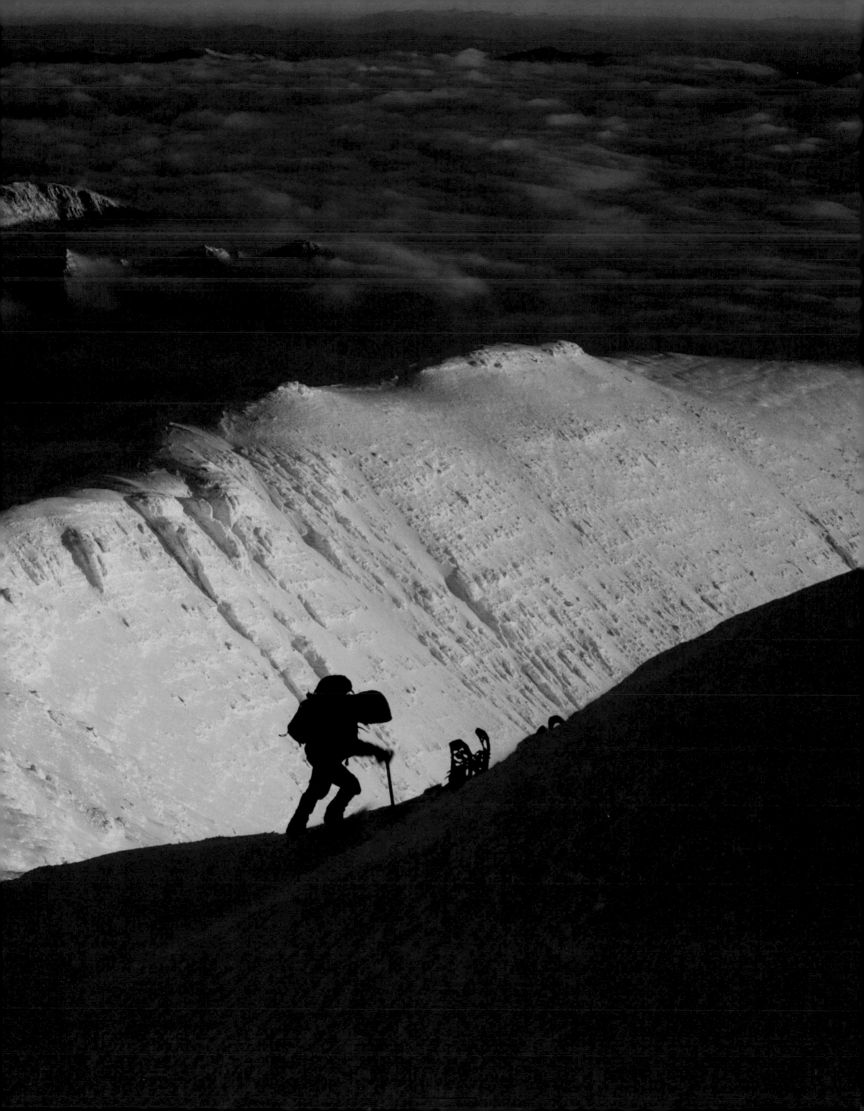

ICE CLIMBING

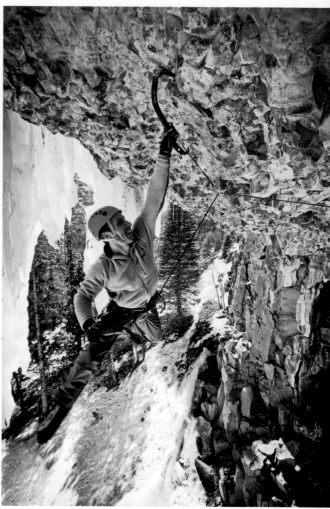

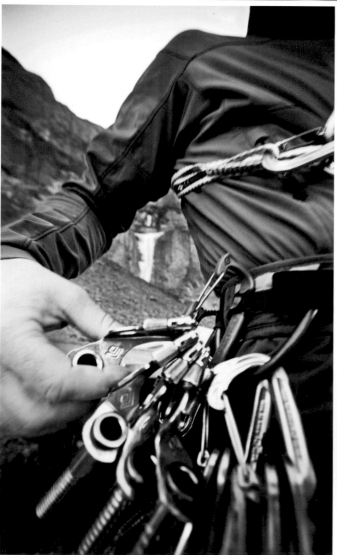

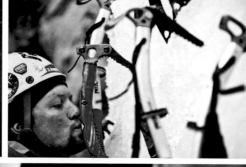

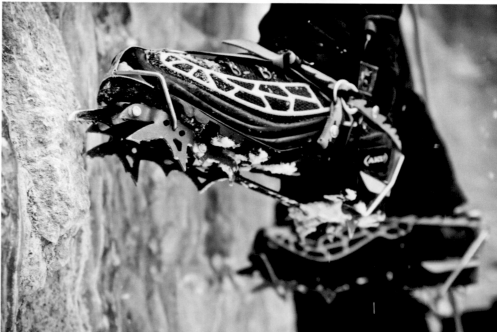

ABOVE, LEFT TO RIGHT, TOP TO BOTTOM: Detail of rime ice, Haffner Creek, Alberta, Canada; Kyle Vassilopoulos making the transfer from rock to ice, Hyalite Canyon, MT, USA; Climber racks up with ice-climbing gear at Banks Lake, WA, USA; Crampon tracks in hardpacked snow, Lewis Range, Glacier National Park, MT, USA; Craig Pope shows some appreciation for his ice tools at Banks Lake, WA, USA; Monopoint crampons looking for a hold · OPPOSITE: Hyalite Canyon, MT, USA

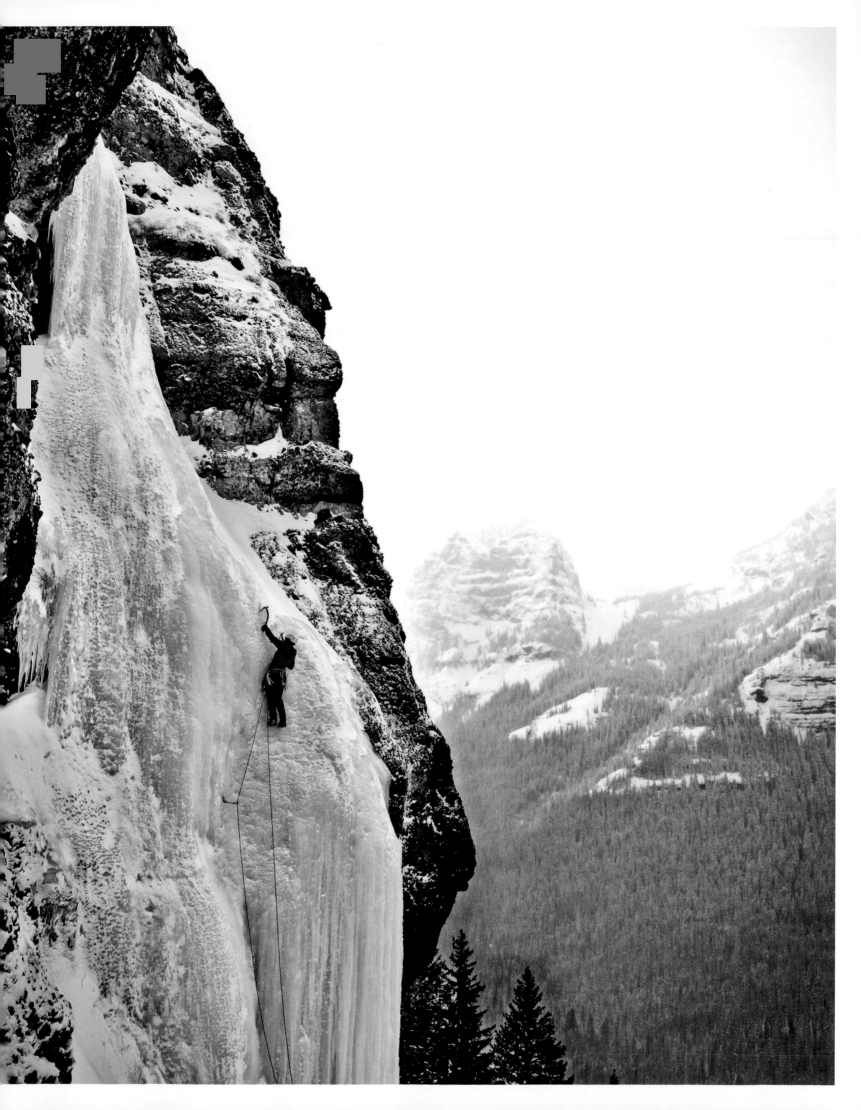

THE HARD-FOUGHT SHOT

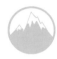

THE ART OF ADVENTURE is the culmination of what I love about photography. Art and adventure are synonymous—people and place coming together in living compositions. Humans in motion interacting with the beauty of the natural world to create a resonance that is visibly transcendent.

Self-awareness isn't what sets us apart from other animals; it's the ability to turn it off. Turn it off and climb unclimbable mountains, kayak raging rivers, run fifty miles across rugged trails, or surf waves capable of swallowing oil tankers. To capture both a uniquely stunning landscape and a person at the peak of mental and physical achievement in wholly unique (and often challenging) weather and lighting, well that's just beer and skittles. And it's worth suffering a little to do those pursuits visual justice.

Manly man Ernest Hemingway once said, "There are only three sports: bullfighting, motor racing, and mountaineering; all the rest are merely games." In a way, this applies to photography, too. Though I can't vouch for bullfighting as a viable subject to base a career in photography on, I appreciate the figurative implications and like the idea of having my business card read: "Ben Herndon ~ Bullfighting Photographer."

Hemingway sets apart those activities because at their core resides the heart of adventure—a heightened risk, a heightened passion for living, and a heightened respect for death. For a photographer, this sometimes means pushing beyond what's comfortable in order to capture the unfiltered spirit of the outdoor lifestyle, shooting with a challenging objective in mind, or following an athlete into impossible situations and returning home with photos that reveal freshly broken boundaries. Other times, simply photographing people immersed in the beauty of the natural world is enough to stoke the spirit of adventure.

Regardless of motive, though, the playground is the same—granite spires, desert canyons, cirrus-streaked skies, and boiling rivers—all canvases awaiting a subject.

—BEN HERNDON
Photographer

OPPOSITE: Josh Granberg climbs by headlamp on a picked-out Genesis I, Hyalite Canyon, MT, USA

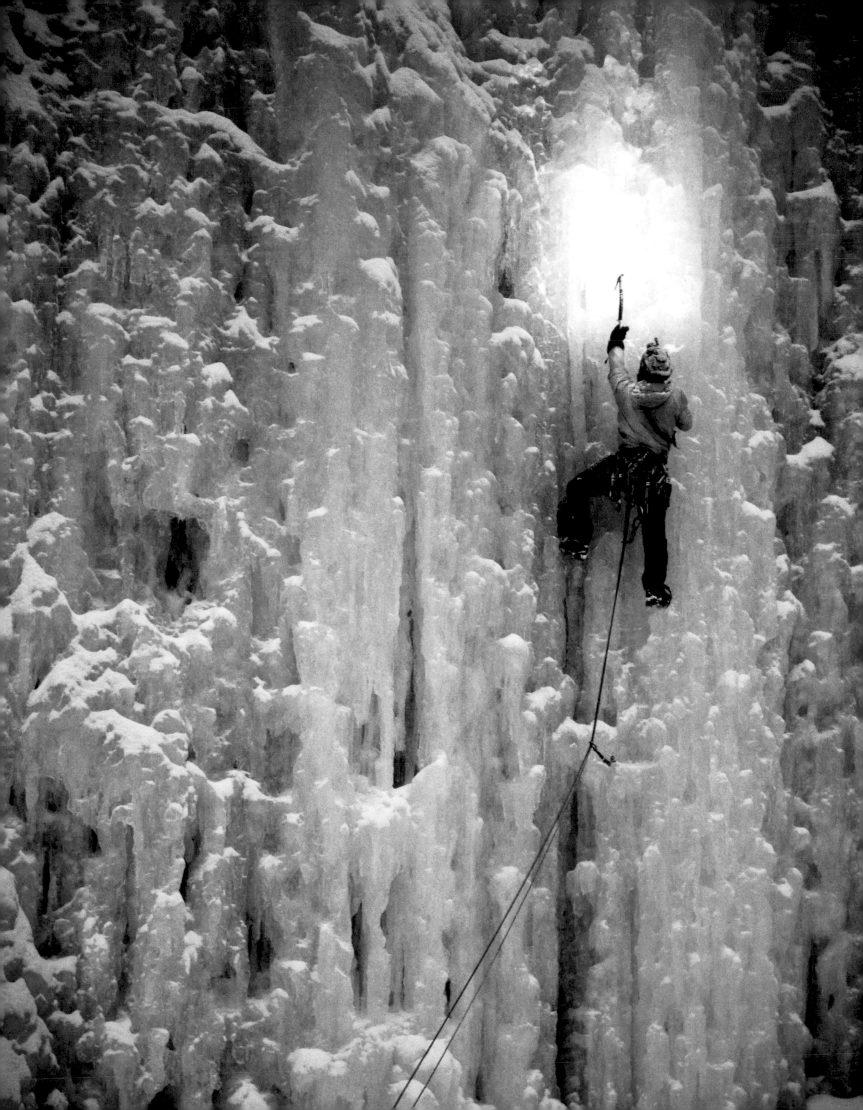

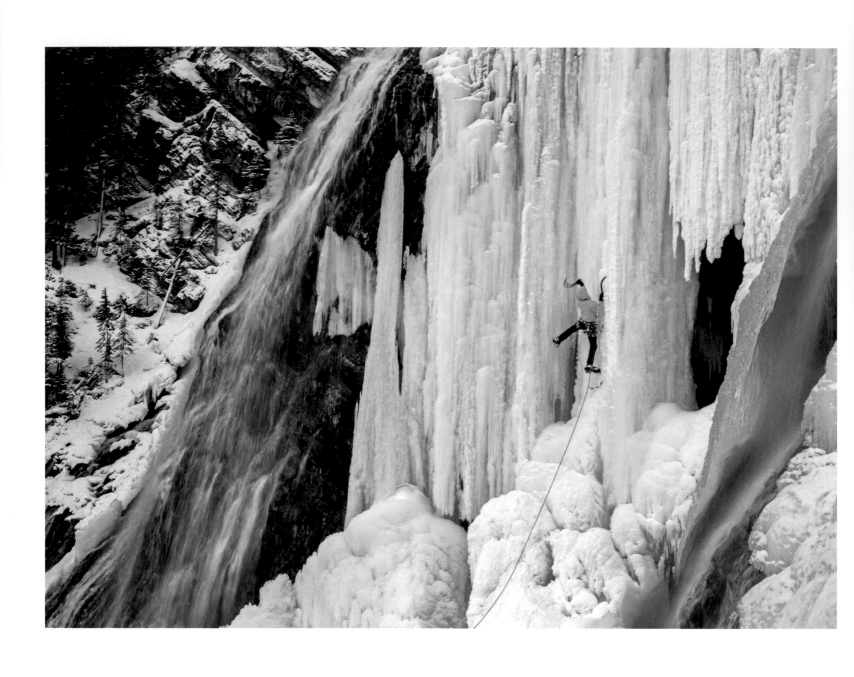

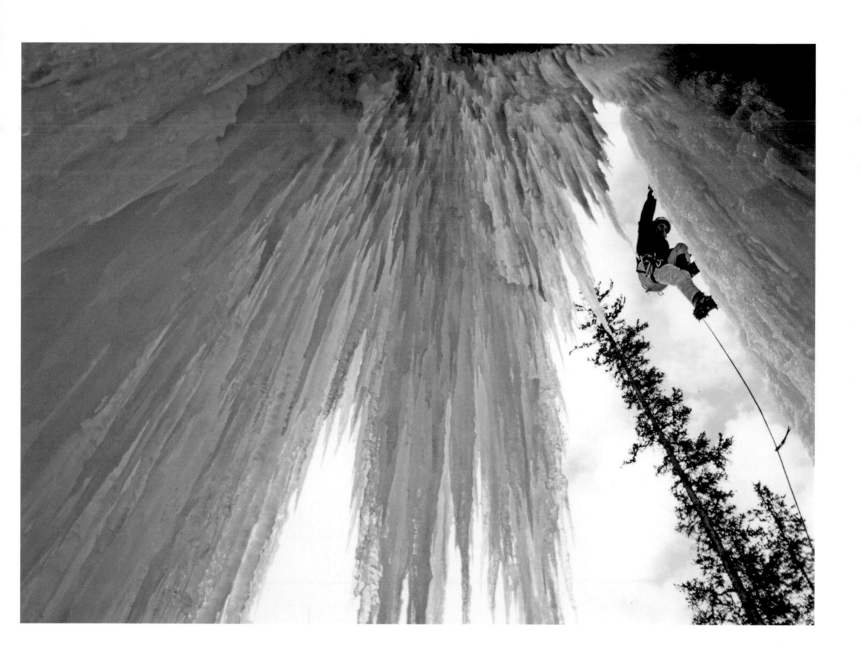

OPPOSITE: Jess Roskelley climbing a beautiful line in between
flowing waterfalls at the Junkyard, an ice-climbing crag near
Canmore, Alberta, Canada
ABOVE: Ice climber on a blue curtain of ice near Banff,
Alberta, Canada

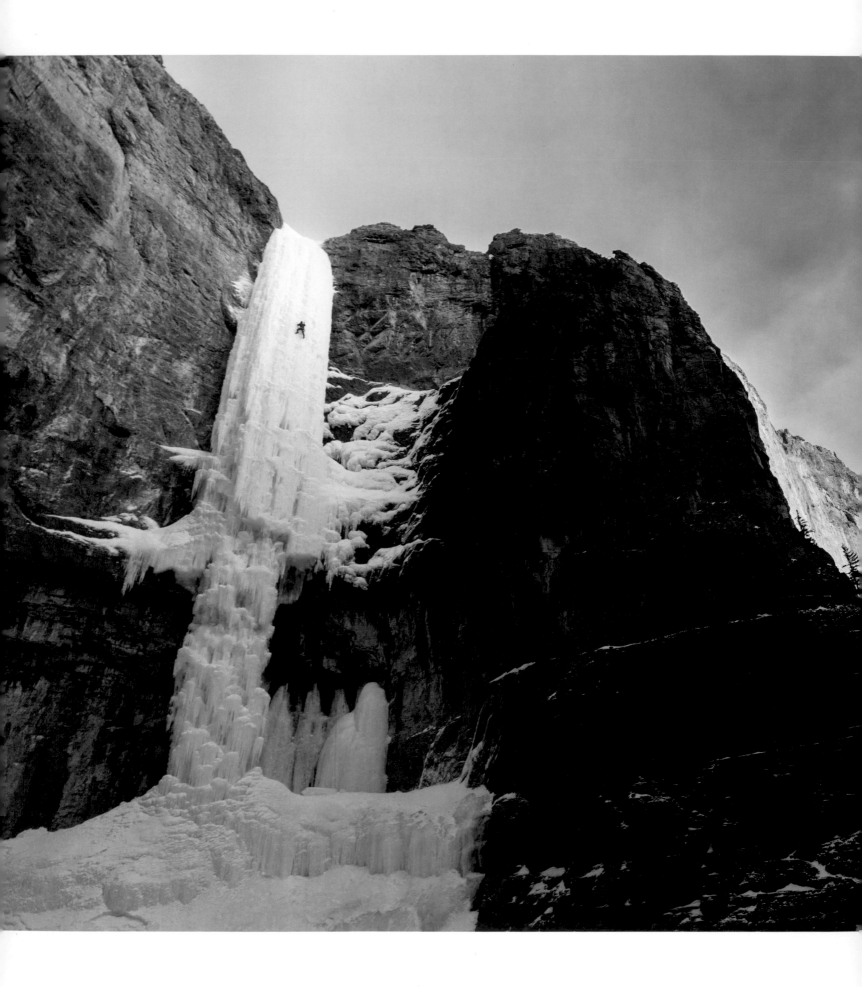

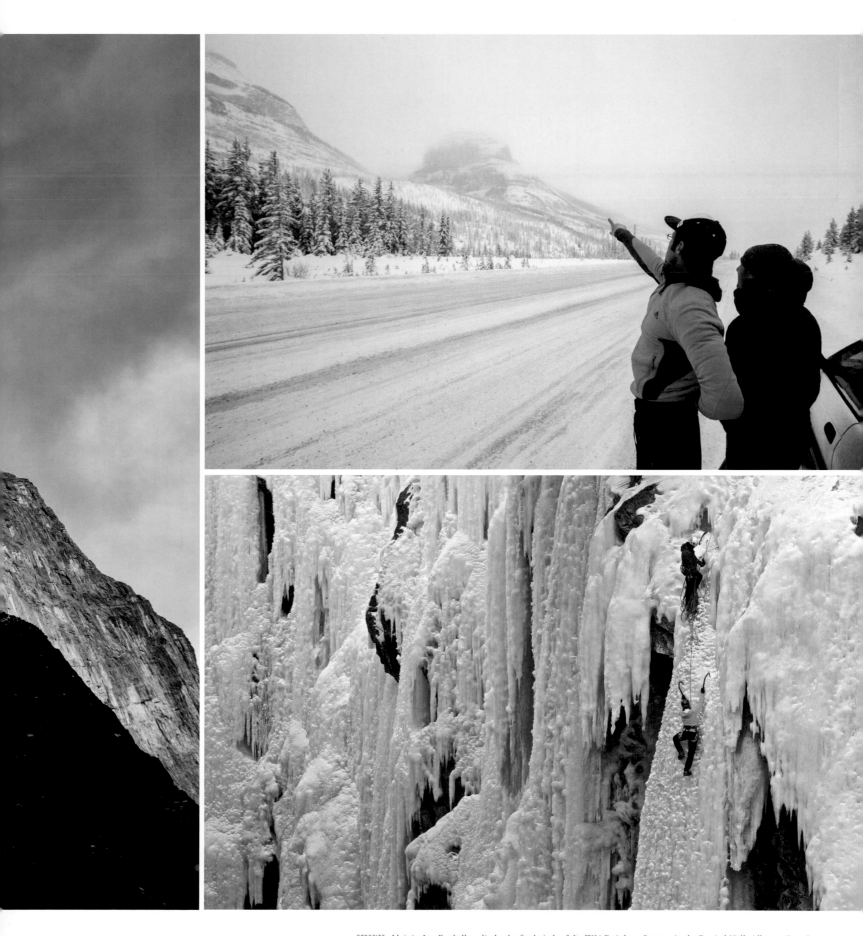

OPPOSITE: Alpinist Jess Roskelley climbs the final pitch of the WI6 Rainbow Serpent in the Recital Hall, Alberta, Canada
TOP: Jess Roskelley and Kyle Vassilopoulos scout alpine ice on the Stanley Headwall near Banff, Alberta, Canada
ABOVE: Chad Peele belays Althea Rogers during a day of ice climbing at the Ouray Ice Park, CO, USA

131

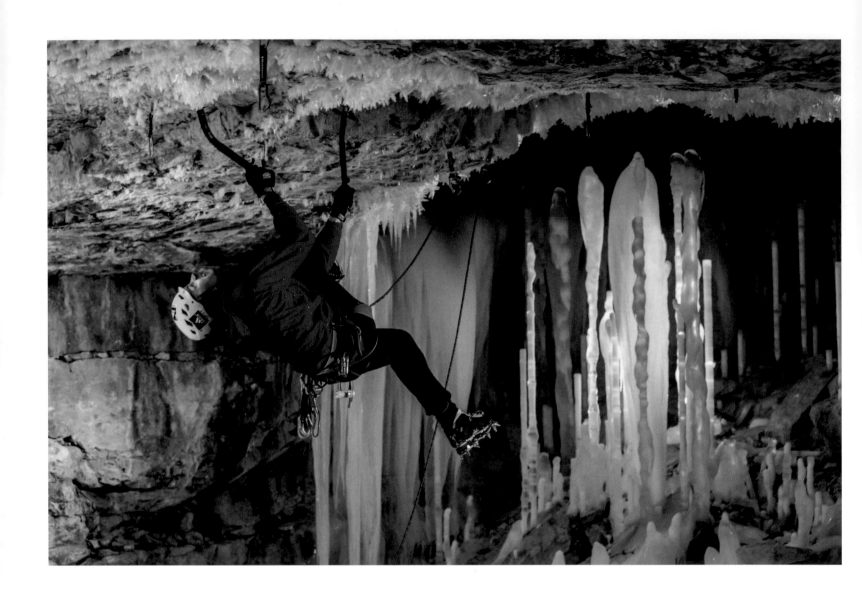

ABOVE: Lights illuminate unique ice stalagmites while climber Jess Roskelley gets primitive on Caveman, a hard mixed climb at Haffner Creek near Banff, Alberta, Canada
OPPOSITE: Jess Roskelley on the Cable in sustained WI5+ conditions, WA, USA
FOLLOWING PAGES: Kyle Vassilopoulos climbs Inglorious Bastards M12 in Bozeman, MT, USA.
Considered one of the most difficult climbs in the world, Kyle completed the second-ever ascent.

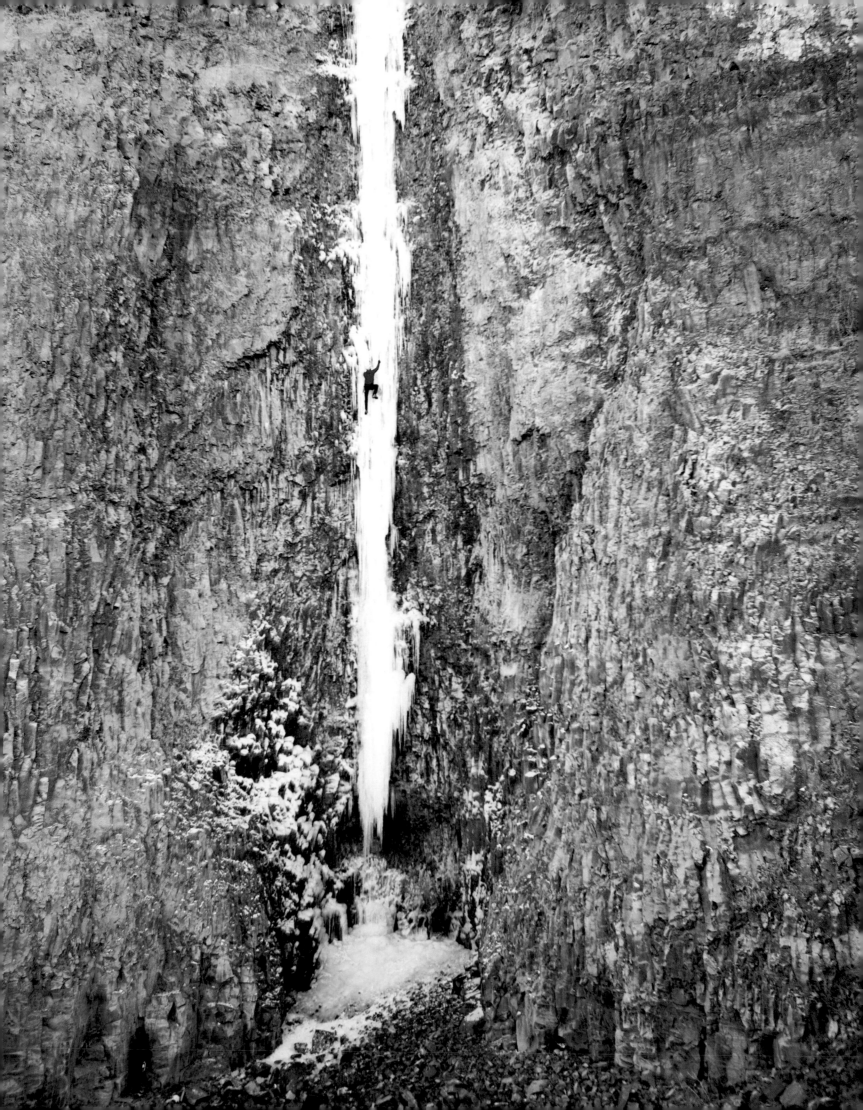

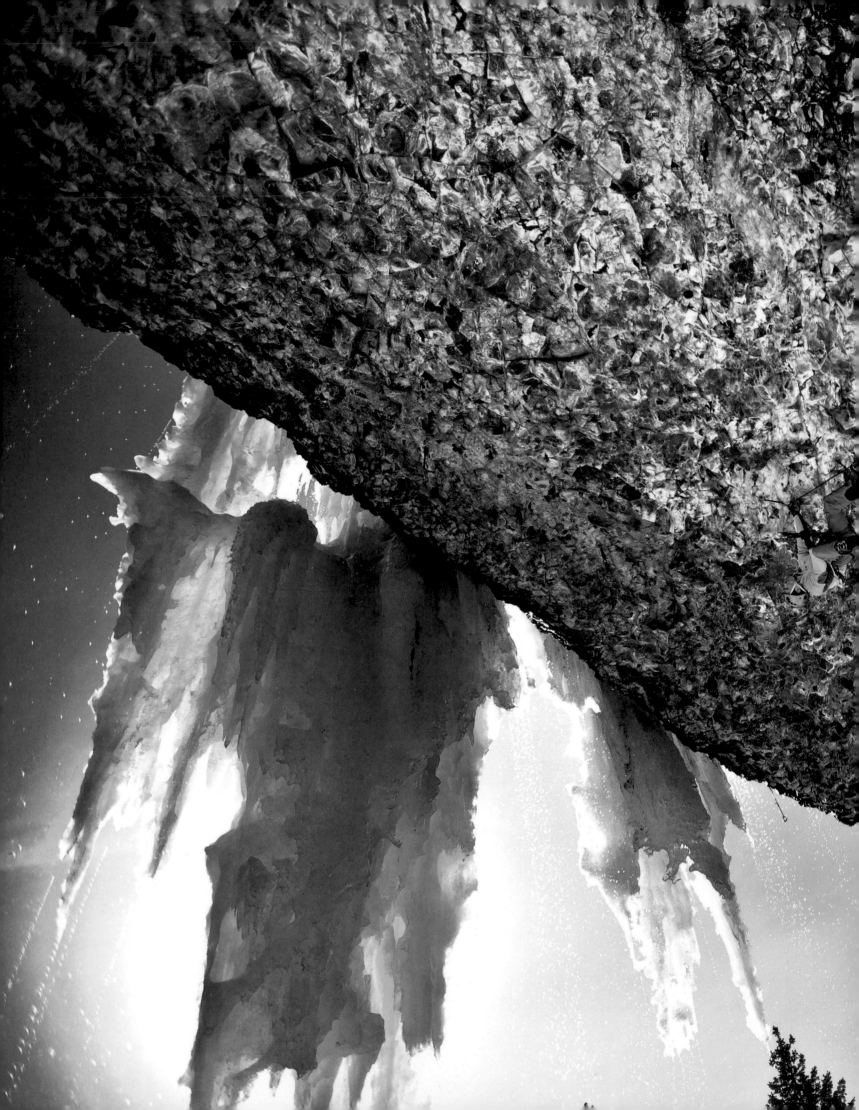

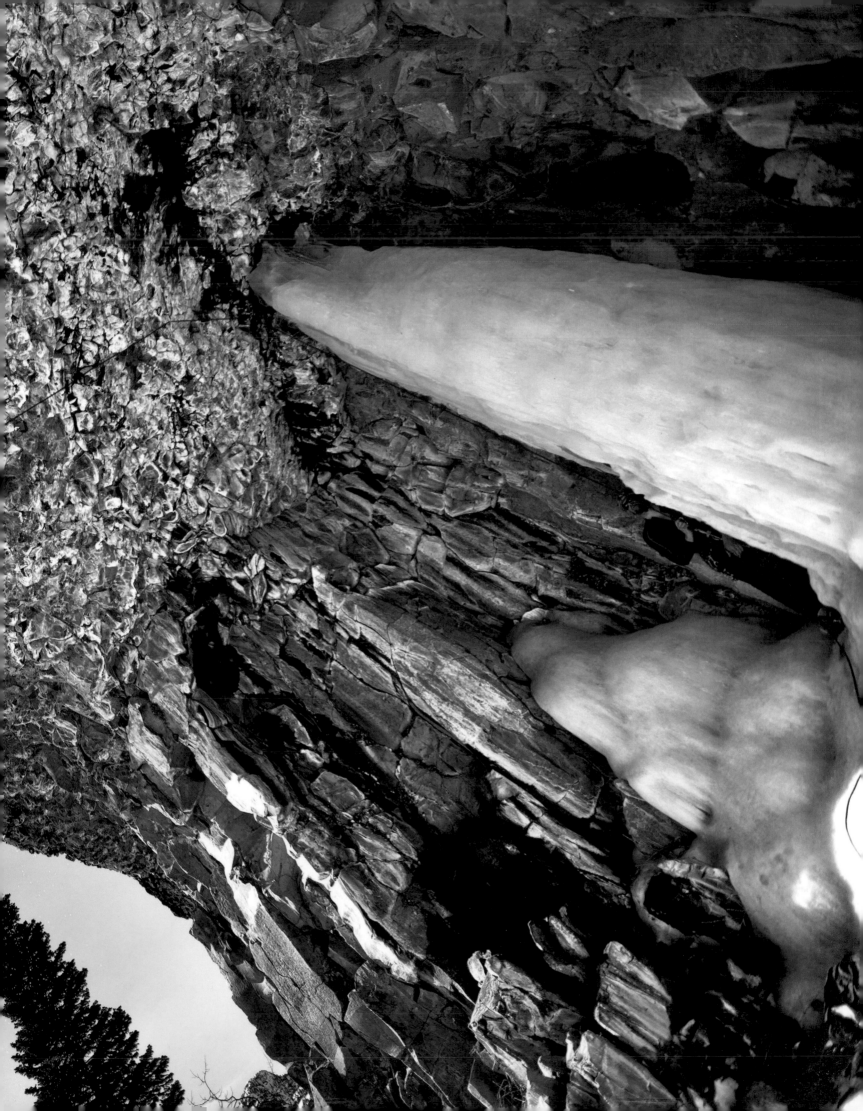

MOUNTAIN BIKING

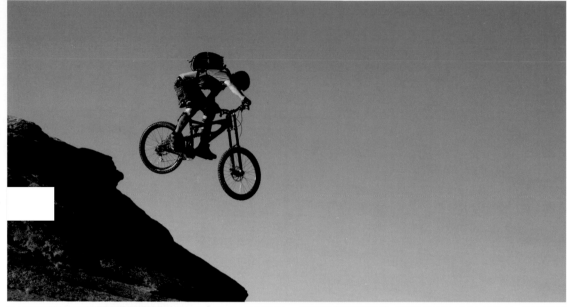

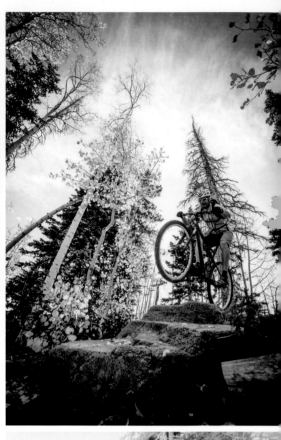

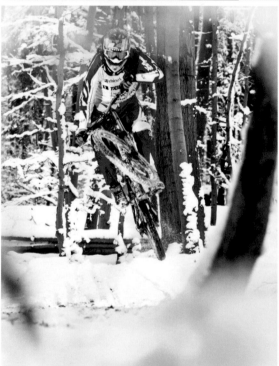

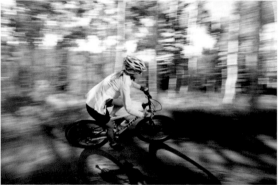

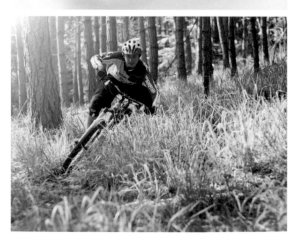

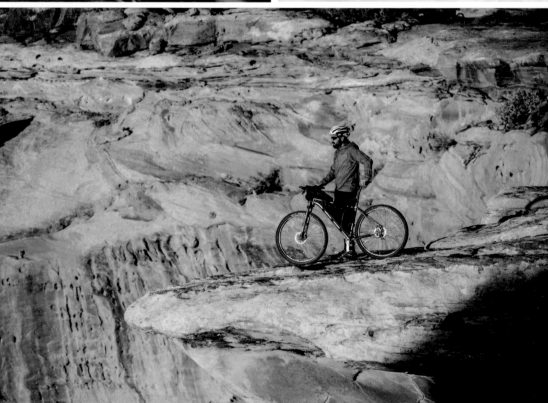

ABOVE, LEFT TO RIGHT, TOP TO BOTTOM: Slickrock Trail, Moab, UT, USA; Brian Head Mountain, Iron County, UT, USA; Riding snowy single track in Korb, Germany; Deer Valley Resort, Park City, UT, USA; Laurin Bettermann riding through the deep snow in Albstadt, Germany; Stefan Frost enjoying a summer ride near Stuttgart, Germany; Canyonlands National Park, UT, USA · OPPOSITE: Owen Dudley rides a rock drop in the Pacific Northwest rainforest near Bellingham, WA, USA

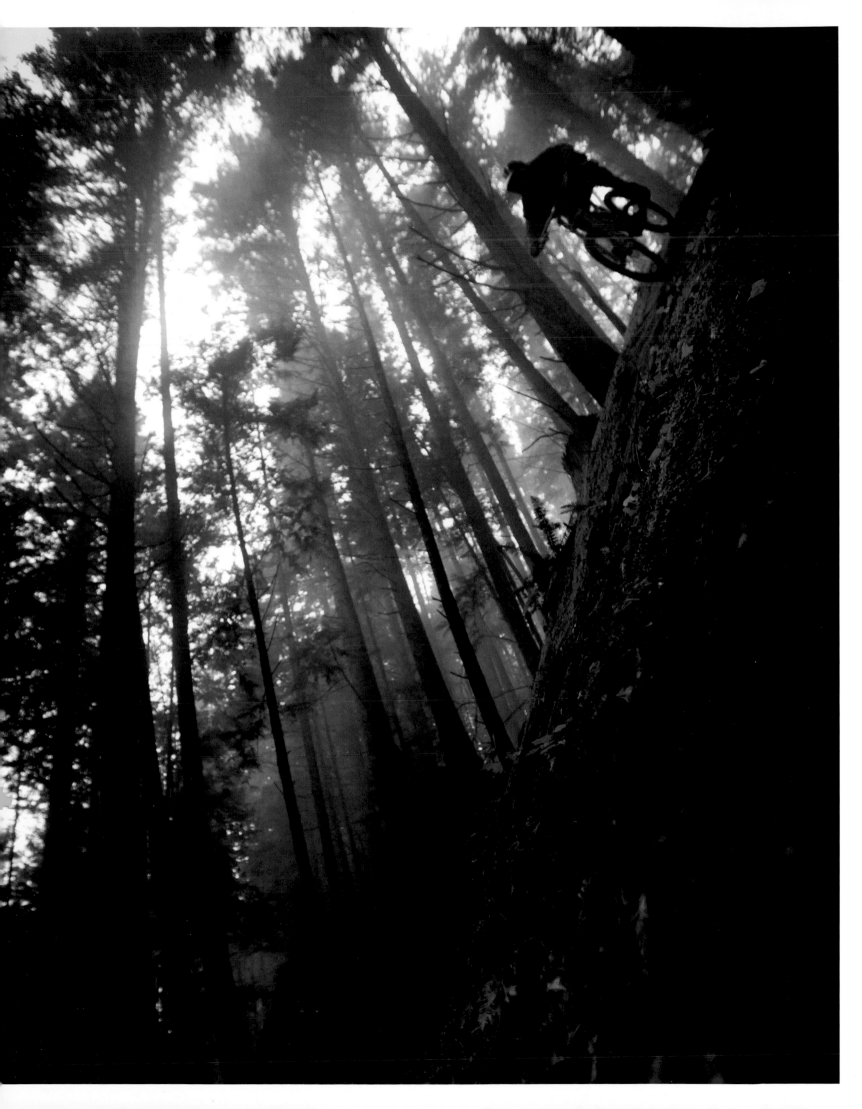

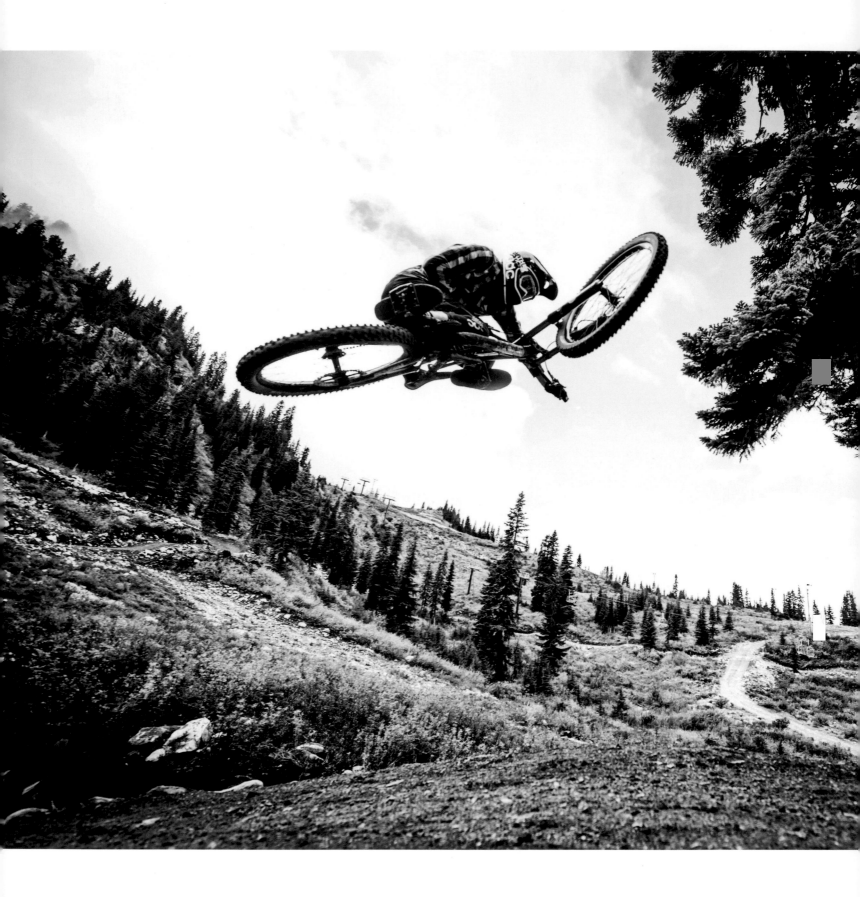

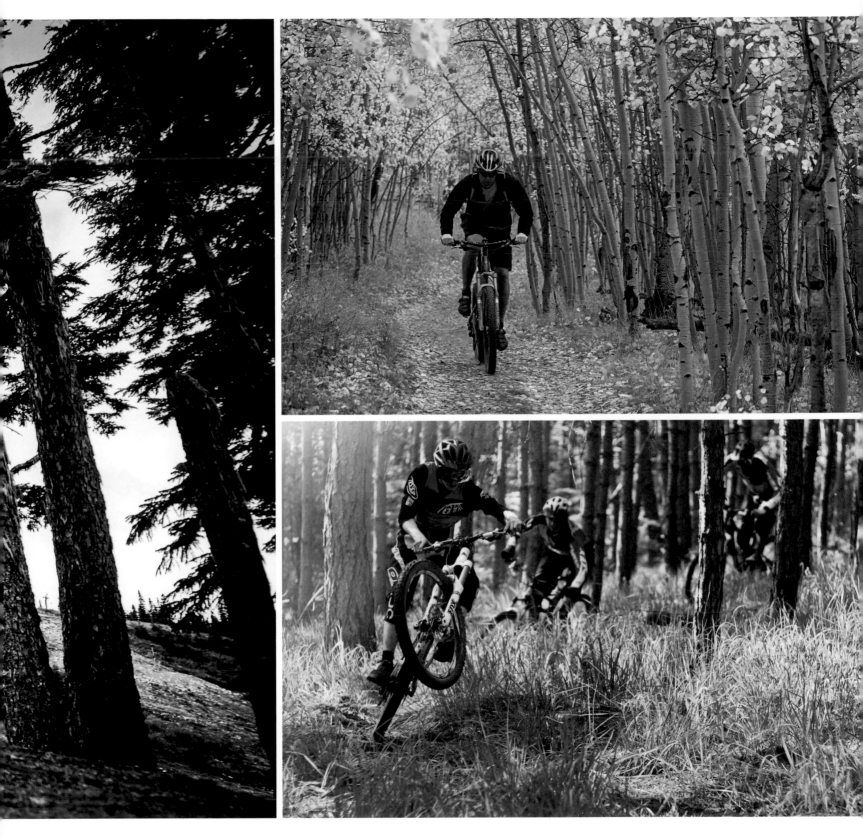

OPPOSITE: Stevens Pass Mountain Bike Park, Skykomish, WA, USA
TOP: Fall day on Colorado Trail near Kenosha Pass, CO, USA
ABOVE: Summer single track near Stuttgart, Germany

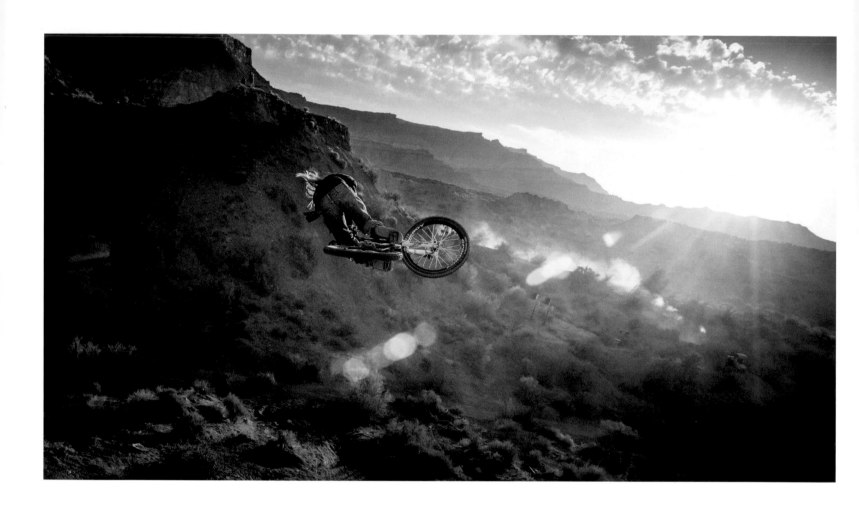

ABOVE: A downhill biker airs into the desert sky in Virgin, UT, USA
OPPOSITE: North Rim Trail, Gooseberry Mesa just west of Zion National Park, UT, USA
FOLLOWING PAGES: Enduro World Series, Les Deux Alpes, France

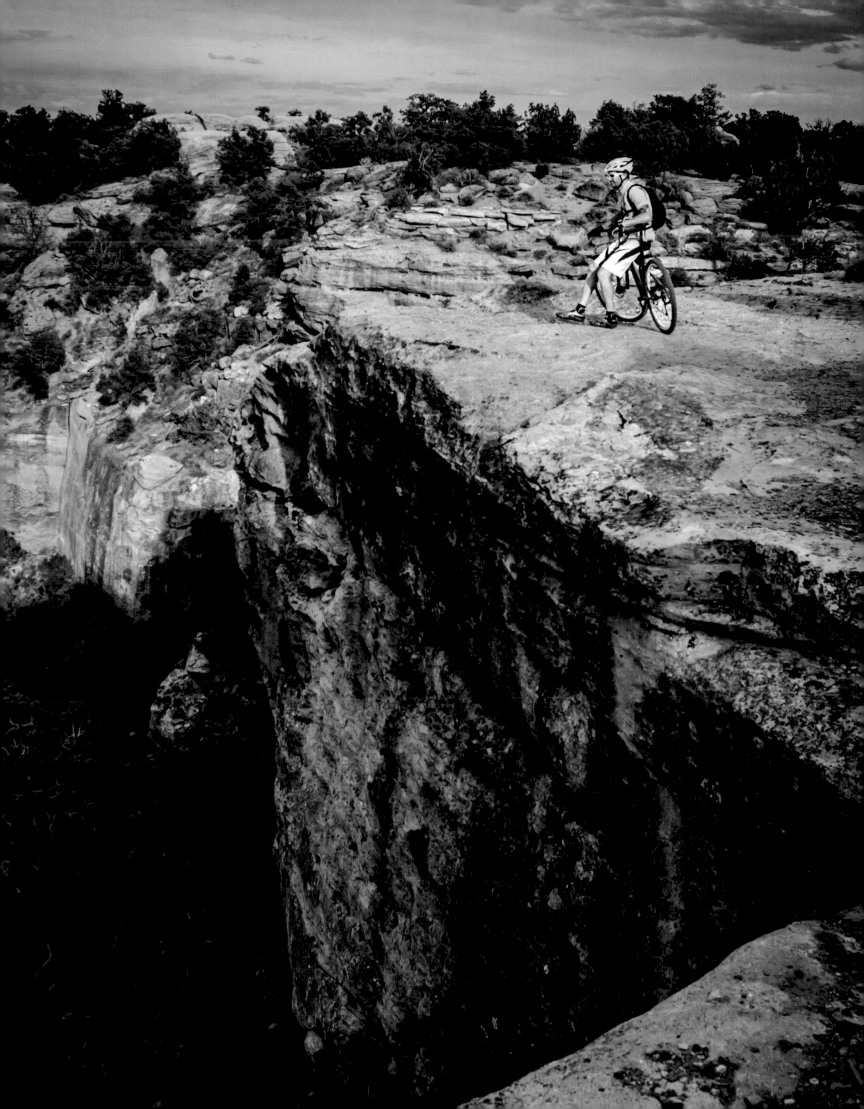

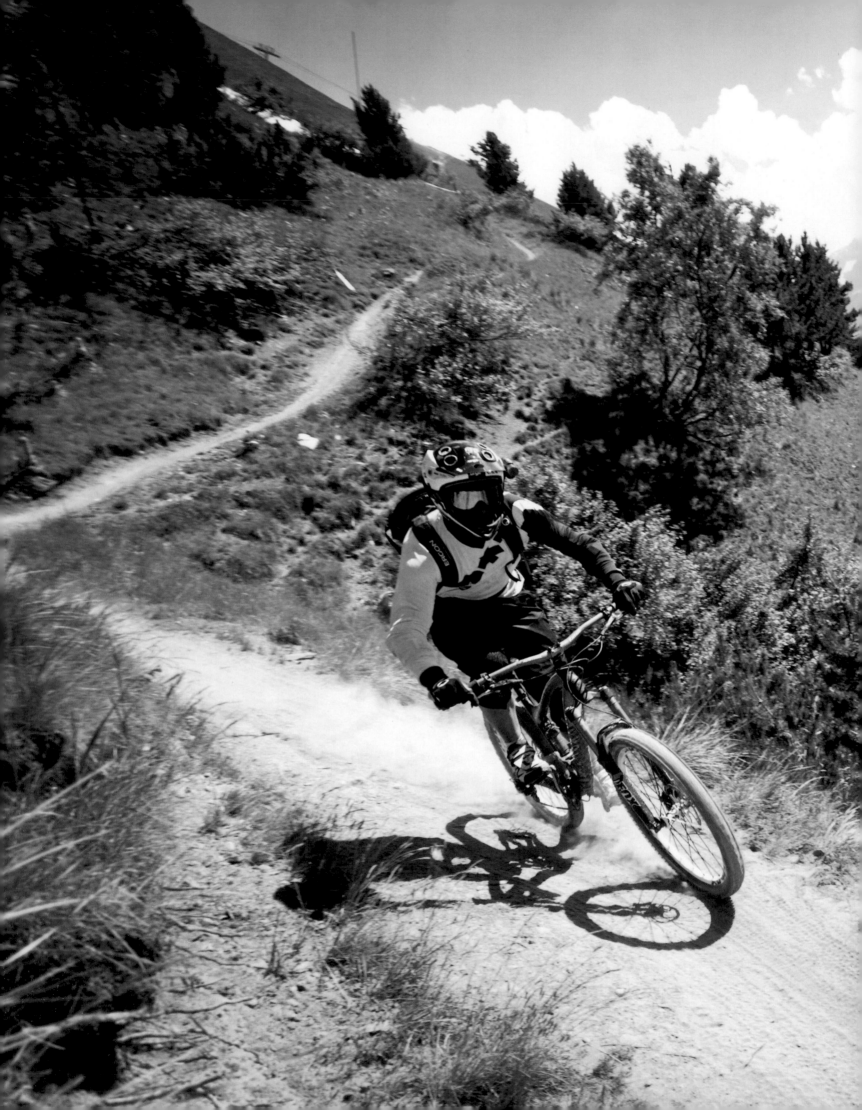

BACKPACKING

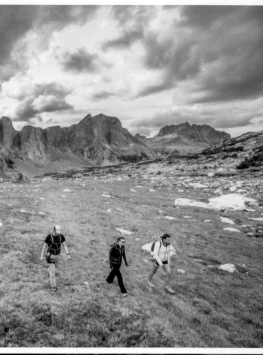

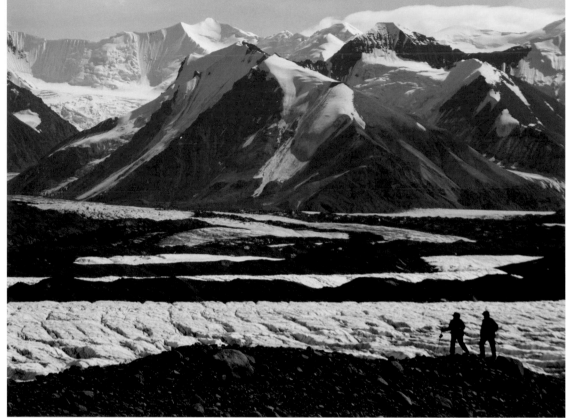

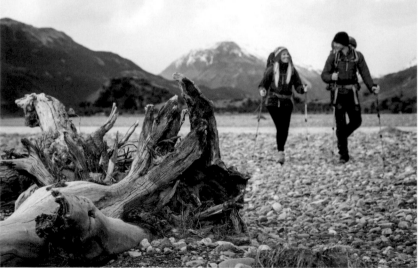

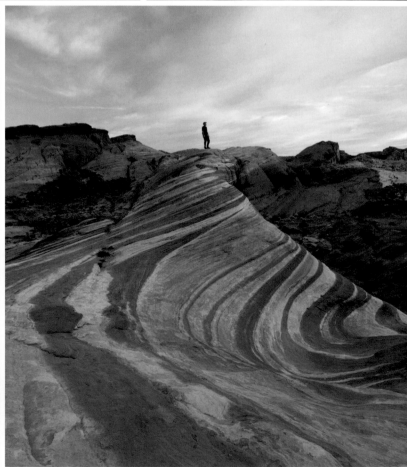

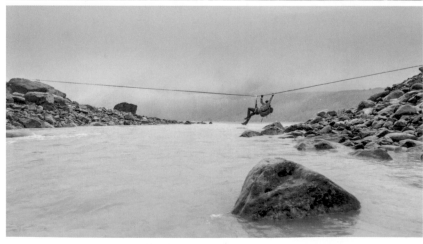

ABOVE, LEFT TO RIGHT, TOP TO BOTTOM: Russell Glacier, St. Elias National Park, AK, USA; Ambush Peak, Wind River Range, WY, USA; Humboldt Redwoods State Park, Humboldt, CA, USA; El Chaltén, Santa Cruz Province, Argentina; Michael Booth pulls himself along a Tyrolean traverse, Los Glaciares National Park, Santa Cruz Province, Argentina; Fire Wave, Valley of Fire State Park, NV, USA · OPPOSITE: Rocky Mountain National Park, CO, USA

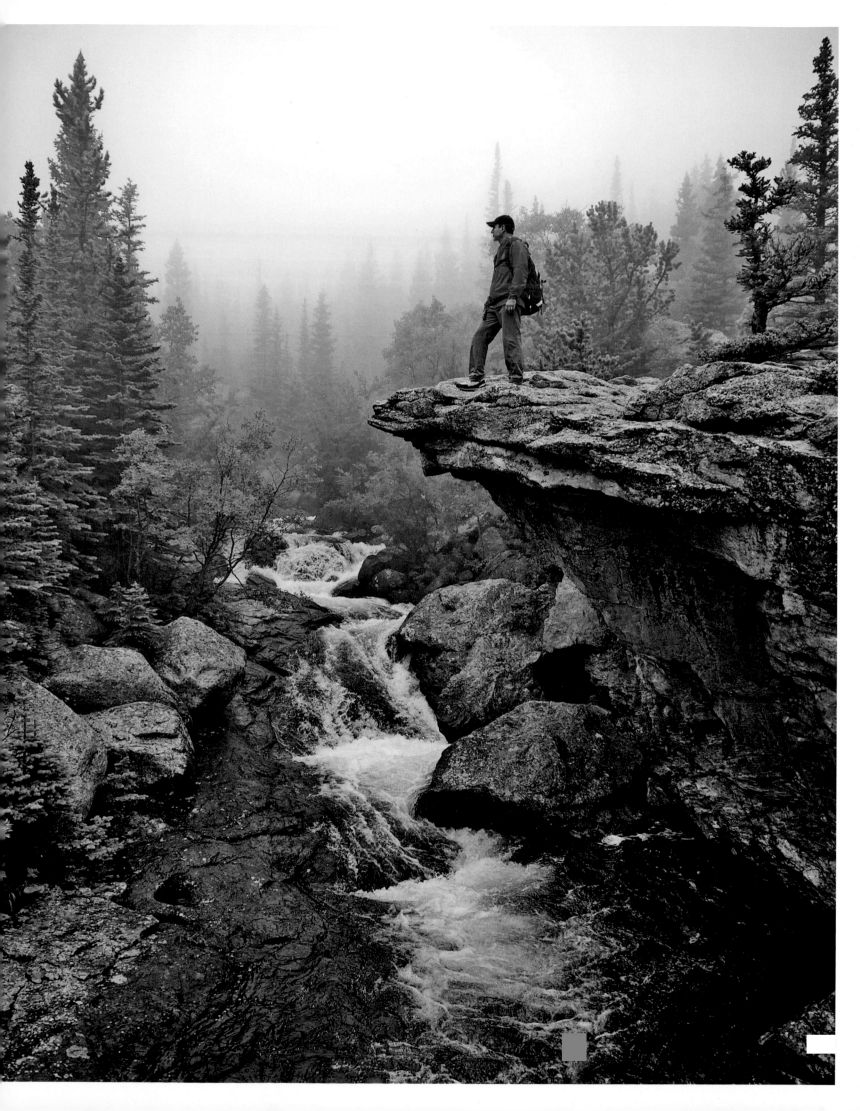

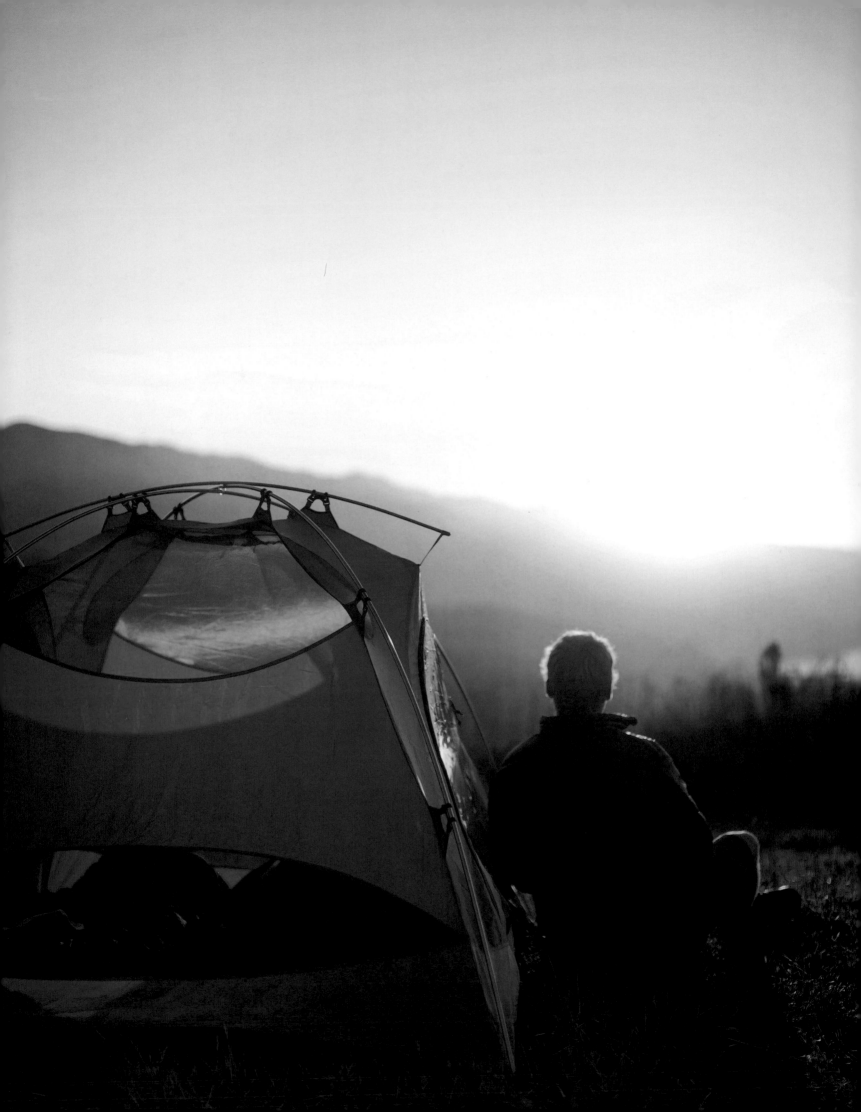

THE PERFECT VIEW

Genny Fullerton, *Backpacker*

AS A PHOTO EDITOR at *Backpacker* magazine for the last decade, I've seen tens of thousands of amazing backcountry pictures. But there's one photo I keep looking for—a photo I've realized I won't find. It's of the best view I've ever seen. A view that changed my life. A view that, I've come to realize, may exist only in my memory.

It was my first real hike. Sure I'd been running around the fields behind my parents' two-hundred-year-old farmhouse in Connecticut since I was tiny, playing in the woods and climbing trees and building forts with my cousin for as long as I could remember. I went to rock collecting camp the summer before fourth grade, and we swam in brooks and under waterfalls each afternoon. But for the first time I was on a trip with a real plan—three days of hiking and camping in New Hampshire's White Mountains.

It was August and it had been raining for days, but we hoped the rain would stop and we would be able to climb Mt. Lafayette and Mt. Lincoln. Our church pastor and youth group leader had given us a packing list and training schedule. We all wondered if we had what it would take to do the big hike, and if the weather would let us. We had rain on our driving day and rain on the first day's short hike to Lonesome Lake. It rained through an afternoon of football and through dinner. But on the morning of the second day we woke to clear skies and the chaperones telling us to pack up. We were going to go for the summits.

A little ways in on the hike—I have no idea if it was a mile, or less, or more—we hit the sunlight and stopped suddenly, hearts pounding, out of breath. We'd been hiking single file through the narrow forest trail—heads down, concentrating on our steps. Suddenly my world opened up and I stepped out onto a rock to take in an amazing view, still one of the best I've ever experienced.

I was looking out and over this huge basin with the 5,249-foot peak of Mt. Lafayette towering across from me in the distance. I could see the AMC hut, surreally tiny on the way up to the summit. To the right of Lafayette, a dramatic ridge descends before leading up again to the slightly smaller Mt. Lincoln. It was like standing on the cusp of a huge bowl—verdant forests below, the enormous mountain peaks beyond, stony ridges connecting the whole vast skyline.

I looked out with the group in awe. The sun was so bright and beautiful, the mountain was so green, the Oreos we snacked on so delicious. We all stared out wondering what it would take—nine days, maybe—to hike around everything we could see from that viewpoint. We wanted to do that. But today, first, we just had to get up the mountain we were on, and that still seemed like a lot of work.

Backpacker has written about the hike I did that day—Franconia Ridge. It's a classic. Turns out the eight-mile loop we were on covered the whole skyline we could see from that first vantage point—the same skyline we imagined would take days to traverse. The route comes up in the magazine more than once a year: best loop hike in New Hampshire, a great fall foliage hike, the best ridge hike in the Northeast. We call it a lot of things. My job is to find photos to go with the story each time. And each time, I wish I had a picture from that day. I've never found a photo of the Franconia Ridge hike that made

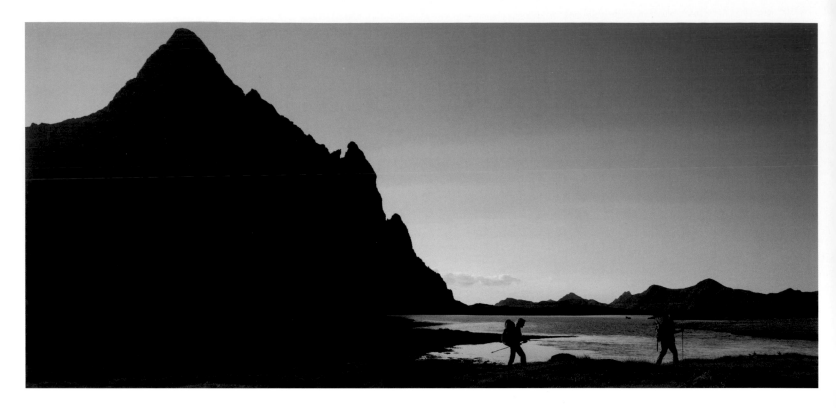

me feel like I did early that Friday morning when I took in the view. Have no northeastern photographers been to that lookout on a bluebird day to capture a picture on par with my memory?

After years of looking for the perfect photo, I've finally realized it's just not out there. In one photo, using only two dimension and the colors that we can reproduce on paper, how can a photographer capture what it was really like to be there, the world opening up to me? The warm sunlight, the sweat on my skin, the buzz of working hard to that point and knowing I still have so much more to go. . . .

That's the challenge photographers take on when they pick up a camera and decide to make it their work. What an amazing and never-ending task. I see thousands of professional photos every week, and many show the terrain of a hike we're writing about. Some show it in nice light or with a hiker and a strong artistic composition. But every now and then there's some sort of magic that happens in the photographer's capture, and there's an image in front of me that makes me feel a place. While I'm still just using my eyes to see the photo on my screen, something in it is evocative enough that I can also feel sunlight on my face, the warmth on my skin. Or the photographer has caught the moisture of the air in a morning scene that is so perfectly lit and is concealing and revealing the view in just the right way to make me feel like I'm there in the mist. As I breathe, I feel like I should be breathing in the fog.

Those are the photos I love to publish. Those photos are the ones that make people go out and actually do a hike. They remind people of the awesomeness of our world and ignite a stronger desire to go out and get somewhere, to hear the roar of a waterfall, or take in the silence of a deep forest, or see a sunrise from a high peak, or camp for three days at a lake and experience life without e-mail again.

Since the invention of cameras, photographers have been creating images in an attempt to share the deep emotional experiences they've had with the broader public. Outdoor adventure photographers invite their viewers to climb, paddle, swim, hike, and camp in the wild lands of the world. They invite viewers to come and enjoy the places the photographer cherishes, and to value and take care of them, and in turn to share them with others who will continue the cycle of love and stewardship.

The best photo I can find and print in *Backpacker* is the one that inspires a reader to go and experience the place we're talking about. My hope is that someone sees the illuminated tent under the stars and calls a friend to plan a trip. My hope is that a photo I publish has the magic to call readers to train and head up a mountain higher than they thought they could climb, or take on a longer trail than they thought possible.

But despite all the power that lies within those magically transcendent photos, the very best images won't be the ones I can print in the magazine. Like that scene on my very first hike that I've never quite been able to recapture, the best images will be the ones kept in people's memories, alive with all five senses, and calling them to visit again.

ABOVE: Anayet Peak, the Pyrenees, Spain
OPPOSITE: Allison Creek Trail, Hells Canyon, ID, USA

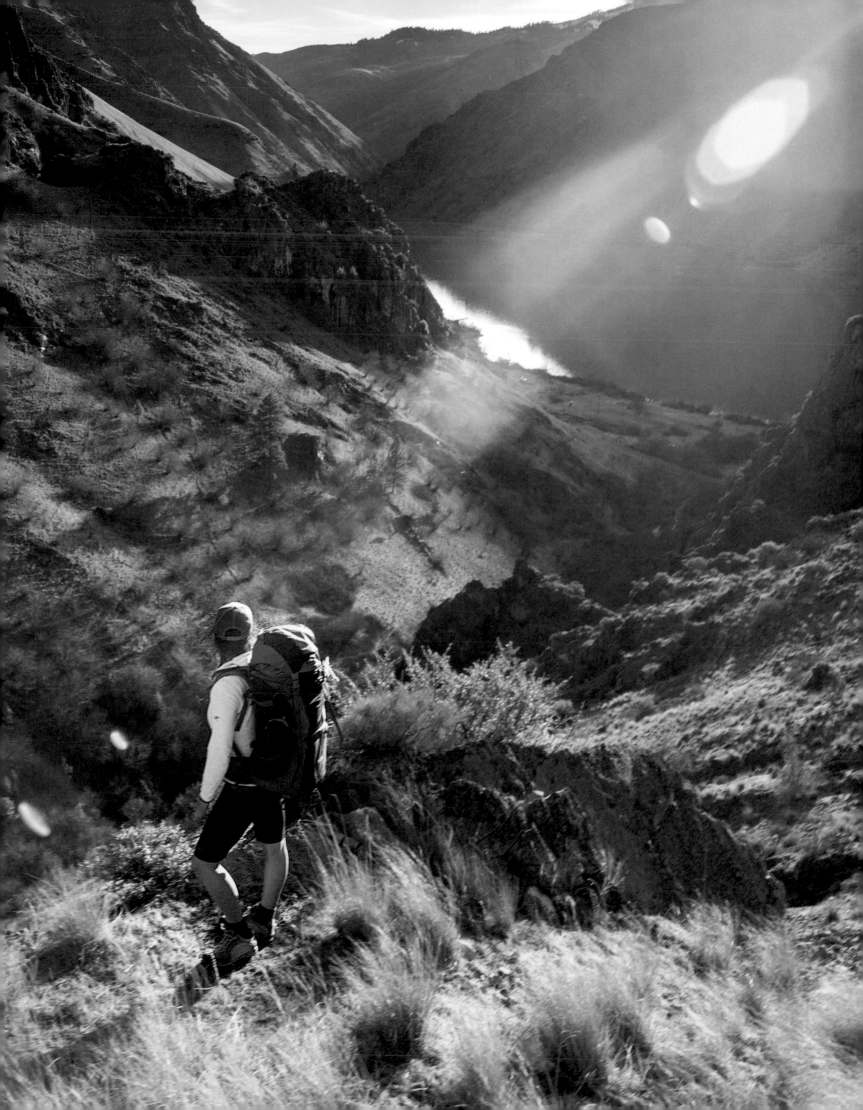

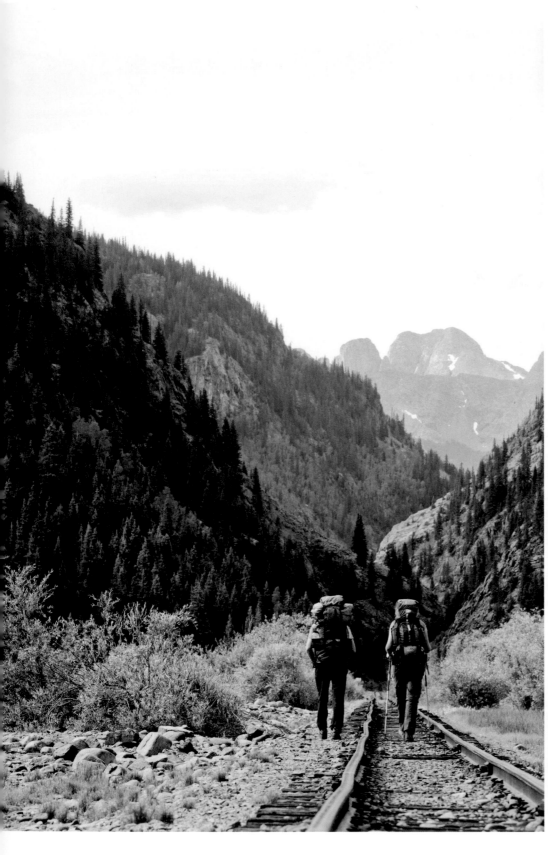
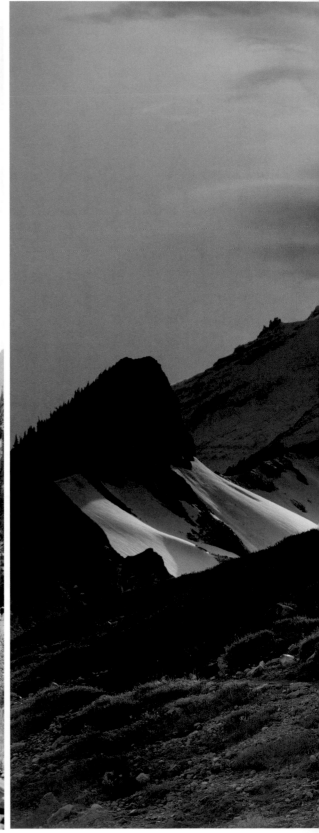

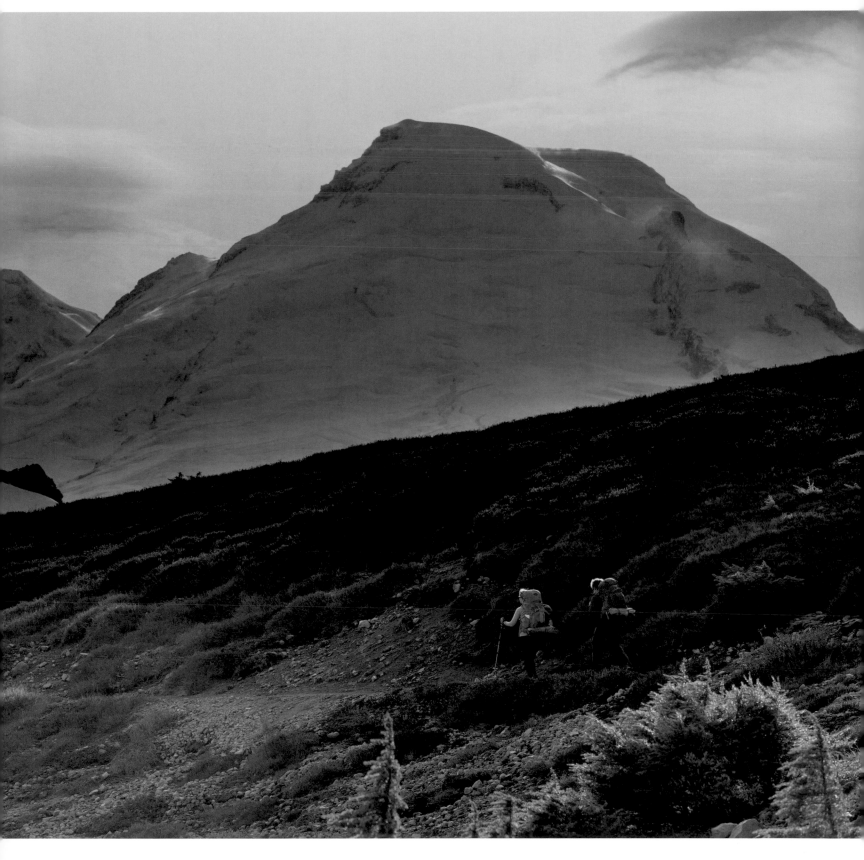

OPPOSITE: Grenadier Range, CO, USA
ABOVE: Chain Lakes Trail, Mt. Baker Wilderness, WA, USA

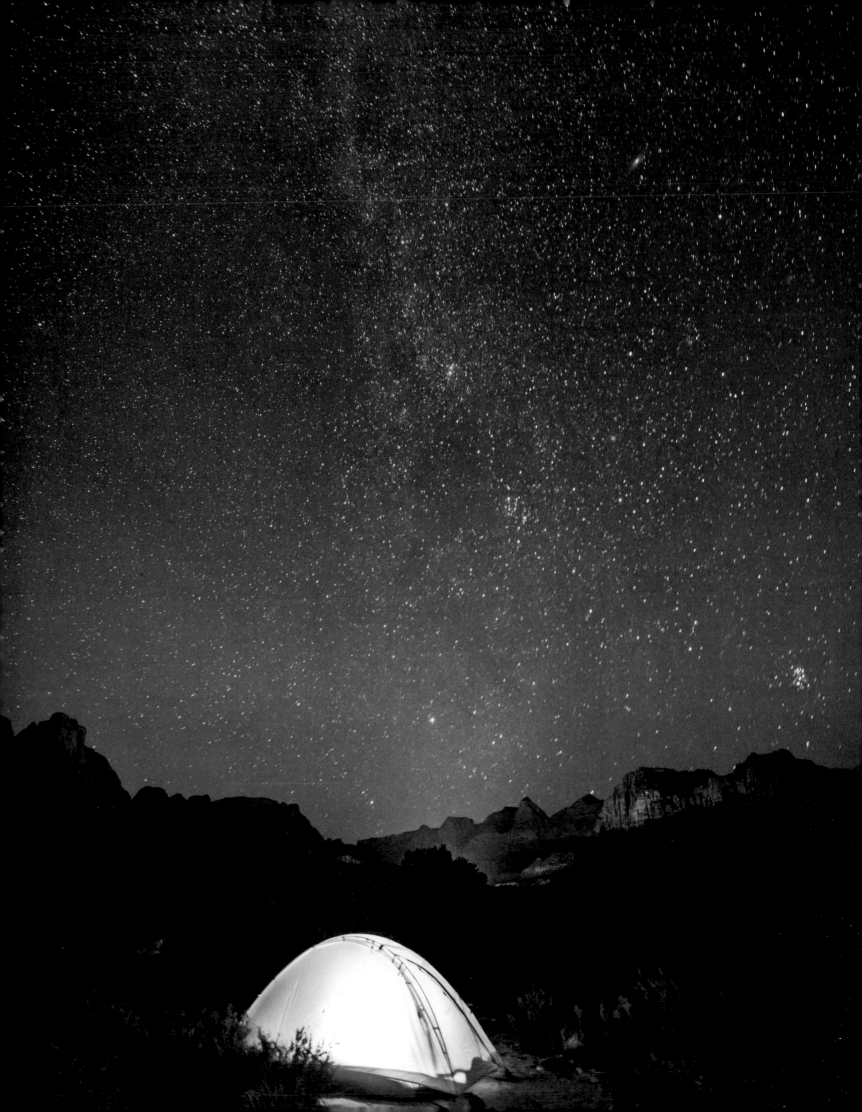

IN PURSUIT OF DREAMS

THE BEST PHOTOS tell their own stories, silently and vividly structuring the platform of dreams. As a child I would spend hours poring over images in *National Geographic* magazines, let my mind wander and revel in seemingly endless possibilities.

At the time, I knew only that I wanted to participate in the world as revealed in those photographs—go on exploratory expeditions, search for unclimbed mountains, discover new skylines, meet people from different cultures, even grin and bear it through the toughest of environments. I didn't realize until much later that my calling was to be behind the camera taking the very pictures that excited my imagination.

Bringing a camera into the mix added fuel to an already well-stoked fire that burned for adventure. Through photography, I've become a storyteller, and happily take on the responsibilities that entails. No more sleeping in. No more relaxing dinners at sunset. Every waking moment revolves around the next shot. Where do I need to be? What lens do I need to bring? What time is sunset? I am always in pursuit.

The place I feel most comfortable now is in the wild, where life is simple and the world is stripped of noise and clutter. Here I focus on simple lines, simple compositions, and simple colors, always striving to capture moments of clarity, moments that beckon viewers to walk into the scene, just as the photographs of others have beckoned me.

I find myself thinking about those early days when I would study a photograph for hours, dreaming of distant landscapes. Now, I create my own adventures, but I also want to create photography that compels others to dream.

—LINDSAY DANIELS
Photographer

OPPOSITE: Tent camping under the stars, Zion National Park, UT, USA
FOLLOWING PAGES: Climber silhouetted against Keeler Needle, Lone Pine, CA, USA

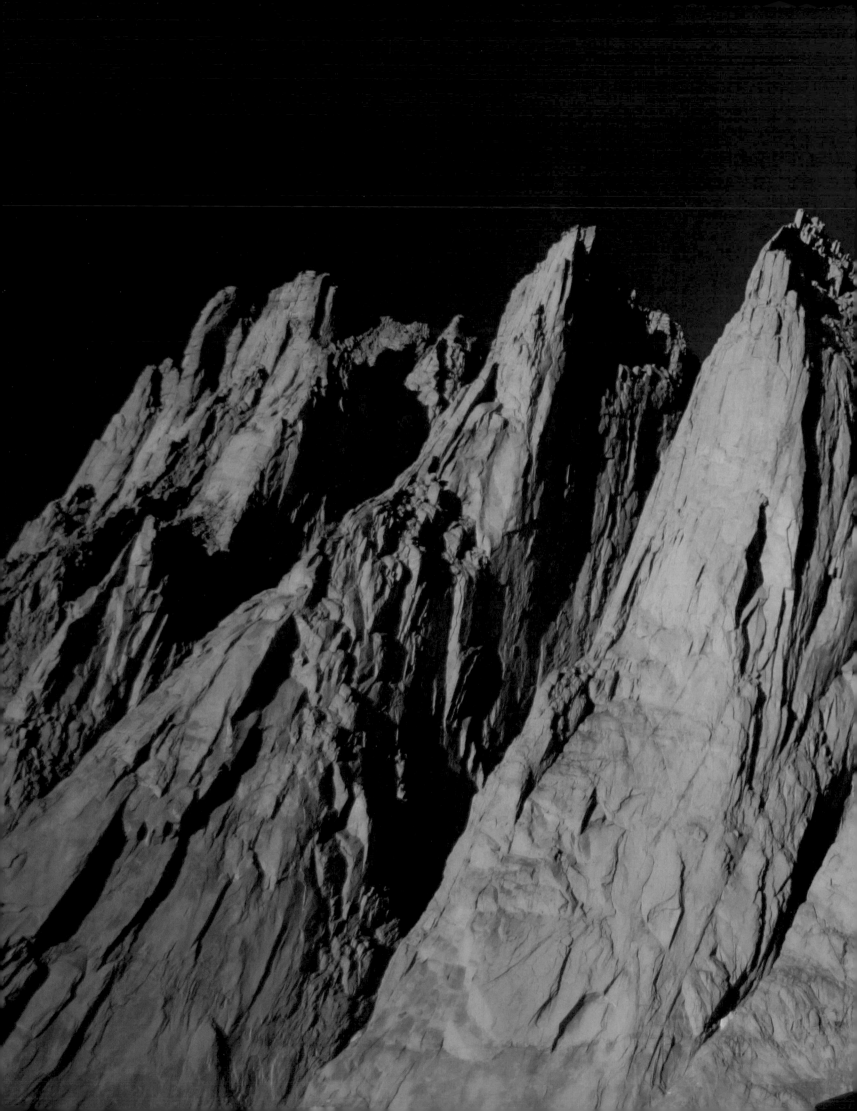

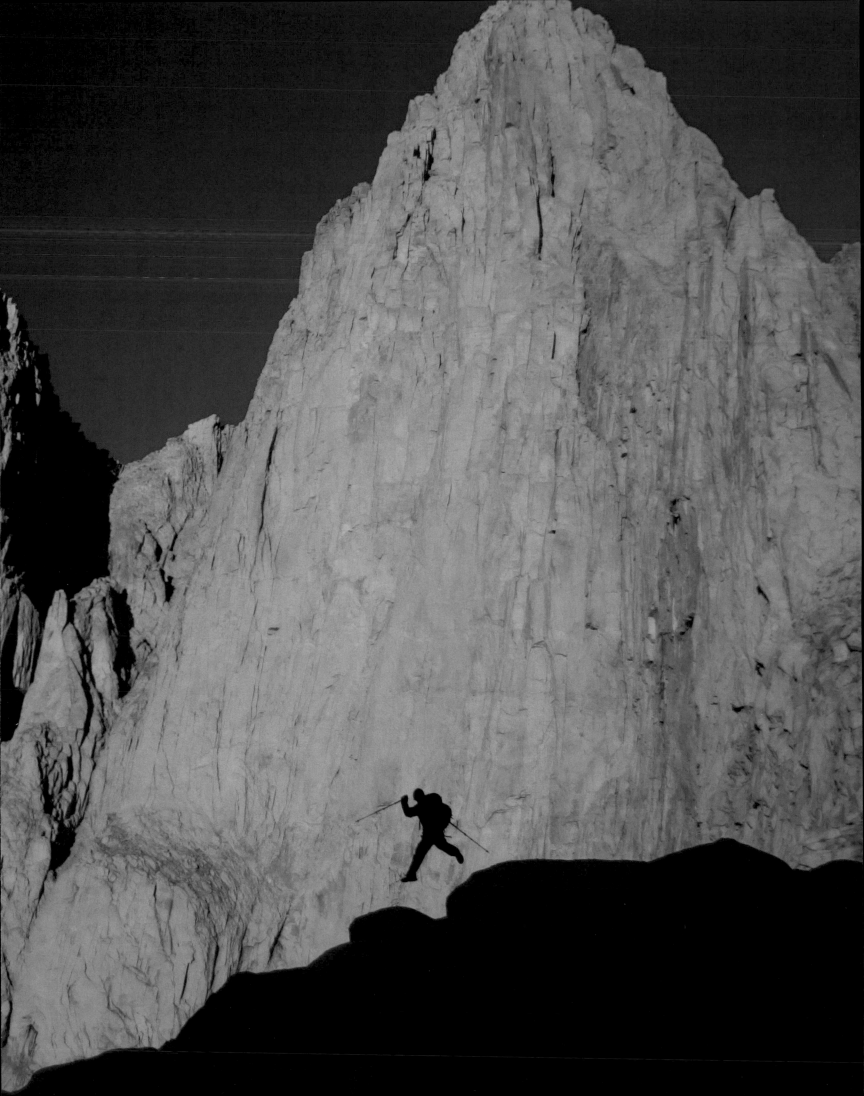

TRAIL RUNNING

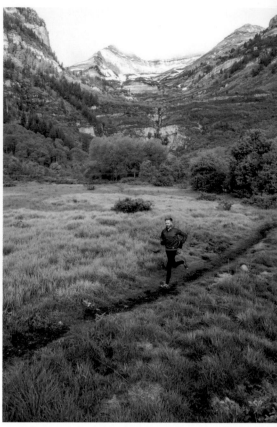

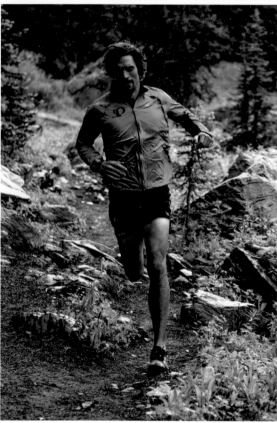

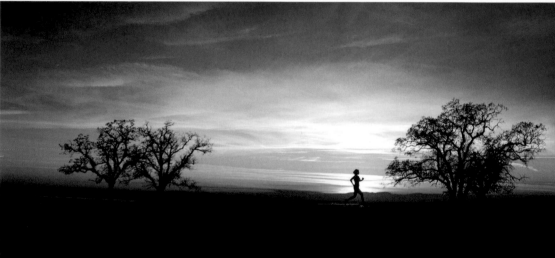

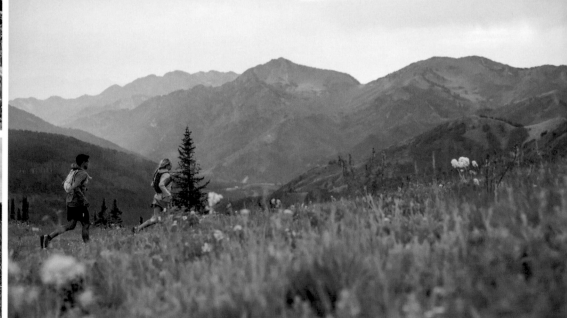

ABOVE, LEFT TO RIGHT, TOP TO BOTTOM: Squamish, BC, Canada; Sundance, UT, USA; Little Cottonwood Canyon, Salt Lake City, UT, USA; Table Mountain, CA, USA; Chautauqua Park, Boulder, CO, USA; Wasatch Crest Trail, UT, USA · OPPOSITE: Trail running in the Cascades, WA, USA

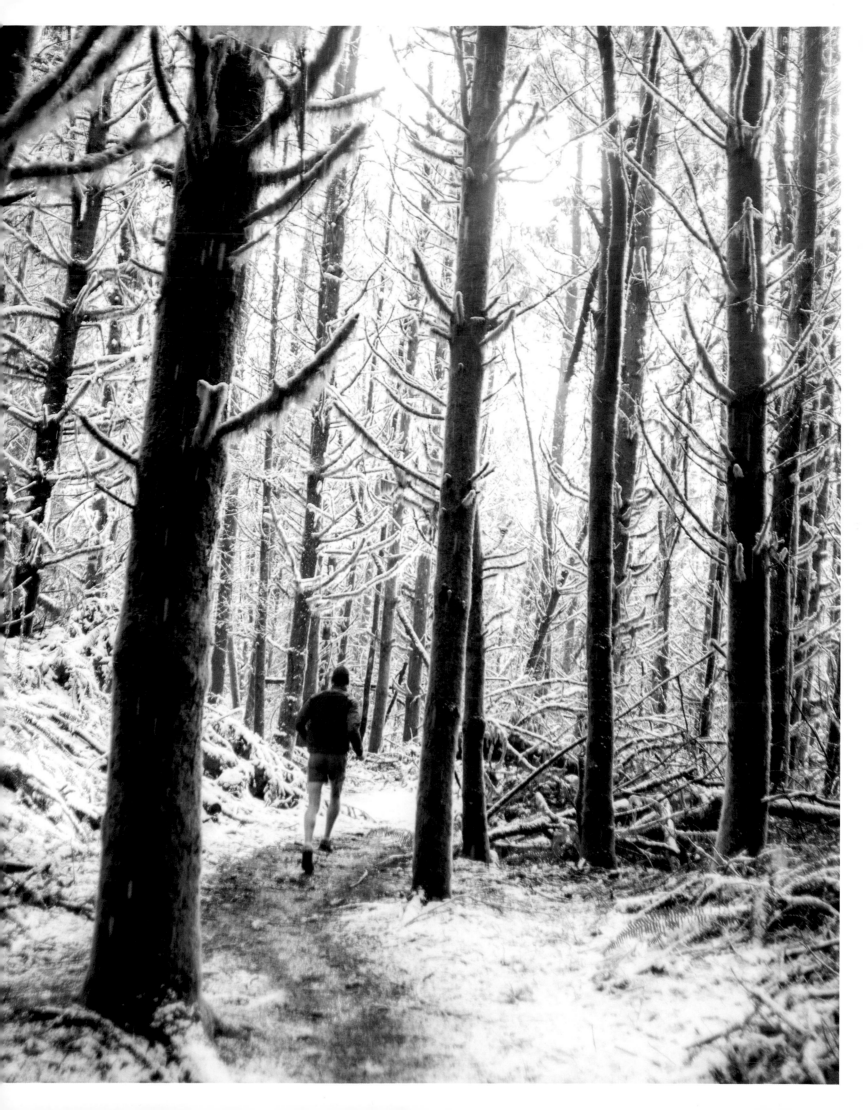

A CHANGING LANDSCAPE

Amy Silverman, *Outside*

THE LANDSCAPE of outdoor adventure is constantly changing. Tools like GoPro cameras and up-to-the-minute blogs from places like Everest Base Camp have enabled people to document and share their own experiences, increasing the visibility of their endeavors and in turn pushing the limits of adventure ever further and at a faster pace.

Time and again dedicated individuals pioneer seemingly impossible feats—rock climbers tackle new routes, snowboarders and skiers clear unfathomable gaps, surfers discover new waves in a well-charted world. The more people pursue and share their adventures, the more others are compelled to follow, even up the ante. This is one of the biggest motivating factors behind the stories we put together at *Outside* magazine—showing the world what's out there, what people are capable of, exploring the breadth and evolving experiences available in an outdoor environment and inspiring individuals to go after them.

There are so many ways people engage with the outdoors, which is why *Outside* is dedicated to a diversity of subject matter. There are very few publications that cover such a range of subjects. From expeditionary adventures to food, athlete profiles to photojournalism, each feature is a window into the world of possibilities awaiting everyone. This diversity keeps the job incredibly interesting—I might be working on sending someone to the Marshall Islands while at the same time assigning a cover to be shot in a studio in L.A. or New York.

Of all the ways to chronicle individuals, places, and experiences, I find profiles and photojournalistic stories the most engaging. Photojournalistic features unveil the

spectacular nature of these outdoor pursuits, while profiles reveal, often in candid, intimate detail, the human spirit of adventurers—the struggle, the danger, the triumph. For example, *Outside* recently ran a piece about four-time Iditarod winner, Lance Mackey. He's a fascinating character—this, coupled with the beautiful images Tom Fowlks captured on assignment, brings to light the nuances of Mackey's story and the environment he competes in. It's always exciting to send a photographer/writer team to far-flung places. We recently assigned stories in Mali and Albania, and it's thrilling to see what comes out of these trips.

One of the greatest perks of my position at *Outside* is getting to travel and witness the events we cover firsthand. Going to Ironman in Kona, Hawaii, to shoot the podium finishers, as well as interesting "age groupers" who completed the Ironman, was definitely one of the most memorable moments in my career, an "I can't believe I get to do this!" moment. Not only was I in Hawaii working with a wonderful photographer, Andrew Hetherington, but I was meeting people like Craig Alexander and Harriet Anderson. Anderson was the first place finisher in her age group of women seventy-five and over, and Alexander was one of the nicest, most humble athletes I've ever met—both true inspirations.

I came back to Santa Fe so fired up from the experience that I volunteered to participate with some other *Outside* staffers in a sprint triathlon in Aspen, Colorado, something I never thought I would do in a million years. Completing that was a huge accomplishment. Afterward I went to a Tough Mudder to shoot another cover. I contemplated taking part

OPPOSITE: Rob Lea trail running in Bryce Canyon, UT, USA

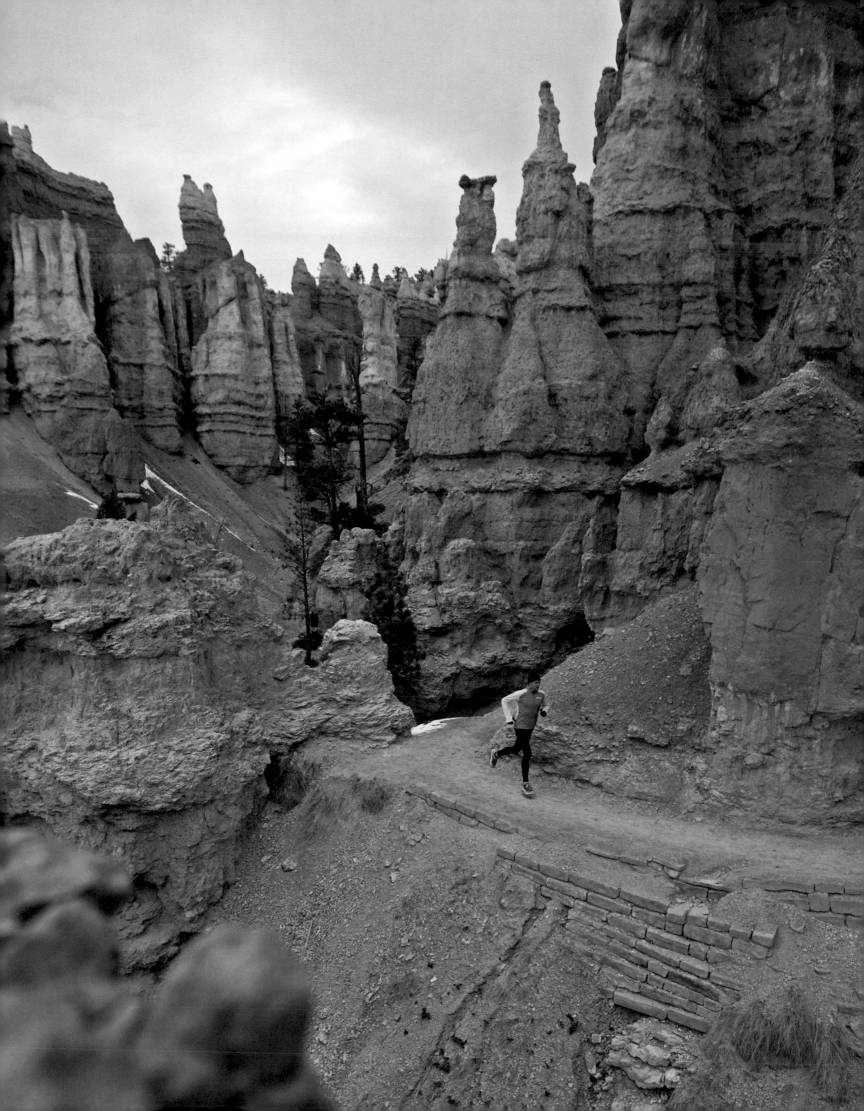

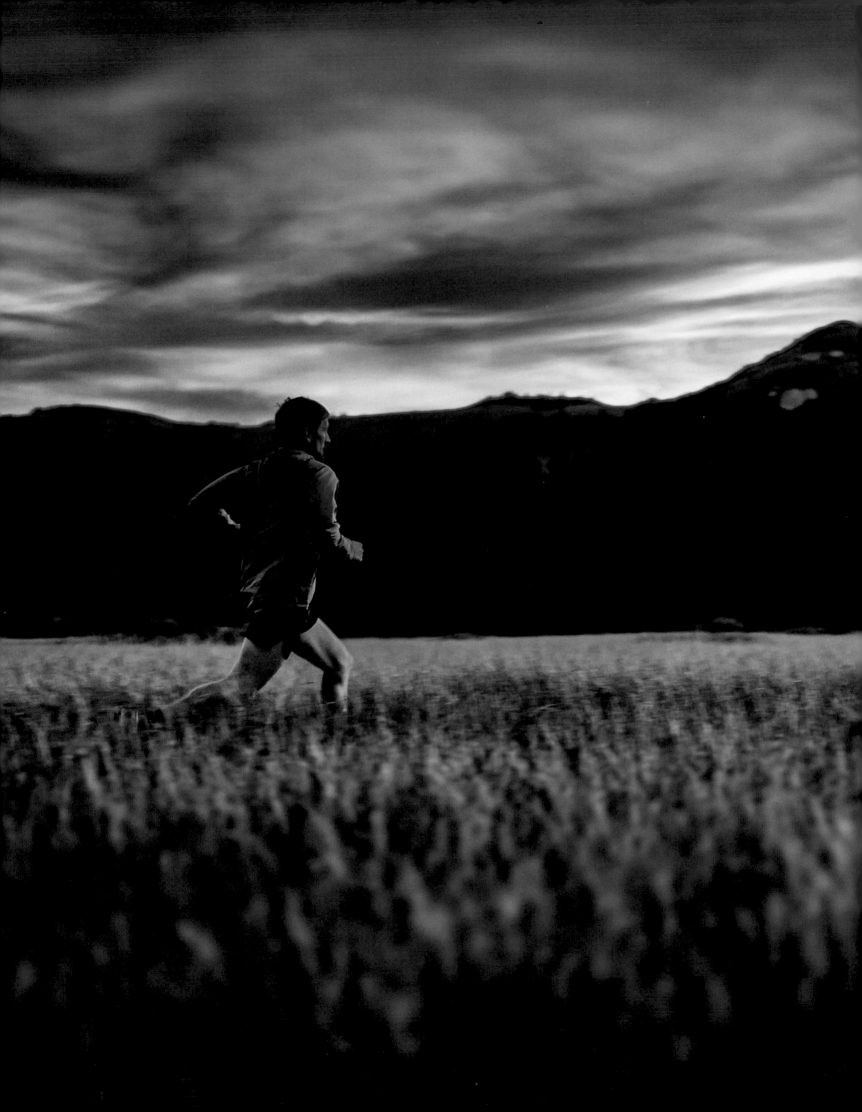

in an obstacle race . . . not there yet. I'll take another sprint triathlon over that! Still, it made me realize what a powerful stimulant getting engaged in people's stories can be. Meeting Craig Alexander and Harriet Anderson was the spark for me, and I hope the stories and images we publish in *Outside* provide a similar spark for our readers.

To this end, we see every image in the magazine as important and don't settle for anything that doesn't feel like it fits our aesthetic or achieves the effect we're after. It can be hard because we often talk about remote places that haven't been photographed much, but we don't stop looking until we have something that works. And when we assign photographers, we give them a lot of freedom because we choose photographers whose work we believe in—just like we do stories we believe in.

The ways in which people document adventure are changing rapidly, and it's only a matter of time before wearable technology makes it possible for viewers to experience the adventures of others in real time. Soon we will be watching people like Felix Baumgartner as if it were us free-falling from the stratosphere. This trend is opening up a long-insulated world and engaging more and more people to participate. It's no longer something only crazy people do. We see through the art of photographers, the dedication of athletes, and the ever-evolving ways of documentation that the world is an expansive playing field . . . each story an invitation to explore.

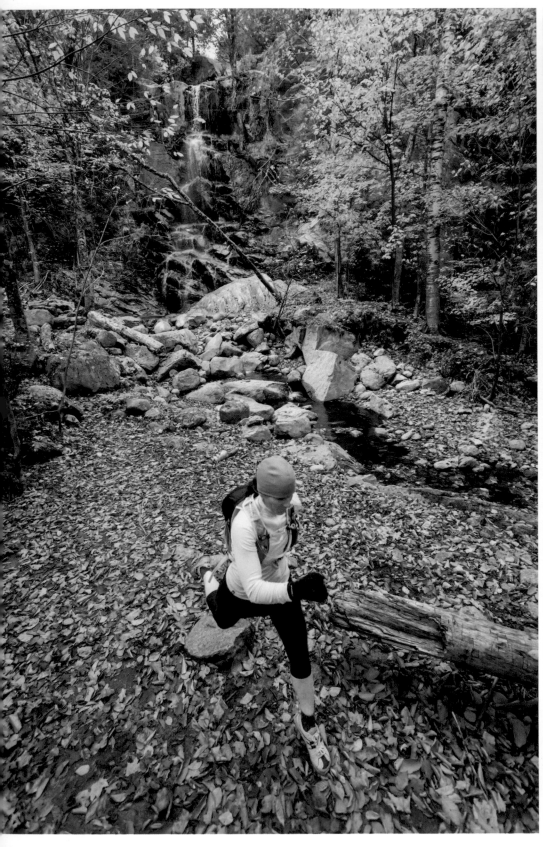

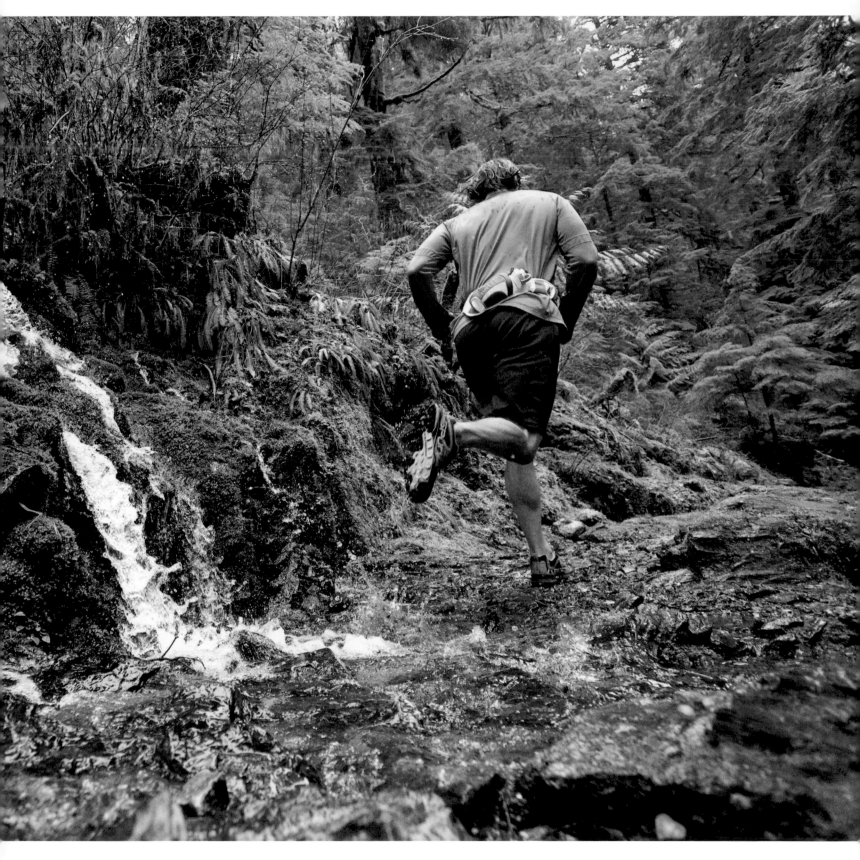

OPPOSITE: Adirondack Mountains, NY, USA
ABOVE: Lake 22 Trail, Mountain Loop Highway, Central Cascades, WA, USA

WHY ADVENTURE?

SO WHY ADVENTURE?

Maybe it was because my mother gave me Galen Rowell's books at a young age, or because my father took me exploring in the mountains. Or perhaps it was hearing a grizzly breathing as it brushed past my tent, or catching trout with my bare hands as a kid.

Am I drawn to the sound of lightning splitting nearby rocks, the faint light before the sun rises, the power of the surf during a winter storm? Maybe I like the feeling in my legs after running 50K, the Zen required for hours of bushwhacking, and the loneliness and wholeness I experience on weeklong solo treks.

Adventure was my companion as a child—as I climbed trees, wandered creek beds, and watched wild animals. It fueled my desire to explore the edges of my known world as a teenager, riding my bike as far as I could to nearby mountains and forests. Through adventure I could press against my limits, physically and mentally, in impossible situations—climbing through the night after a rock fall had severed my rope, bivying on an exposed ledge during a thunderstorm, and remaining calm in the presence of a grizzly I surprised. Now, adventure is just a part of me. I don't go out of my way, as I used to, to find it. Mountains, rivers, storms, and wildlife— and even myself—all have unpredictable elements that are ingredients for adventure. So long as I work and play in the outdoors, adventure will be there with me.

When I started taking pictures, I simply wanted to share what I was seeing and experiencing—spectacular landscapes, encounters with wildlife, and the pain and joy of mountaineering. I remember changing film in the field and being careful to avoid the introduction of moisture or dust into the camera body. The 36-exposure limit of Kodak Ektachrome was a good teacher for making shots count, but there were too many times when I needed to change film

during the action. I now shoot with weather-sealed digital cameras that can endure a full day in the winter rain while I'm steelhead fishing on the Olympic Peninsula and allow me to shoot hundreds of frames in order to catch a fly fisherman's line in a perfect arc before it unfolds. The capacity of this equipment allows me to continually push the edge of what is possible with compositions, ISOs, shutter speeds, autofocus, and dynamic range. The possibilities are endless, and they allow me to constantly create fresh imagery that mingles art with journalism.

I now combine my skills as an artist, climber, runner, skier, and free diver to help me tell stories through photographs and video. I gravitate toward subjects that need their voices amplified and work that demands long-term vision and some grit. I've spent the past few years focusing on lands and animals that make our lives richer—grizzly bears, the Rocky Mountain Front, wolverines, the Crown of the Continent—but are suffering from the effects of development. I've come to see that wild places aren't just arenas for our outdoor adventures—they are also storehouses for fresh water, habitat for wildlife, and sanctuaries for humans. Photography allows me to share the essence and voice of these places and their wildlife with a larger audience. As people are increasingly disconnected from nature, the need for reminding and reaffirming our connection grows.

Good photography speaks both to our intellect and to our heart. It has the power to change our attitudes, assumptions, and ideas. My job is to find ways to make photographs that do this. Embracing a life of adventure puts me in places where beauty often overwhelms me and terror sometimes grips me, and with a camera in hand I can transport others to see what I see and, if everything comes together just right, feel what I feel.

—STEVEN GNAM
Photographer

OPPOSITE: Alyson Dimmitt Gnam trail running in Banff National Park, Alberta, Canada

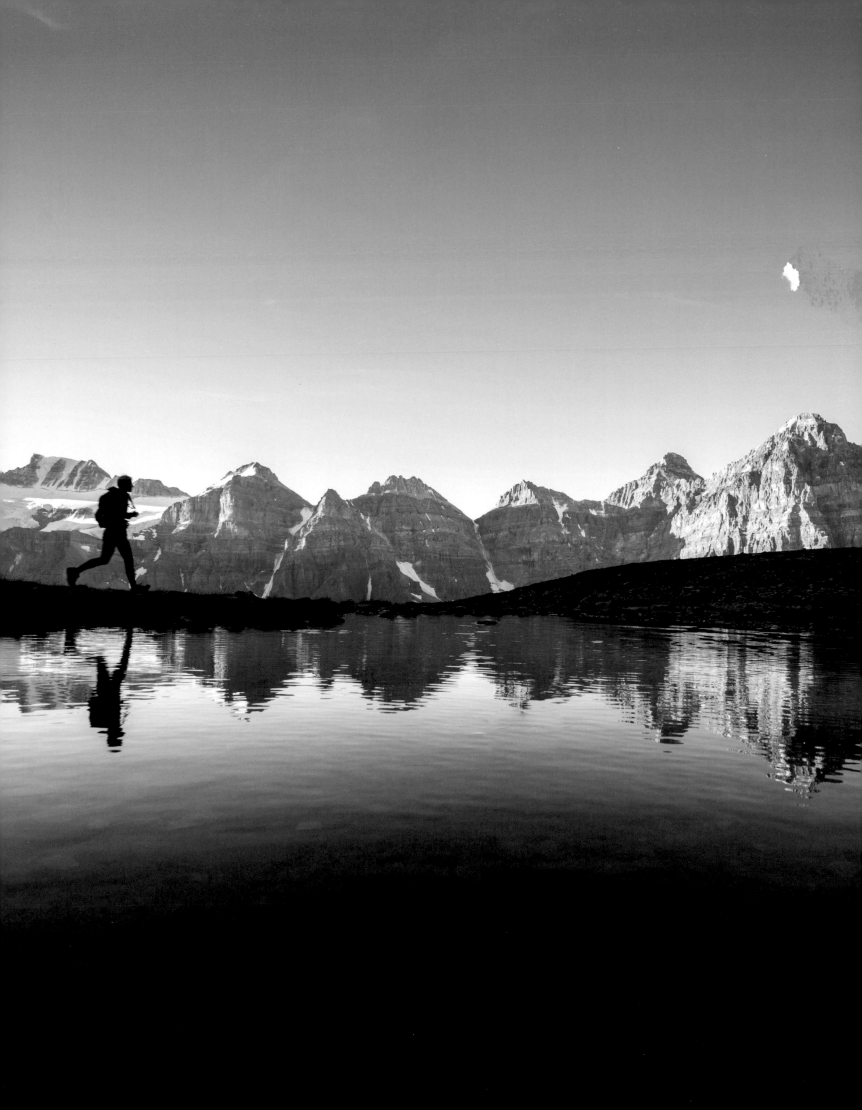

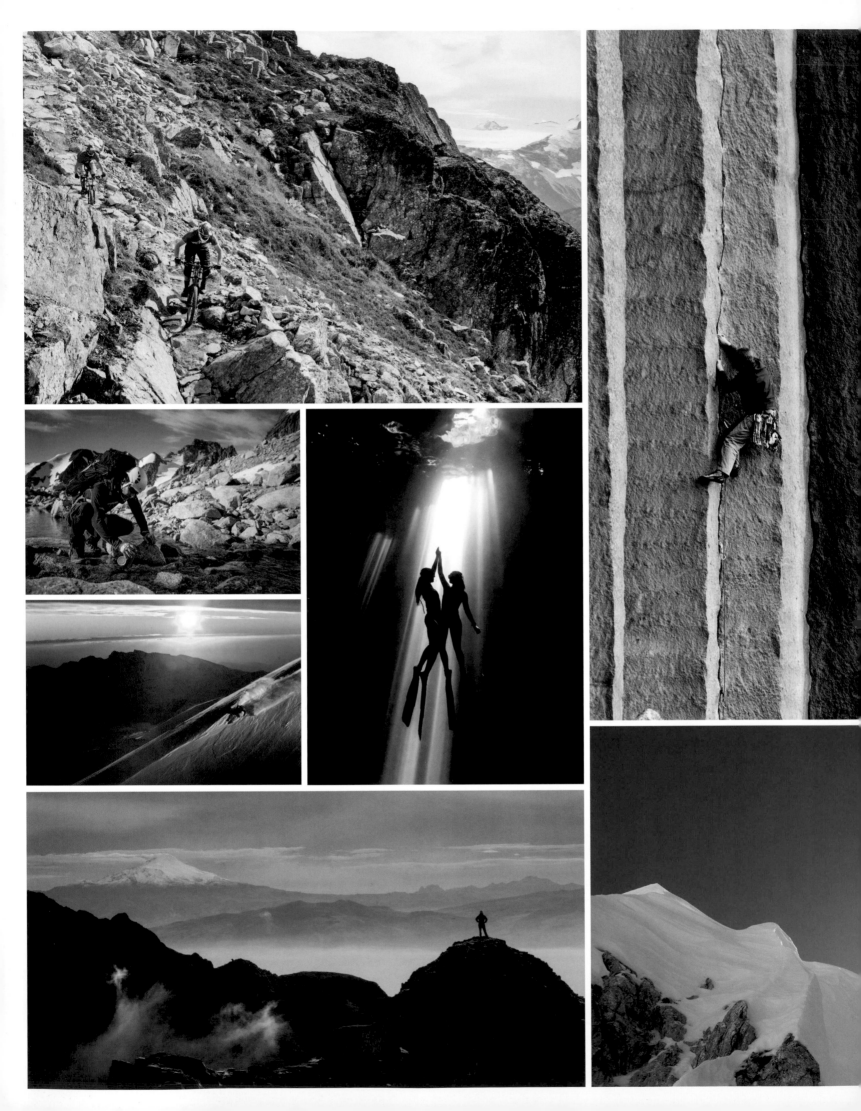

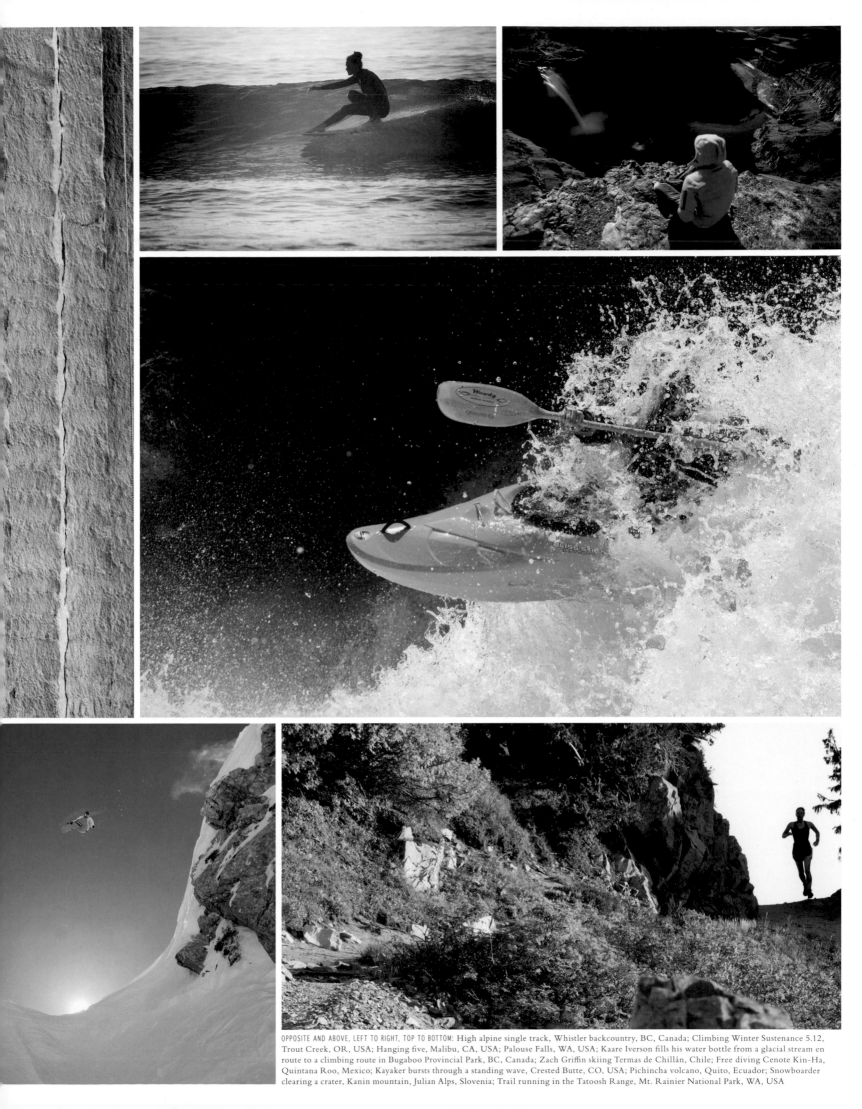

OPPOSITE AND ABOVE, LEFT TO RIGHT, TOP TO BOTTOM: High alpine single track, Whistler backcountry, BC, Canada; Climbing Winter Sustenance 5.12, Trout Creek, OR, USA; Hanging five, Malibu, CA, USA; Palouse Falls, WA, USA; Kaare Iverson fills his water bottle from a glacial stream en route to a climbing route in Bugaboo Provincial Park, BC, Canada; Zach Griffin skiing Termas de Chillán, Chile; Free diving Cenote Kin-Ha, Quintana Roo, Mexico; Kayaker bursts through a standing wave, Crested Butte, CO, USA; Pichincha volcano, Quito, Ecuador; Snowboarder clearing a crater, Kanin mountain, Julian Alps, Slovenia; Trail running in the Tatoosh Range, Mt. Rainier National Park, WA, USA

AFTERWORD

BY JON-PAUL HARRISON
Tandem Stills + Motion

Sitting on the edge of Temagami Island well past midnight, I take in every star in the sky. A fifteen-year-old counselor-in-training at Camp Wabikon nestled on the southern tip of the Island with the crystal blue waters of Lake Temagami between my toes. We slide our canoe into the water with the delicate touch of a ballerina's feet glissading across Carnegie Hall. "Strong but silent." The only three words my friend and I spoke to each other that evening as our paddles cut through the water with the quiet intensity of a chess champion. "Strong but silent."

February 2006 . . . I am about to drop into Firebreak on Heavenly Mountain in Lake Tahoe, and all I can hear is the internal echo of "strong but silent." I was no longer a young man learning wilderness survival with nothing but the stars above me. I was a freshly employed ski-industry professional with a college degree and not much else. $73.37 in my bank account. Trying not to break my femur or lose the trust of my colleagues. I remained silent and shot the line that changed my life. The line that opened internal doors but closed external ones. Professional, social, and career-oriented doors were shut. Introspective, abstract, and creative doors were opened—of this change in course I was markedly self-aware. The move to Manhattan to ascend the corporate pecking order was not happening. Nor was alumni weekend in autumn. The call to family was made. I am staying outdoors.

I am not a photographer or athlete. I do not create moments or break records. Working on the front lines of the outdoor industry, I strive to keep the introspective, abstract, and creative doors open every single day—pushing the creativity of our photographers while respecting the mission statements of the outlets and brands that bring our work to the masses. I create connectivity. Connectivity to the flatlander in Columbus, Ohio, who names the roof of her garage "the Grand Teton" after seeing the cover of *Backpacker* magazine she dug out of a bin at Miller Park library. Connectivity to the family of four that moves to Stowe, Vermont, to ensure the kids can cross-country ski home from school. Connectivity to the Jackson, Wyoming, ski-bum who considers *SKI* magazine her reliable source for world news because nothing else matters. Connectivity to those who cannot sneak out of the office for fresh air.

Inspiration is the tonic of life. Without inspiration, the mind is detached and the heart loiters in the body, gasping for air like a sea anemone waiting for high tide. Inspiration gives you backbone. Backbone to quit the job that doesn't define you. Backbone to summit the garage. Backbone to trust those ahead and those behind us.

Backbone is built with the foundation of strength and silence.

A marriage to Mother Nature is rarely a successful one, but it is well worth the pursuit. Just be sure to remain "strong but silent."

OPPOSITE: A restored 1920s-era canoe sits at the ready at dusk, Lake Sebago, Harriman State Park, NY, USA
FOLLOWING PAGES: Car camping on Shadow Mountain with the Grand Tetons in the background, WY, USA

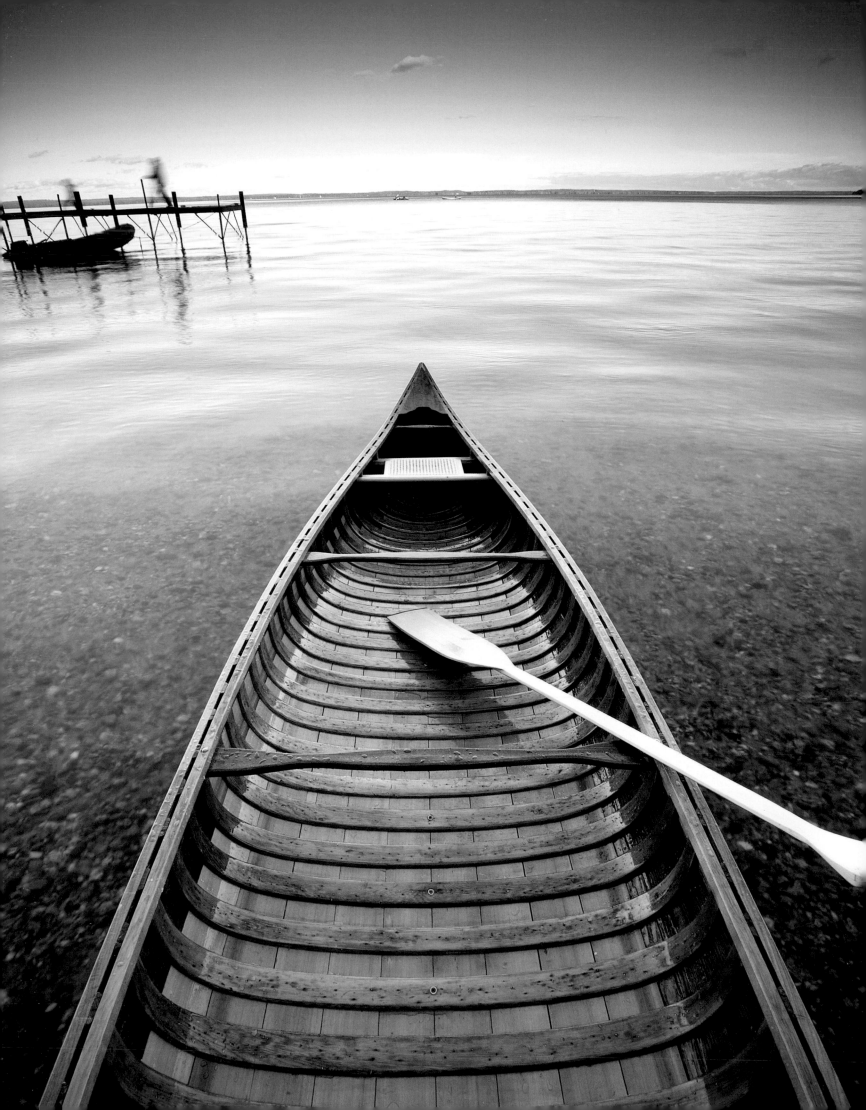

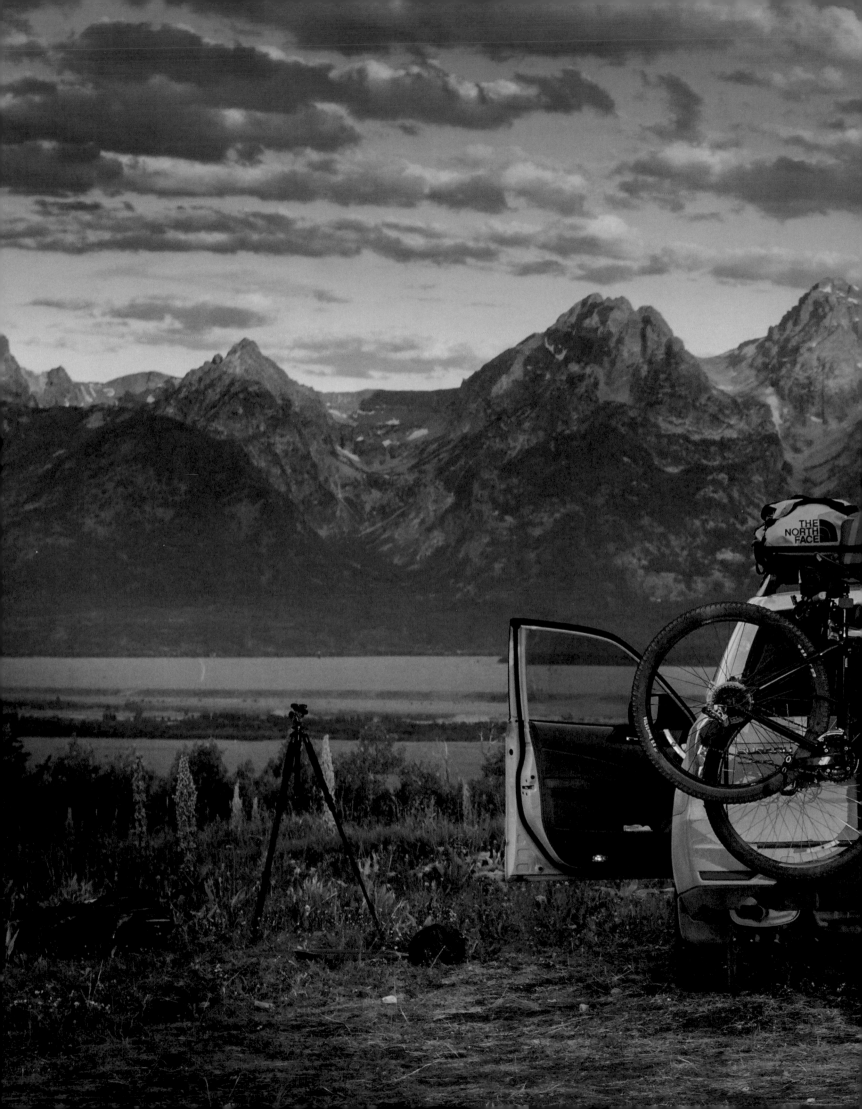

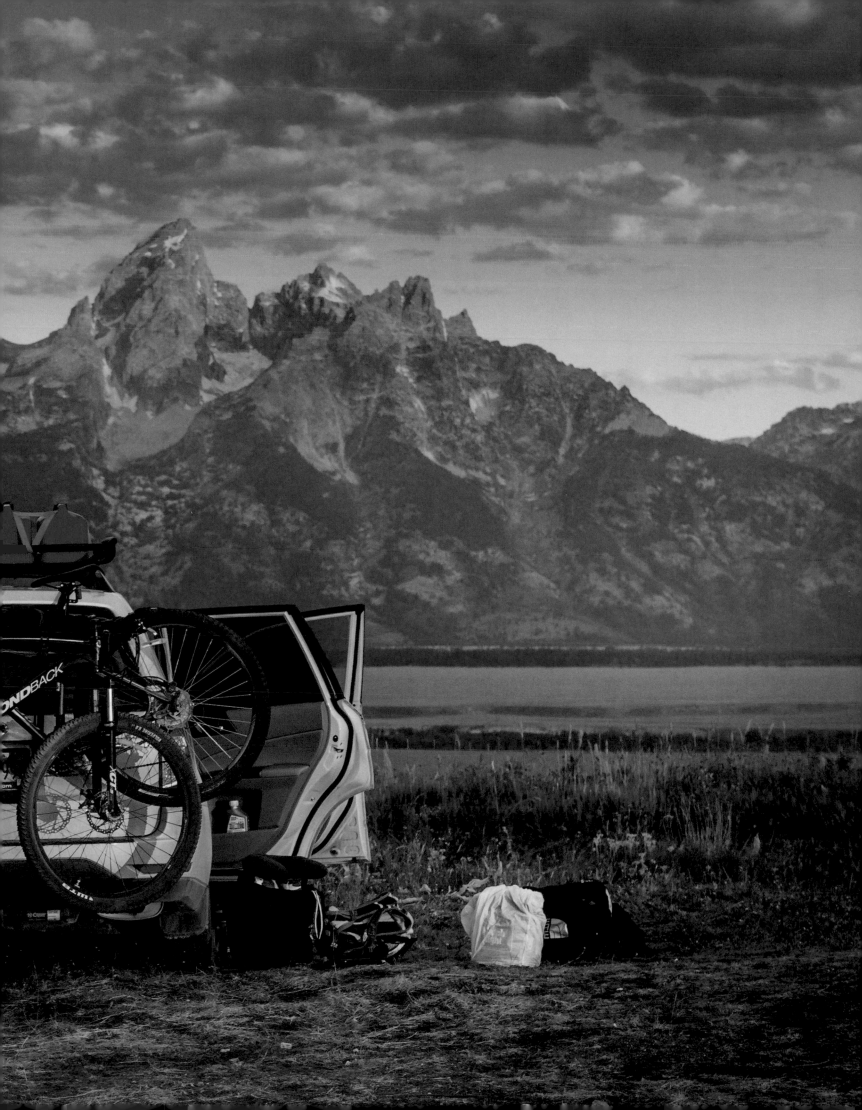

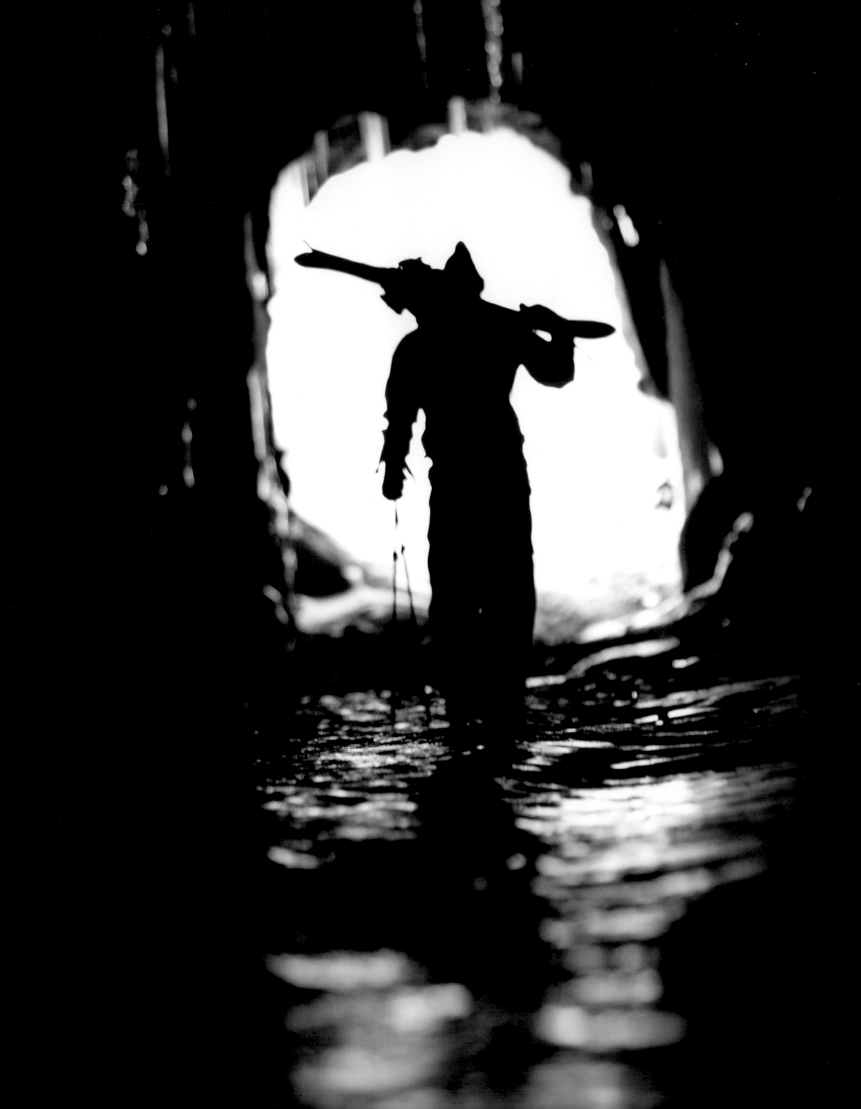

LEAVE NO TRACE
OUTDOOR SKILLS AND ETHICS

 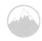

People enjoy the outdoors in myriad ways. We explore on foot, kayaks, horseback, mountain bikes, skis, snowshoes, and crampons, to name a few, and there are more of us pushing our sports to greater extremes and into remoter parts of the natural world every day. Our experiences are personally satisfying, but they can be costly to the places we visit and the animals we observe.

The world's wildlands are diverse and beautiful, but they can also be fragile. Polluted waters, displaced wildlife, eroded soils, and trampled vegetation are just some of the impacts linked directly to outdoor recreation. Even our mere presence has an impact. Considerable damage could be prevented if recreationists were better informed, especially about Leave No Trace techniques.

At the heart of Leave No Trace are seven principles for reducing damage caused by outdoor activities—particularly nonmotorized recreation. These principles and practices extend common courtesy and hospitality to other wildland visitors and to the natural world of which we are all a part.

PLAN AHEAD AND PREPARE

- Know the regulations and special concerns for the area you'll visit.
- Prepare for extreme weather, hazards, and emergencies.
- Schedule your trip to avoid times of high use.
- Visit in small groups. Split larger parties into smaller groups.
- Repackage food to minimize waste.
- Use a map and compass to eliminate the use of marking paint, rock cairns, or flagging.

TRAVEL AND CAMP ON DURABLE SURFACES

- Durable surfaces include established trails and campsites, rock, gravel, dry grasses, or snow.
- Protect riparian areas by camping at least 200 feet from lakes and streams.
- Good campsites are found, not made. Altering a site is not necessary.

IN POPULAR AREAS

- Concentrate use on existing trails and campsites.
- Walk single file in the middle of the trail, even when wet or muddy.

IN PRISTINE AREAS

- Disperse use to prevent the creation of campsites and trails.
- Avoid places where impacts are just beginning.

DISPOSE OF WASTE PROPERLY

- Pack it in; pack it out. Inspect your campsite and rest areas for trash or spilled foods. Pack out all trash, leftover food, and litter.
- Deposit solid human waste in catholes dug 6 to 8 inches deep at least 200 feet from water, camp, and trails. Cover and disguise the cathole when finished.
- Pack out toilet paper and hygiene products.
- To wash yourself or your dishes, carry water 200 feet away from streams or lakes and use small amounts of biodegradable soap. Scatter strained dishwater.

LEAVE WHAT YOU FIND

- Preserve the past: observe, but do not touch, cultural or historic structures and artifacts.
- Leave rocks, plants, and other natural objects as you find them.
- Avoid introducing or transporting nonnative species.
- Do not build structures or furniture or dig trenches.

MINIMIZE CAMPFIRE IMPACTS

- Campfires can cause lasting impacts to the backcountry. Use a lightweight stove for cooking, and enjoy a candle or lantern for light.
- Where fires are permitted, use established fire rings, fire pans, or mound fires.
- Keep fires small. Use only sticks from the ground that can be broken by hand.
- Burn all wood and coals to ash, put out campfires completely, then scatter cool ashes.

RESPECT WILDLIFE

- Observe wildlife from a distance. Do not follow or approach them.
- Never feed animals. Feeding wildlife damages their health, alters natural behaviors, and exposes them to predators and other dangers.
- Protect wildlife and your food by storing rations and trash securely.
- Control pets at all times, or leave them at home.
- Avoid wildlife during sensitive times: mating, nesting, raising young, or winter.

BE CONSIDERATE OF OTHER VISITORS

- Respect other visitors, and protect the quality of their experience.
- Be courteous. Yield to other users on the trail.
- Step to the downhill side of the trail when encountering pack stock.
- Take breaks, and camp away from trails and other visitors.
- Let nature's sounds prevail. Avoid loud voices and noises.

OPPOSITE: Sugar Bowl, Placer County, CA, USA

ACKNOWLEDGMENTS

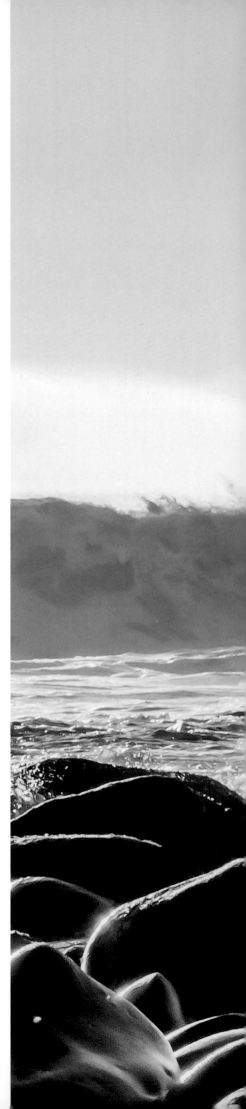

The Tandem Stills + Motion team would first like to acknowledge all of the photographers, friends, and clients who are part of our community. Without the passion, dedication, and creative vision of the one thousand–plus people who have chosen Tandem to represent their work, we would not be in the position to bring this title to life.

In particular, we would like to thank the numerous athletes and commentators who have contributed to this book, including Genny Fullerton from *Backpacker*, Keri Bascetta from *SKI* and *Skiing*, Dave Cox from *Mountain*, Aaron Schmidt from *Canoe & Kayak*, Julie Ellison from *Climbing*, and Amy Silverman and Sara Bielecki from *Outside*. Their editorial contributions and day-to-day love for outdoor adventure are showcased throughout this book and the magazines they produce every month. We are thankful for the opportunity to call these friends our "clients." We also want to extend a thank you to the Tandem photographers who provided images and editorial contributions to the book, including Ben Herndon, Justin Bailie, Adam Barker, Steven Gnam, Stephen Matera, Louis Arevalo, Mike Schirf, Tobias MacPhee, Bennett Barthelemy, Dan Holz, and Lindsay Daniels.

We thank Susan Alkaitis and the Leave No Trace Center for Outdoor Ethics for the important work they do to ensure a future for outdoor adventure sports.

We thank Insight Editions for believing in the vision of this book, with special thanks to publisher and president Raoul Goff and to editor Dustin Jones, whose enthusiasm for outdoor sports shines through these pages. Without Dustin's day-to-day efforts, this project would not have been completed.

We also would like to thank those who have provided our team with personal support in and out of the office, including Ian Maliniak, Amy Fulgham, and our ever-so-patient families, who always trust our various ideas even if they exist only on napkins.

Last but most important, we thank the everyday adventurer who made this book possible. Without the passion and drive of those folks who seek a life that's a bit more exciting, a bit more dangerous, and a lot more fun, we would never have been afforded the opportunity to create such beautiful work.

OPPOSITE: A young surfer prepares to paddle out at El Capitán during an epic northwest swell, Gaviota, CA, USA

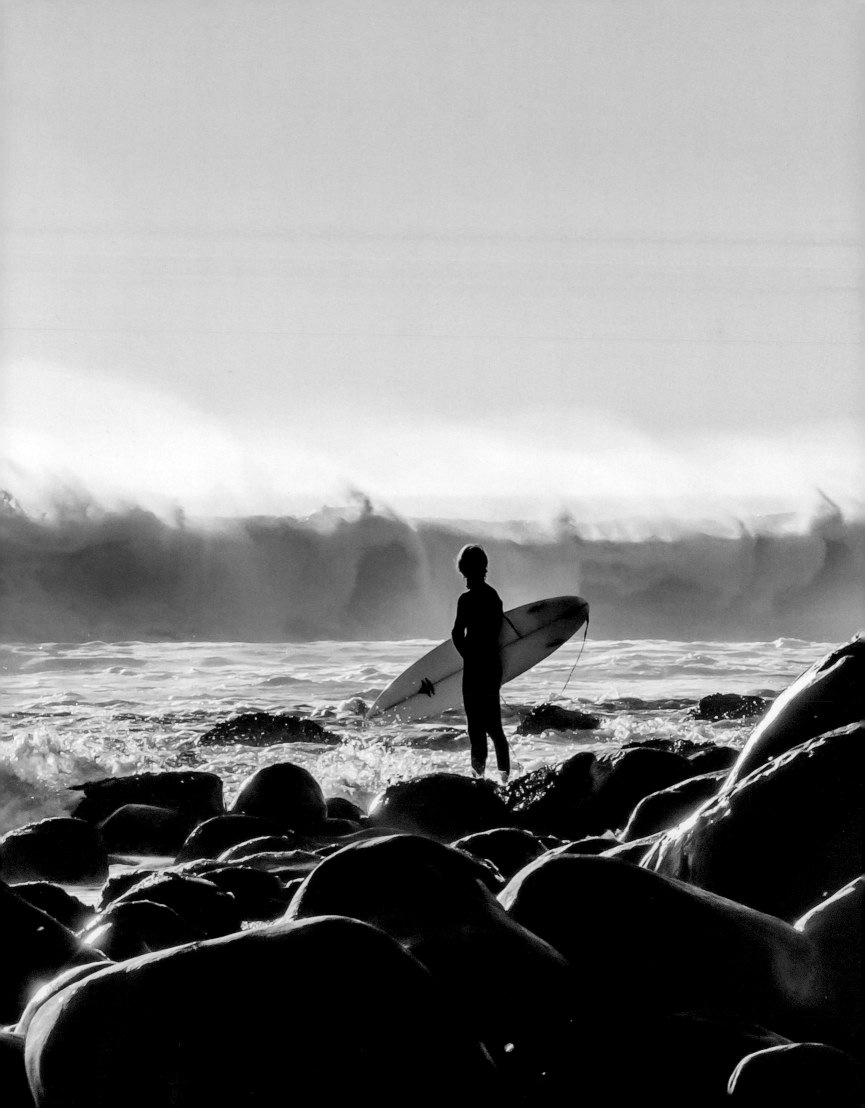

PHOTO CREDITS

CARLO ACENAS: Pages 56 (top right and bottom left), 58 (top), and 61

JAMES AIKMAN: Page 101

LOUIS AREVALO: Pages 14, 96 (middle left), 100, 114 (top right), 115, and 162

ALLISON MAREE AUSTIN: Page 42 (middle right)

JUSTIN BAILIE: Pages 23, 31, 32 (all), 33, 34 (top), 35, 36, 38, 39, and 144 (middle right)

ADAM BARKER: Pages 79 and 136 (middle)

BENNETT BARTHELEMY: Pages 22 (middle left and bottom right), 24, 110 (all), 113, and 145

BRAD BECK: Page 57

AXEL BRUNST: Pages 56 (middle left, middle, middle right, and bottom right), 136 (middle left, middle right, bottom left), 139 (bottom), 142-143, and back cover (bottom left)

VINCE M. CAMIOLO: Pages 50 (middle left) and 53 (bottom)

AARON CHABOT: Page 56 (top left)

DANE CRONIN: Page 166 (top left)

AUSTIN CRONNELLY: Page 144 (bottom right)

LINDSAY DANIELS: Page 152

ALAIN DENIS: Page 129

SCOTT DICKERSON: Pages 48-49, 52, 53 (top), 54-55, and 58 (bottom)

OSCAR DOMINGUEZ: Page 148

LIAM DORAN: Page 167 (middle)

STAN EVANS: Pages 86 (middle left) and 87

MAUREEN EVERSGERD: Pages 20-21

COLT FETTERS: Pages 76 (top left) and 96 (middle right)

BRANDON FLINT: Page 156 (top right)

REBECCA GAAL: Pages 44-45 and 114 (top left)

DANIEL GAMBINO: Pages 102 (top) and 124 (bottom right)

STEVEN GNAM: Pages 71, 86 (top and bottom left), 114 (middle left), 121, 122-123, 124 (middle), 157, 165, and back cover (second from top middle)

JAY GOODRICH: Pages 70 (middle left) and 137

GRANT GUNDERSON: Pages 17 (middle), 17 (bottom right), 70 (top left, top right, bottom left), 72, 74 (top right), 75, 80-81, 86 (middle right), 88-89, 166 (second from bottom left), 172, and back cover (second from top left)

TOBY HARRIMAN: Pages 4-5 and 47 (top)

KENT HARVEY: Pages 114 (middle right), 120, and back cover (second from bottom middle)

KIM HAVELL: Page 118

MEG HAYWOOD-SULLIVAN: Page 92 (top)

BEN HERNDON: Pages 6-7, 10, 17 (top right), 70 (bottom right), 77, 96 (middle and bottom right), 114 (bottom left, bottom right), 124 (top left, top right, middle left, and bottom left), 127, 128, 130, 131 (top), 132, 133, 144 (top right), 149, 166-167 (middle), 167 (top right), and back cover (bottom right)

BRETT HOLMAN: Pages 22 (top right), 136 (top left), 154-155, and 156 (middle right)

DAN HOLZ: Pages 96 (bottom left), 97, 103, 104, 106-107, 136 (top right), 141, 144 (middle and bottom left), 166 (second from top left), and back cover (top right)

KAARE IVERSON: Page 96 (top left)

MATT JONES: Pages 34 (bottom), 136 (bottom right), and back cover (top left)

RON KOEBERER: Page 22 (middle)

RYAN KRUEGER: Pages 68-69

DANIEL KURAS: Page 43

JASON LOMBARD: Pages 42 (middle left and middle), 59, and 60

TOBIAS MACPHEE: Pages 2-3, 17 (middle right), 50 (middle right), 83, 84-85, 92 (bottom), 96 (top right), 102 (bottom), 109, 125, 156 (middle left), 160, and back cover (second from bottom left)

STEPHEN MATERA: Pages 41 and 163

ALEX MESSENGER: Pages 170-171

JIM MEYERS: Pages 98, 138, and 151

GREG MIONSKE: Page 140

DAVID MOSKOWITZ: Pages 16-17 (bottom left)

ARI NOVAK: Pages 134-135

NEIL EVER OSBORNE: Page 62 (top left)

STEVEN ROOD: Pages 16-17 (top left), 167 (top left), and 174-175

RONNY ROSE: Page 17 (top middle)

MIKE SCHIRF: Pages 74 (top left), 156 (bottom right), and 159

AARON SCHMIDT: Pages 30, 42 (top right, bottom left, and bottom right), 46, and 50 (bottom right)

LISA SEAMAN: Page 150

CELIN SERBO: Pages 18-19, 108, 131 (bottom), 139 (top), and 156 (bottom left)

IAN SHIVE: Pages 50 (top left), 62 (bottom left), and 169

MAC STONE: Pages 22 (top left) and 166 (bottom right)

TIM SZLACHETKA: Page 47 (bottom) and back cover (second from top right)

RANDALL TATE: Page 13

JASON THOMPSON: Page 167 (bottom right)

PHIL TIFO: Pages 26-27, 28-29, 50 (bottom right), 86 (top and bottom right), 90-91, 93, 156 (top left), and 166-167 (bottom middle)

ANTHONY TORTORIELLO: Page 42 (top left)

CHRISTIAN VIZL: Pages 8, 62 (top right, middle, middle right, and bottom right), 63, 64-65, 66-67, and 166 (middle right)

ETHAN WELTY: Pages 16-17 (middle left), 94-95, 114 (middle), 117, 119, and 144 (top left)

WOODS WHEATCROFT: Page 50 (top right)

BEN YORK: Page 22 (bottom left)

JONATHAN YOUNG: Page 76 (top right)

ROBERT ZALESKI: Pages 51 and 146

CARL ZOCH: Page 76 (bottom)

INSIGHT EDITIONS
PO Box 3088
San Rafael, CA 94912
www.insighteditions.com

Find us on Facebook: www.facebook.com/InsightEditions

Follow us on Twitter: @insighteditions

Published by Insight Editions, San Rafael, California, in 2014. No part of this book may be reproduced in any form without written permission from the publisher.

Library of Congress Cataloging-in-Publication Data available.

ISBN: 978-1-60887-404-0

PUBLISHER: Raoul Goff
EXECUTIVE EDITOR: Vanessa Lopez
PROJECT EDITOR: Dustin Jones
ART DIRECTOR: Chrissy Kwasnik
DESIGNER: Malea Clark-Nicholson
PRODUCTION EDITOR: Rachel Anderson
PRODUCTION MANAGER: Jane Chinn

Manufactured in China by Insight Editions

10 9 8 7 6 5 4 3 2 1

PAGES 2-3: San Rafael Swell, UT, USA
PAGES 4-5: North Shore, Oahu, HI, USA
PAGES 6-7: Craig Pope climbs the Scepter, Hyalite Canyon, MT, USA
PAGE 8: Cenote Cristalino, Quintana Roo, Mexico

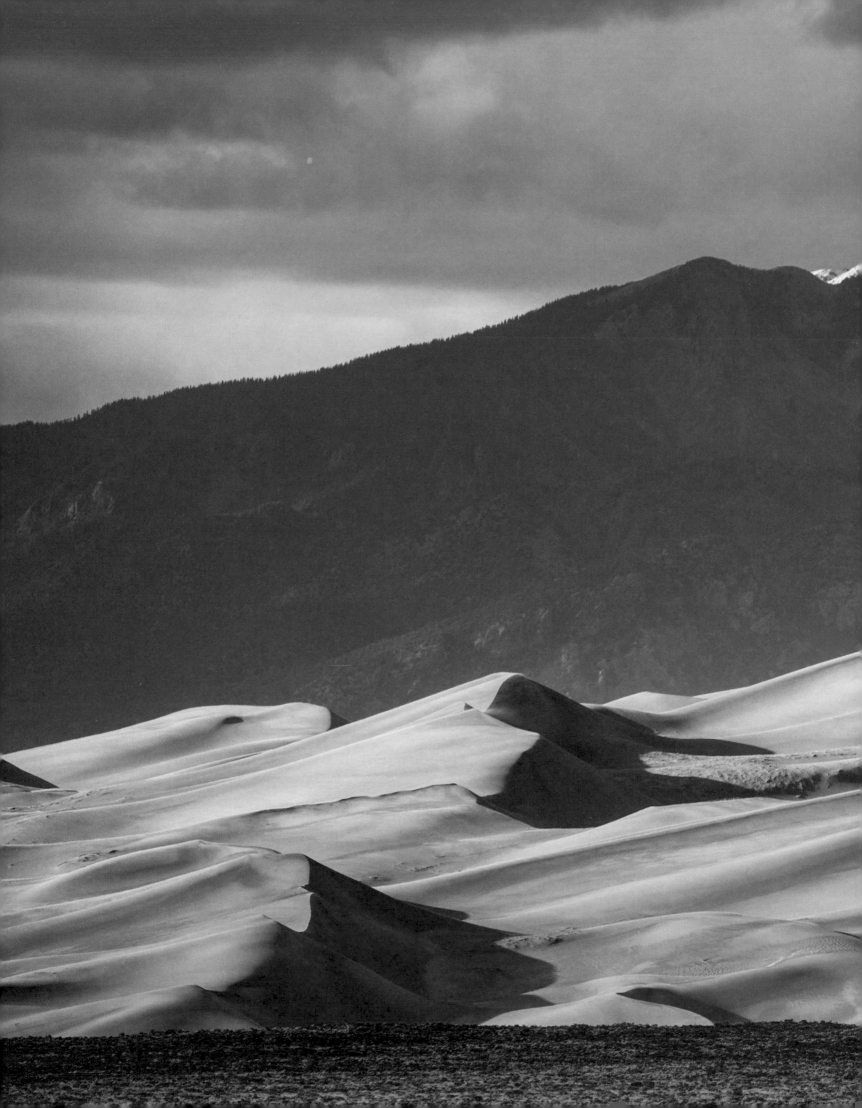